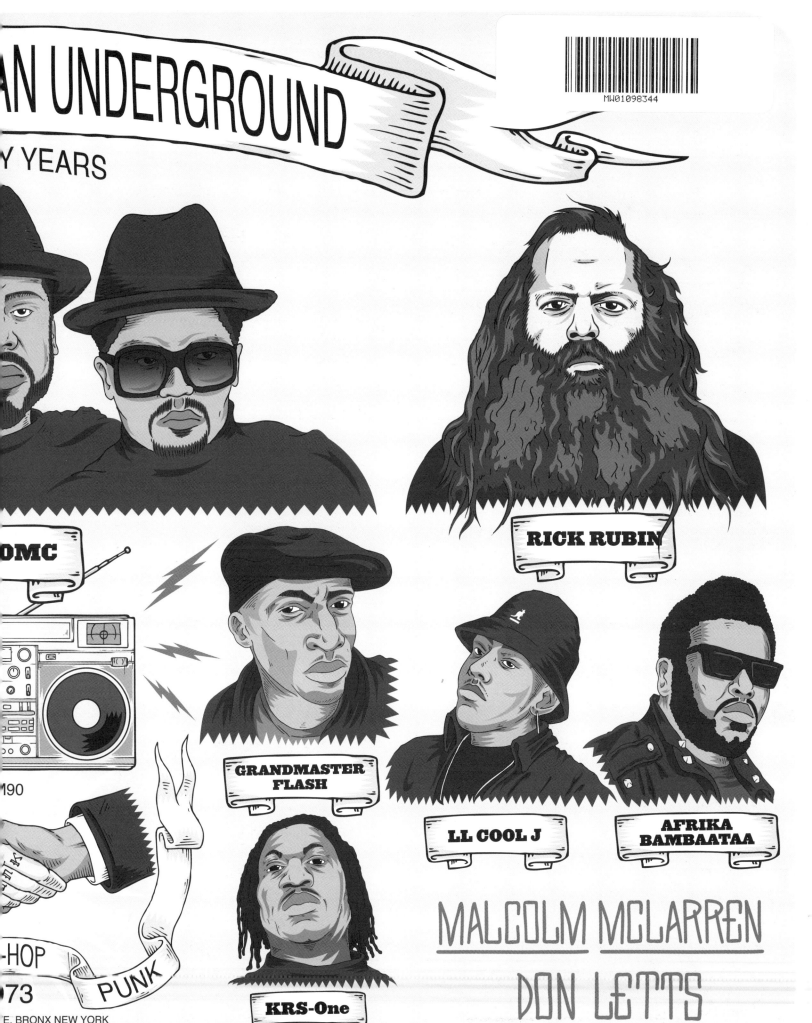

THE BOOMBOX PROJECT

the machines, the music, and the urban underground

THE BOOMBOX PROJECT

the machines, the music, and the urban underground

Lyle Owerko
foreword by Spike Lee

Boombox photography by **Lyle Owerko**
Design by **Lyle Owerko** and **Jeff Streeper**

Abrams Image, New York

CONTENTS

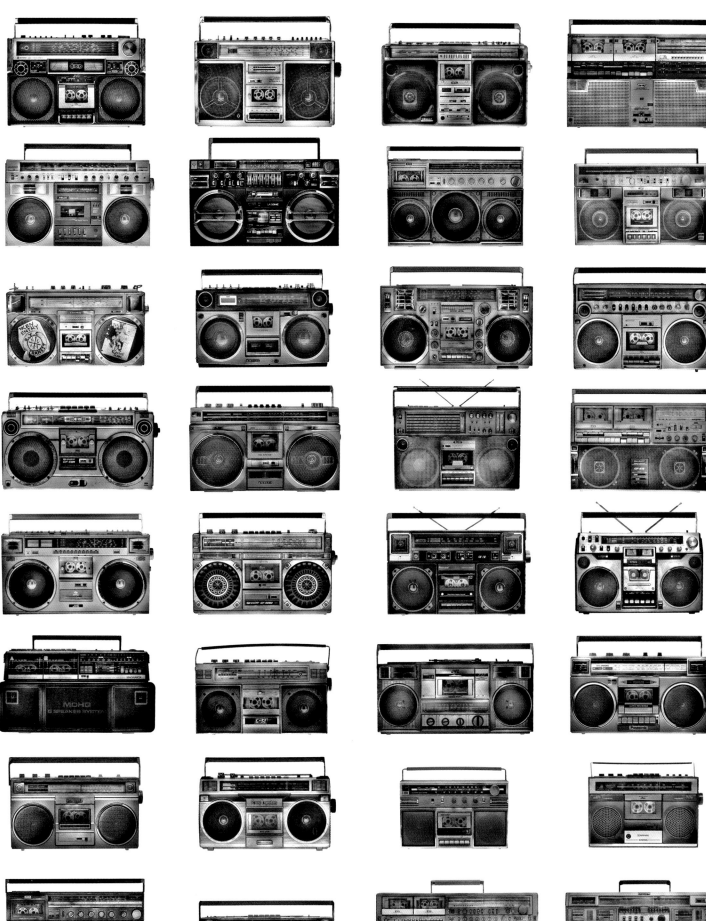

COVER YA' EARS

Growing up in the Brooklyn neighborhood of Cobble Hill in the mid-sixties I was first introduced to the power of portable music. There was this guy everybody called Joe Radio. He got that moniker because he stood on the corner of Henry and Warren Streets with a small transistor radio on his shoulder. I should say attached, because if you saw Joe Radio, you saw that small transistor on his shoulder. He would listen to the WMCA Good Guys or WABC with Cousin Brucie night and day, day and night. Joe Radio was the only one I ever knew who did that. The image of him constantly listening to his radio was burned into my mind at the young age of eight. Many, many years later, that boyhood experience reemerged as the character Radio Raheem in my 1989 film *Do the Right Thing*. I witnessed the tiny transistor radio evolve into the boomboxes of the eighties. I never owned one; number one reason, they weighed a ton; number two, it cost a fortune in batteries. I didn't have stock in Eveready or Duracell. It was some serious work lugging that shit around, and you had to have a strong will to impose your musical taste on the world. There was no sense in having a boombox if you did not play it at eardrum-shattering levels. You also had to be ready to fight if somebody dared ask you to "turn that shit down." Radio Raheem would die for his boombox, for his music, blasting Public Enemy's anthem "Fight the Power" all throughout the film.

This fine book by photographer Lyle Owerko superbly documents the long-gone era of the walking boombox (I never liked the racist term "ghetto briefcase") in all its loud glory. These photographs bring back many memories, but do I miss them? Hell no. Thank God for Sony's Walkman, which eventually evolved into today's Apple iPod. Although, every once in a while, when driving my New York Yankees–pinstriped Mustang in Martha's Vineyard (home to many fans of the hated Boston Red Sox), I blast Public Enemy's "Fight the Power" and Radio Raheem lives.

— Spike Lee, March 20 in the Year of Our Lord 2009, Brooklyn, New York

PORTRAIT OF SPIKE LEE
ERICA SIMMONS

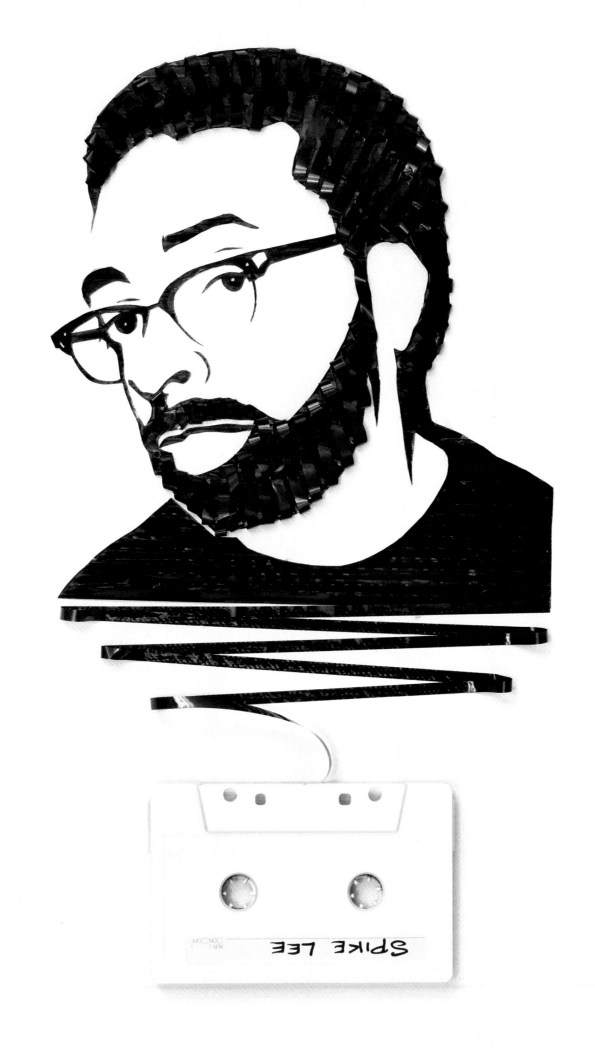

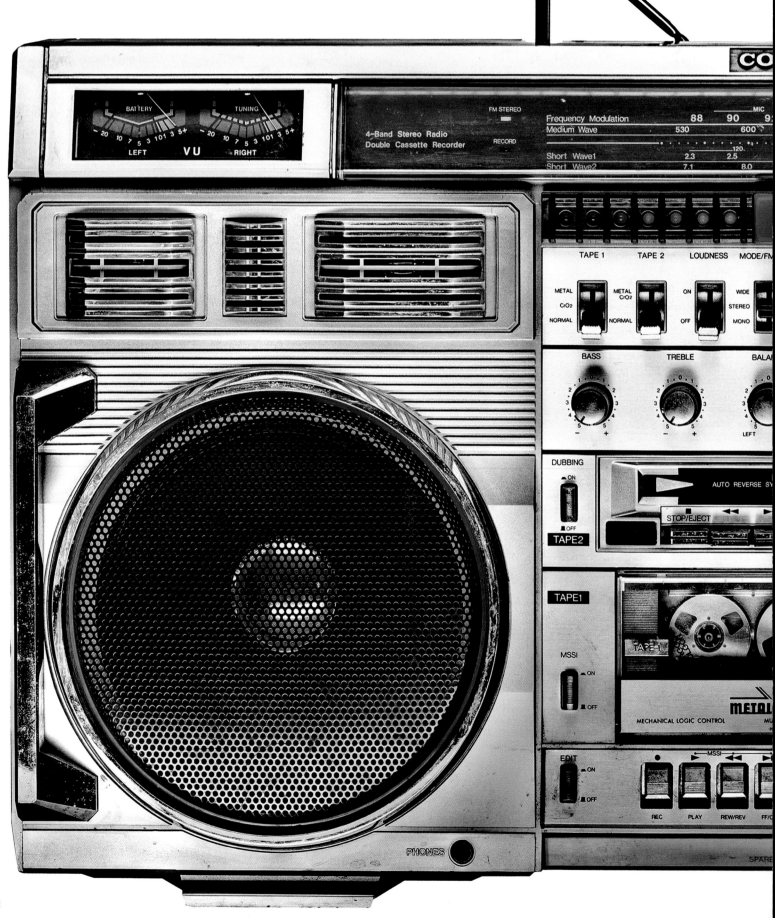

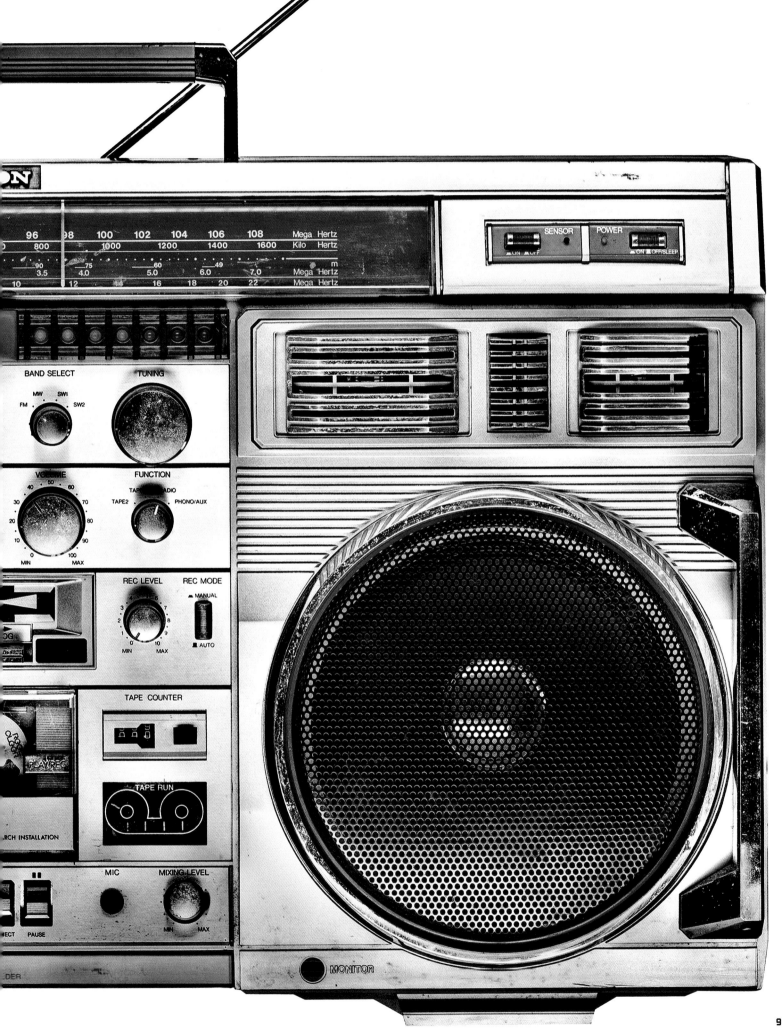

9

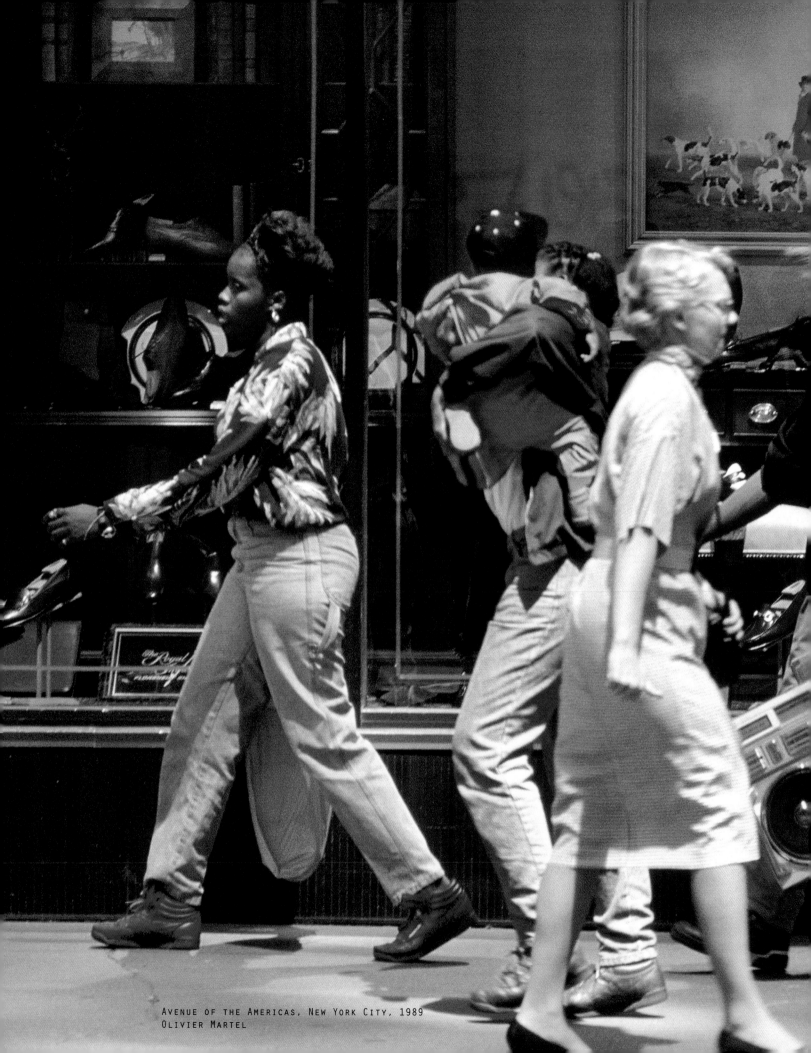

AVENUE OF THE AMERICAS, NEW YORK CITY, 1989
OLIVIER MARTEL

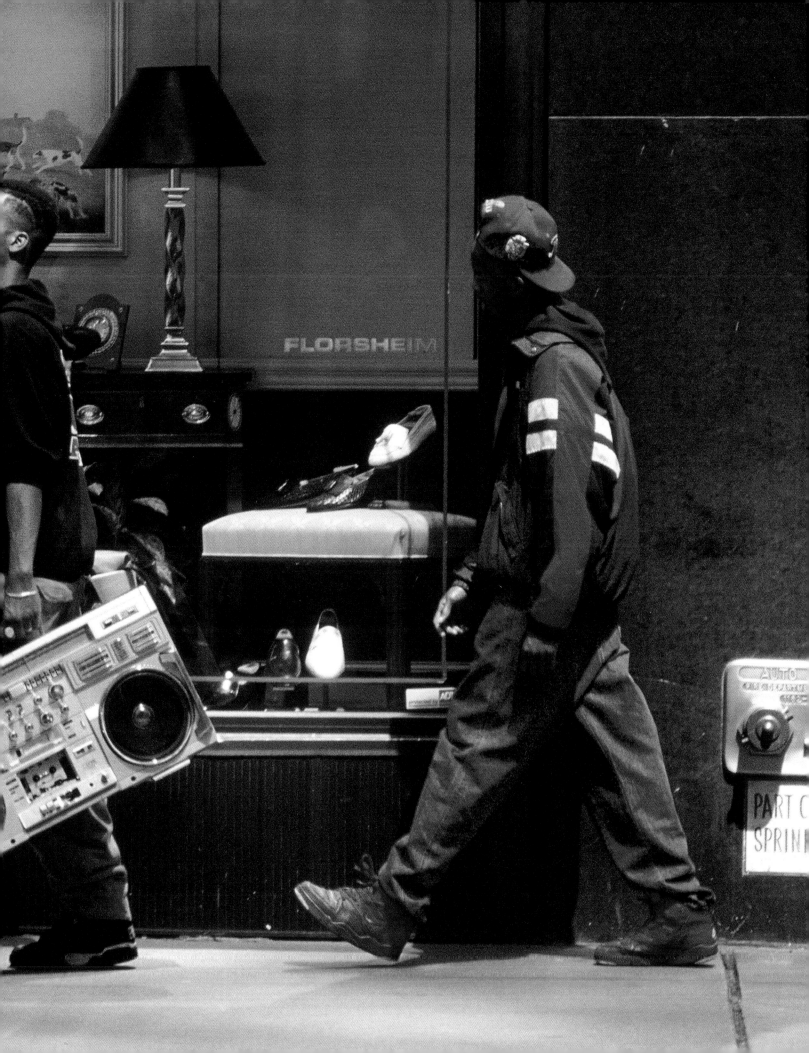

WEAPONS OF MASS DISTRACTION

I've always been fascinated with the meanings of things, more than just the visage of it. To me that's what makes long-lasting art. That's what makes long-lasting history. That's what makes anything that is culturally significant. It isn't just the visual of it. It's the meaning behind it and somehow that's how I found boomboxes (or more like boomboxes found me).

Exactly when the term *boombox* hit the streets is not known for sure. In the United States, department stores apparently began using the term in marketing and advertising as early as 1983. Street slang linguists pin the term down at 1981, and define the boombox as "a large portable radio and tape player with two attached speakers." Initially, it became identified with certain segments of urban society, hence the nicknames like "ghetto blaster" and "beatbox." And due to their size and relative portability, as the general public began to embrace these gargantuan creations of electronics, lights, and chrome-plated gadgetry, a new form of expression was born.

I was given my first box in the early eighties to listen to while I did my artwork. It was an upgrade from the one-speaker Realistic tape deck that I had been using to listen to mix tapes. Throughout college I worked in silk-screen shops, taking my boombox from gig to gig until it gradually was entirely covered with ink, paint, and caustic solvents. After college, I moved to New York and lived on Forty-first Street in an industrial building a few blocks from the center of Times Square. It wasn't long before I hit up one of the electronics shops in the area for an all black and shiny metallic-plated Lasonic box. That box stayed with me through many moves, different girlfriends, and some really odd living situations.

Over the years, I worked as a photographer in some pretty hairy situations, both in Africa and New York. After the events of 9/11 ripped apart my downtown neighborhood, I took every assignment I could to travel. In December of '01, I was in Japan on tour with the band American Hi-Fi, directing their tour documentary. During a few hours off in Tokyo, I lucked out in picking up an absolutely mint late-seventies Victor (JVC) at an outdoor market—I was stoked. It went everywhere with us. The band insisted on having it onstage with them, placed next to the drum kit at each night's gig. The box saw so much fun on that trip. On the last night of the tour, the band headlined at a huge venue in Tokyo with MTV Japan on hand to film the gig. Hi-Fi pulled out all the stops. The crowd went ballistic as the band rocked the joint. Stacy Jones, the lead singer, destroyed his Fender during the last encore, then turned and grabbed whatever he could get his hands on next . . . my boombox! It was sitting comfortably in front of the bass drum. He snatched it and in one quick swoop pummeled it into the stage like Godzilla swatting down a tiny fighter jet. I watched as my beautiful, mint-condition box was obliterated in a rock star crash test. Pieces were everywhere . . . a fractured rut was left in the stage. After the lights went up, I found my box and dragged its eviscerated remains backstage for one final photograph. Meanwhile, the venue's bewildered road crew stood in a circle staring at the gaping hole in the stage that looked as if an asteroid had knifed through the ceiling and left a small impact crater.

The picture I took of the ruined remains of the box became the front of their live-in-Japan album called *Rock n' Roll Noodle Shop*—it made a great cover. After that I was determined to find another one like it. Fervid searches expanded my collection through flea markets and thrift stores, eventually leading me online to eBay, which gradually built the remainder of the collection that I have today.

This book grew out of a portrait series of my boombox collection that I began working on some years ago. I wanted to capture the physicality of nostalgia, of what had been a cohesive element between so many genres of music. Initially, I intended to create a photobook so other people could have a set of my work, a version of their own boombox collection. But as I spoke to friends

about the project, the conversations we had made me realize that there was a much bigger story here. In documentary-style photos of boomboxes from the seventies and eighties, you always see groups of people hanging out around boxes on the street, in parks, and on subways, sharing their music. I kept hearing talk about a connection between the box and the ideals of empowerment and community.

Determined to find a deeper story, I reached out to musicians and DJs from the late seventies and eighties (as well as present-day artists and personalities) to find out if they had recollections they might want to share with me. Soon I was hearing from DJ and musician Don Letts about how the box connected like-minded people, and how the mobility of the boombox influenced New York street culture and facilitated a defining sound at the crossroads of punk and early hip-hop. In a conversation with Fab 5 Freddy the idea sparked to life that the boombox phenomenon was like a sonic campfire, with people gathering around to generate dialogue, debate, heat. Before long, Spike Lee reached out and expressed an interest in being involved—and what could be more appropriate? His character Radio Raheem crystallizes the power of the boombox as an urban culture icon reflecting the determination to be seen and heard.

I began to arrange all of this material together, juxtaposing my own photos of boxes with other people's perspectives: DJ Spooky's sentiment that the boombox represents a democratization of sound, next to memories from Rosie Perez of the boombox's influence on dance culture. Ed Burns, the director, even called the box "one generation's weapon of choice," a phrase that seems to encompass all the different ways that communities and subcultures latched onto the box as a vessel of expression. Kool Moe Dee illuminated that the Boombox was the sole force for communicating the early voices of Hip-hop.

The groups I heard from who were influenced and connected to the boombox seemed to grow exponentially. I found myself interviewing graffiti artists and skaters, people from the business side of the music industry, and the designers of iconic album covers. As a result, there are names you'll know immediately (who hasn't heard of LL Cool J?) while other names may not elicit immediate recognition. All these people are profound commentators on the subject not necessarily because they became (or were) famous during that time period, but for the reason that they were participating and observing the lifestyle as it was developing. My hope is that their stories will bring to light the great contributors behind the scenes as well as those in the spotlight. If you find yourself wondering how various people quoted in the book are connected to boombox culture, flip to the back pages of the book (which I think of as the liner notes), where you'll locate a list containing mini-biographies of these fascinating people.

And truly, this book project has turned into its own sort of gigantic mix tape, with all of these different perspectives and subcultures razor-bladed together, bonded in unity by their shared experience of boombox culture. In the end, putting this material together illuminated for me that my passion for boomboxes is about more than an obsession with a collection of electronics, lights, and plastic. It's about remembering what it felt like to be part of something bigger—a community of voices—across a range of varied youth cultures that embraced the boombox as their weapon of mass distraction.

Today the boombox has evolved into an icon of popular culture. It has been referenced by rockers, poppers, hip-hoppers, and graffers alike. It is a symbol of rebellion and a way to shout your message at the system. Turn up the volume on your boombox, whatever the size, and let the capstan wheels of the tape deck drive a favorite mix tape to life. As the defiant voice of punk-rock legend Joe Strummer sang, "This is Radio Clash using audio ammunition . . ."

— Lyle Owerko, December 12, 2009, New York

PLAY

▶

1. PLAY ▶ Growing up in the late 1970s through the mid-1980s meant that a boombox in some way, shape, or form had to have been a major part of your life. ▶ It was certainly a part of mine. ▶ I distinctly remember the act of pressing play on a tape deck, activating the mechanical jaw of the audio head to grasp the magnetic strand of cassette tape ribbon held inside its mouth. ▶ This simple act of engineering wizardry conjured to life the anthems of my youth. ▶ Once alive and whirling out an audio assult, a boombox became the sonic campfire in any environment. ▶ It was the place that people would gather around to exchange thoughts, mellow out to, or start the party. ▶ The boombox left an indelible and lasting impression on many lives; igniting a generation of innovation by facilitating bonding over music, sports matches, romances and news events. *LO*

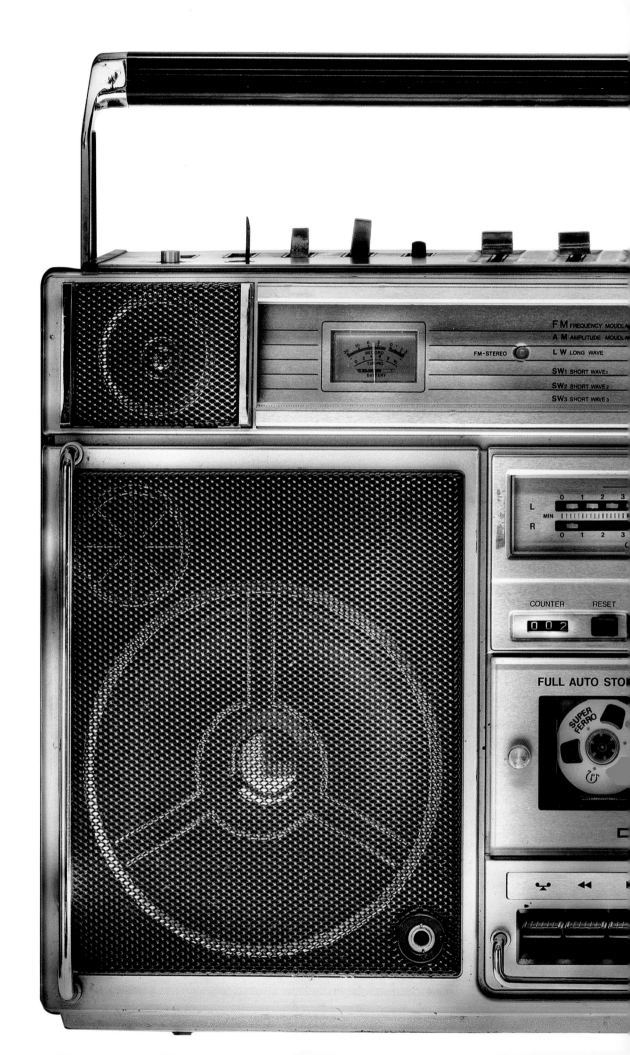

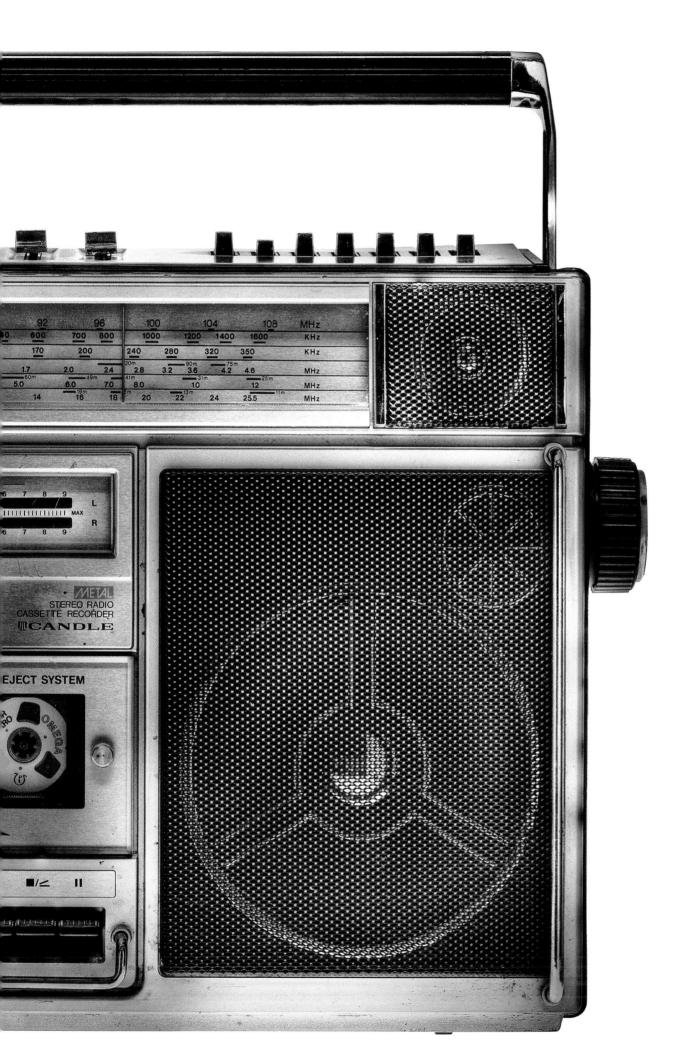

17

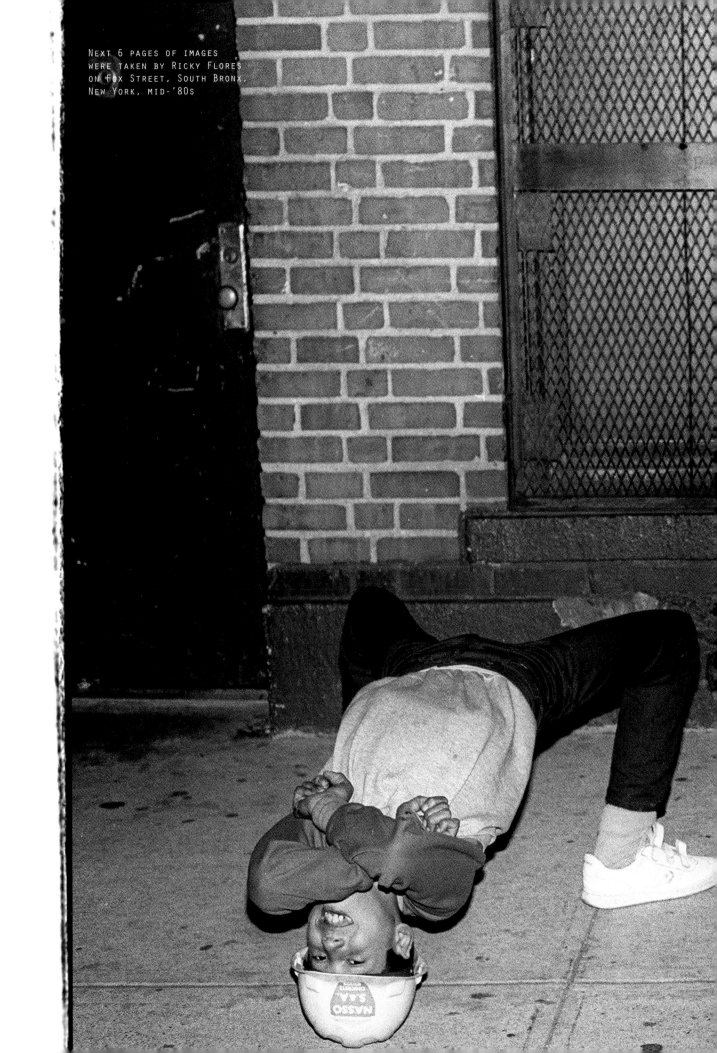

NEXT 6 PAGES OF IMAGES
WERE TAKEN BY RICKY FLORES
ON FOX STREET, SOUTH BRONX,
NEW YORK, MID-'80s

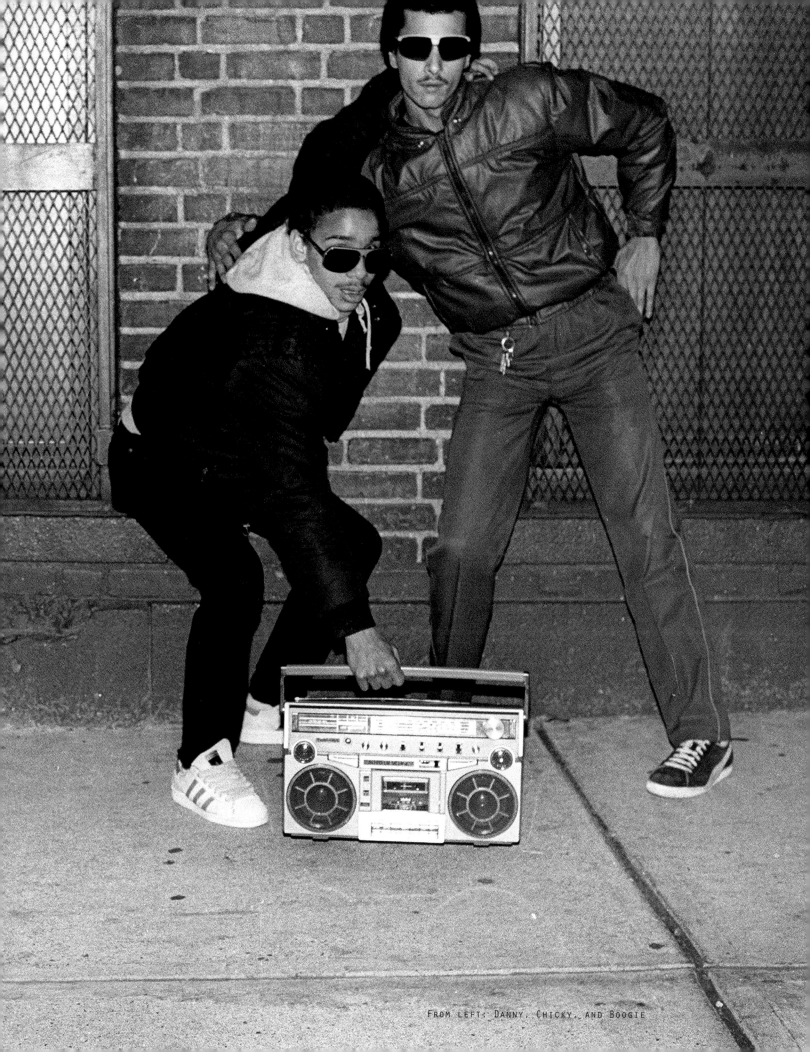

FROM LEFT: DANNY, CHICKY, AND BOOGIE

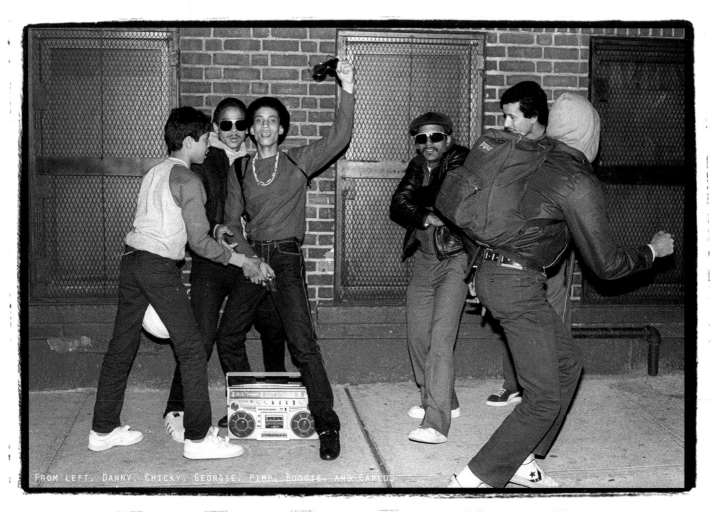

From left, Danny, Chicky, Georgie, Pimp, Boogie, and Carlos

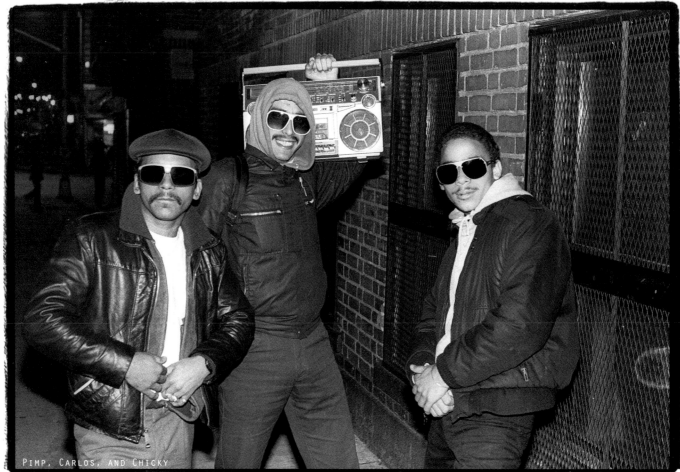

Pimp, Carlos, and Chicky

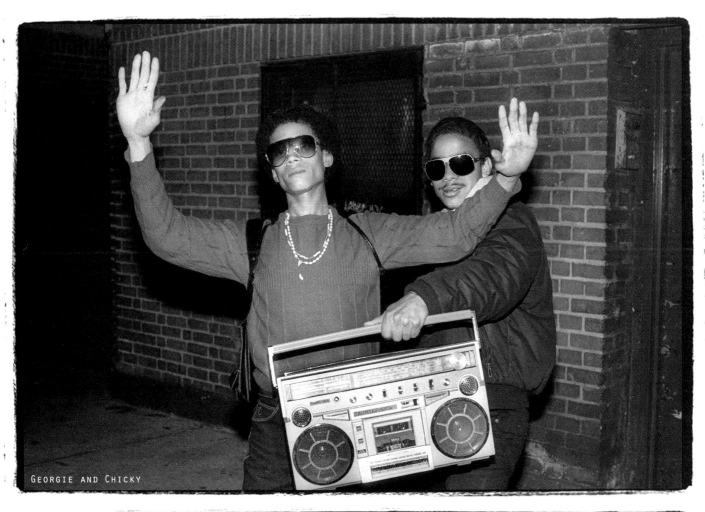

Georgie and Chicky

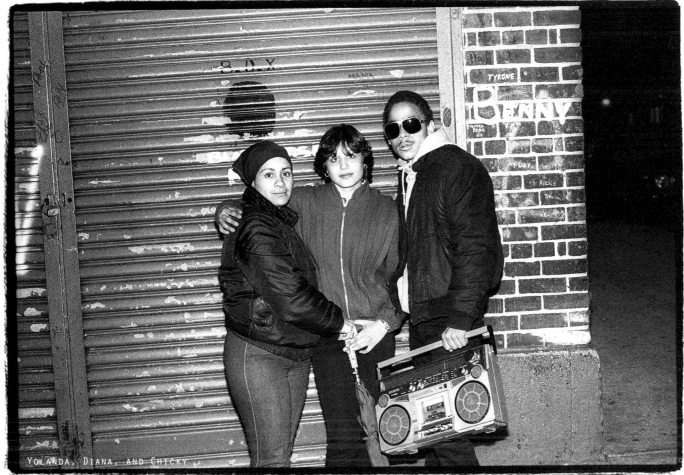

Yolanda, Diana, and Chicky

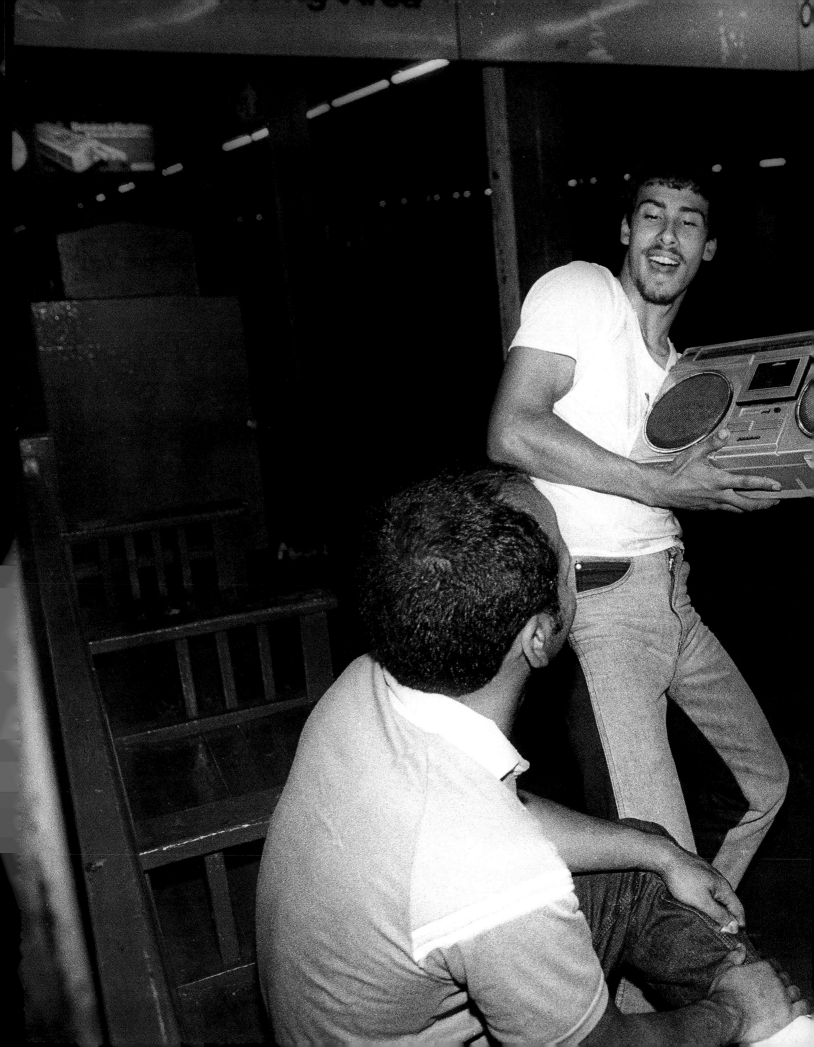

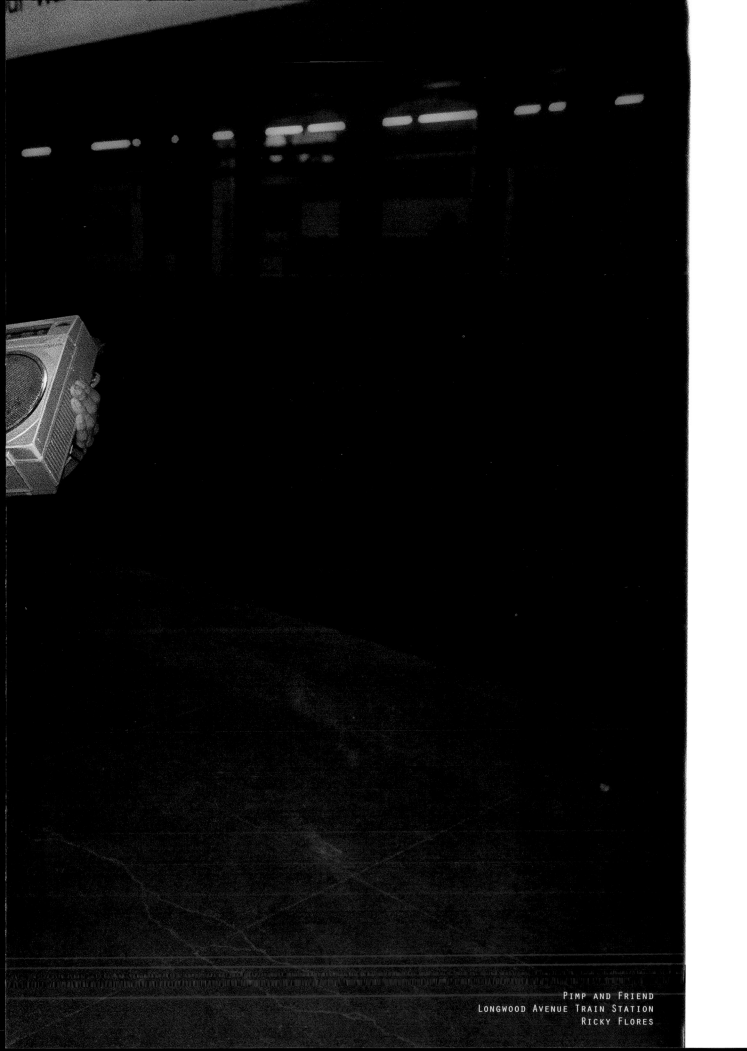

PIMP AND FRIEND
LONGWOOD AVENUE TRAIN STATION
RICKY FLORES

PLAY

During the postwar years of the fifties through the late sixties, the radio as a home stereo went through a rapid downsizing. Innovations in solid-state technologies such as transistors and integrated circuits reduced the size of radios, allowing for even greater portability. What was once literally tethered to the living room floor of most families' homes could now be carried around by hand. In Japan, where living space is at a premium, it was very apparent that there was a public need to create small but excellent-sounding stereos. What began initially as a device to facilitate the movement of Japan's youth from their parents' homes to small urban dwellings ended up birthing an entirely new genre of electronic contraptions. The rapidly spreading need (and somewhat of a rage) for quality sounding portable stereos in Japan took on an audible stature of sorts in America (and the rest of the world), and the "boombox" gained notoriety.

Recording changed the way we listened to music. By popularizing the phonograph, Thomas Edison set the tone for the rest of the twentieth century. And the boombox is the inheritor of what he was going for with portability in sound—the early phonographs were meant for recording and playback. That had never happened in human history before. If you wanted to see something and hear it, you had to be there physically. Recording changed that and, like the phonograph, the boombox embodies a sense of portable experience.

—Paul Miller / DJ Spooky (MUSICIAN / ARTIST)

The early models of these portable stereos, first introduced in the 1970s, were dual-speaker monoliths of sound that came from a number of different manufacturers, such as Sharp, JVC, AIWA, Sanyo, and Sony. Immediately upon their arrival to stores they were a hit with the general public. Initially the goal was to try to replace the homebound hi-fi system. The first models to be unleashed on consumers were small and heavy, with somewhat rudimentary features. However, the true birth of the really large beasts of sound (the hallmark of the boombox) occurred when stereo capabilities were added to the portable radio cassette player. Soon after the launch of these first models, advances in speaker design and cassette fidelity met together with an explosion of industrial design creativity and audio ingenuity that peaked during the golden era of models rolled out during the mid-eighties.

Music went from home collective to public collective. Around '77, '78, I noticed music took a step from being in somebody's apartment to cats literally taking their speakers and turning them outside their windows. These were people who were not DJs, who were just sharing music. This was not like an opportunity to dance. This was just "I love music, and I'm sharing it with my peers." So once that public form of sharing was introduced with the speakers in the windows, then the next sort of public forum was those speakers becoming mobile . . .

—Bobbito Garcia (DJ / WRITER)

Based on their sonic power, boomboxes played a seminal roll in the development of modern music tastes and pop culture both on a visual and auditory level. The golden era of the boombox did not last long, but it definitely made a major impact on society at large. Before they topped out in size (then disappeared from sight to take up residence in our collective memory) what defined a boombox was the presence of two or more loudspeakers, an amplifier, a radio tuner, and a cassette deck housed in a boxlike shape that could be carried around with an oversize lunch bucket–type handle. The main feature was that this device was transportable, making it easy to take your musical taste with you and share it with others. As consumer demand grew, more powerful and more sophisticated models were introduced to customers (over a roughly ten-year period, literally thousands of models flooded the market). The larger and louder they became, the more they gained a deeper foothold within youth culture—which led to the era of breakdancing and the incubation of hip-hop. As urban culture grew and expanded from the inner city outward, the major manufacturers tried to outdo one another, each attempting to produce a louder, bigger, flashier, more bass-pumping, and totally unique-looking boombox (with flickering LEDs, flashing equalizer lights, and VU meters as icing on the cake). They've changed a lot over the years, but their undeniable sonic footprint is indelibly tied to the good memories and creative output of a distinctive generation. *LO*

The boombox became a means of how to listen. And then you could move around with it, flex your street style and your whole persona. Having a boombox and a bigger box, it was almost like a car in a way, if you think about how essential a thing that can be for someone's image.

—**Fab 5 Freddy** (PIONEER GRAFFITI ARTIST)

When I closed my door and turned on my boombox, the world around me disappeared! My room became my bomb shelter, my escape, my cave. Music was my first love, and my boombox created my sanctuary to the chaotic world surrounding me. Losing a family and mother, being shipped around from house to house, relative to relative, and school to school didn't matter any more. When my boombox turned on, my world opened and "their" world closed.

—**Billy Graziadei** (BIOHAZARD / SUICIDE CITY)

The boombox reflects a more public use of the radio that hearkens back to radio's first years, when speakers and amplification were part of the technological package, particularly in the 1930s and '40s when radio was a people magnet, and it was a much more public sort of thing.

—**Mike Schiffer** (WRITER, THE PORTABLE RADIO IN AMERICA)

The beat box was just so much more than a transistor radio; it was like bringing your entire living room stereo out in the open with you—on the street, on the beach, in the park. Before that, portable radios were very small—basically had a two- to three-inch speaker. It was a tinny little sound . . . They made certain types of portable record players, but that was a little suitcase that you could set up maybe at a party or bring to college with you, and even then, records were large and heavy. But the combination of the cassette tape and the quality player that was totally portable—that made the music so much more available everywhere. It wasn't until the boombox that people even had the concept of traveling with their music.

—**Bob Gruen** (ROCK 'N' ROLL PHOTOGRAPHER)

It wasn't long before they became status symbols, with guys wanting the biggest one with the most lights and the most chrome. I was never really into that.

—**Don Letts** (DJ / MUSICIAN / DIRECTOR)

The boombox was an essential part of the hip-hop culture, like that was your PA system, that was your concert device, you know, that was your MPC, that was your ASR. That was the outlet to broadcast your music.

—**Rahzel** (HUMAN BEATBOX / THE ROOTS)

When I would travel, the music had to come with me. I remember riding the bus and it could be, like, during a rush hour. And for whatever reason, I'll have some really nice mellow music and I would play it and it would just set a certain type of tone. The boombox allowed me to share it. The Walkman was cool, but I wanted people to hear what I had.

—**Jamel Shabazz** (PHOTO DOCUMENTARIAN)

The loudest boombox was the one that got the respect.

—J-Zone *(HIP-HOP ARTIST)*

I was addicted to my boombox. If it was raining and my friends wanted to hang out, I would take a GLAD Bag and wrap my boombox in it and walk around, still playing my boombox. I couldn't be without it. Back then, the black man wasn't being heard in American society. His ideas, his thoughts, his passions, his fears, his hate, his love were just swept under the rug. And so when he's got his boombox in his hand, he forced you to hear him; when he's sitting in that car with twenty speakers blaring out of his backseat, playing "Fuck tha Police," playing "Rebel Without a Pause," playing "Teachers," playing "Too Short," only then can he make sure that you hear him unobstructed.

— Adisa Banjoko *(HIP-HOP HISTORIAN)*

The boombox was a hip-hop staple, and if you had one in a photo, you didn't have to tell people where you came from and what you were into. The radio kind of said it all, along with things like shell-toe Adidas and Kangol and a lot of the other clothes that we were wearing . . . and it translated amazingly well visually. You know, you just had those two cylinders on the left and the right, and the little cassette deck.

— Cey Adams *(GRAFFITI ARTIST / ART DIRECTOR)*

In the absence of computers and the absence of the Internet, the boombox was the actual conduit to how we communicated the music.

— Kool Moe Dee *(PIONEER HIP-HOP MC)*

I had a boombox when I became a choreographer. Because you couldn't rely on the sound system. Like, you'd go into a certain studio, and they didn't necessarily have the right sound that you needed. I had to make my dancers the beat and the bass. If they couldn't feel it, they couldn't boogie. And if you can't boogie, you can't dance. So if they couldn't nod their head to it and feel it, I was like, "This is going to be a lost cause." And that's when I started using a boombox. But them shits were heavy—really, really heavy.

— Rosie Perez *(CHOREOGRAPHER / ACTRESS)*

It was sort of like a throwback piece of art. Kind of like the Nipper RCA dog with the Victrola; it's just such a great-looking thing and it looks like this vision of the future, right? Everything in the eighties was futuristic. And then when the future comes, it doesn't necessarily look like what the vision of the future is It always felt very Japanese to me because it's like this Blade Runner meets, you know, samurai warrior. And it's this, like, insane mix of, like, completely different time periods.

— Jonathan Daniel *(MUSIC HISTORIAN / BAND MANAGER)*

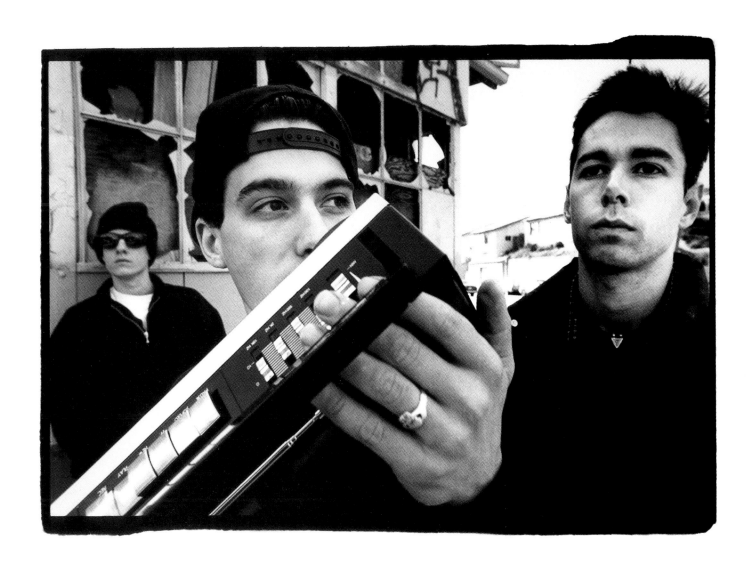

The box is a commitment. Like when it started getting into the mid-eighties, that was when the box really was the commitment. They were so big—basically like half your size if you're a kid.
—**Adam Yauch** (MC / BEASTIE BOYS)

BEASTIE BOYS, ATWATER VILLAGE, CALIFORNIA, 1992
ARI MARCOPOULOS

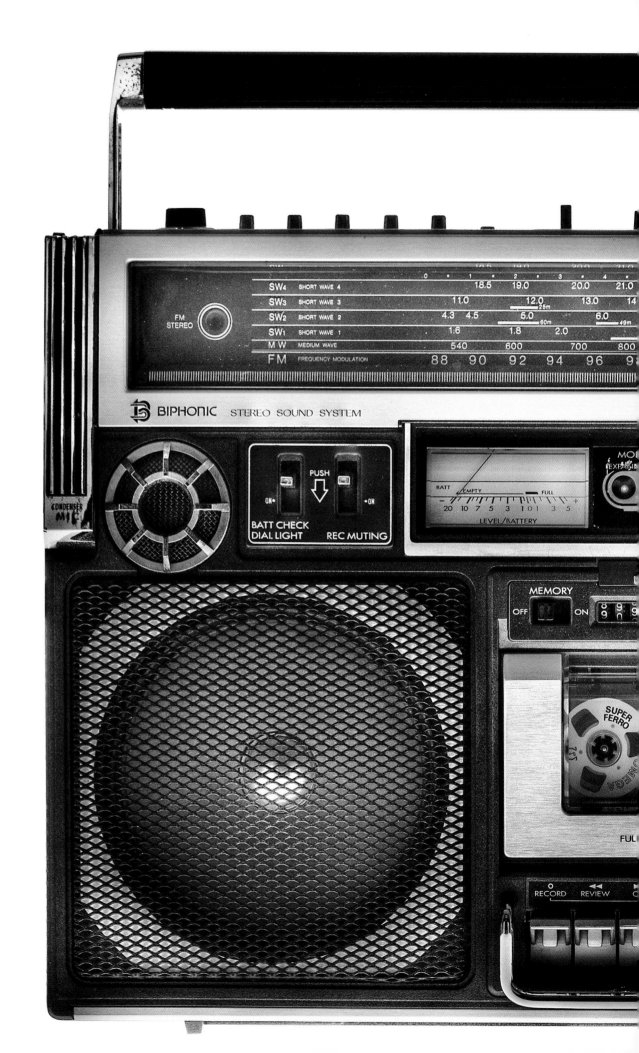

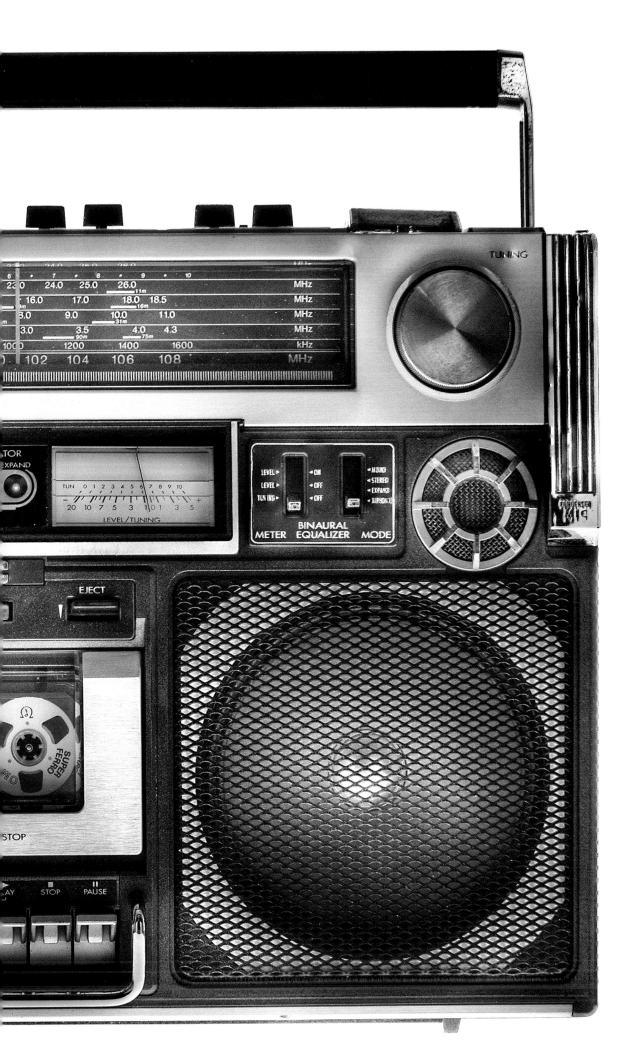

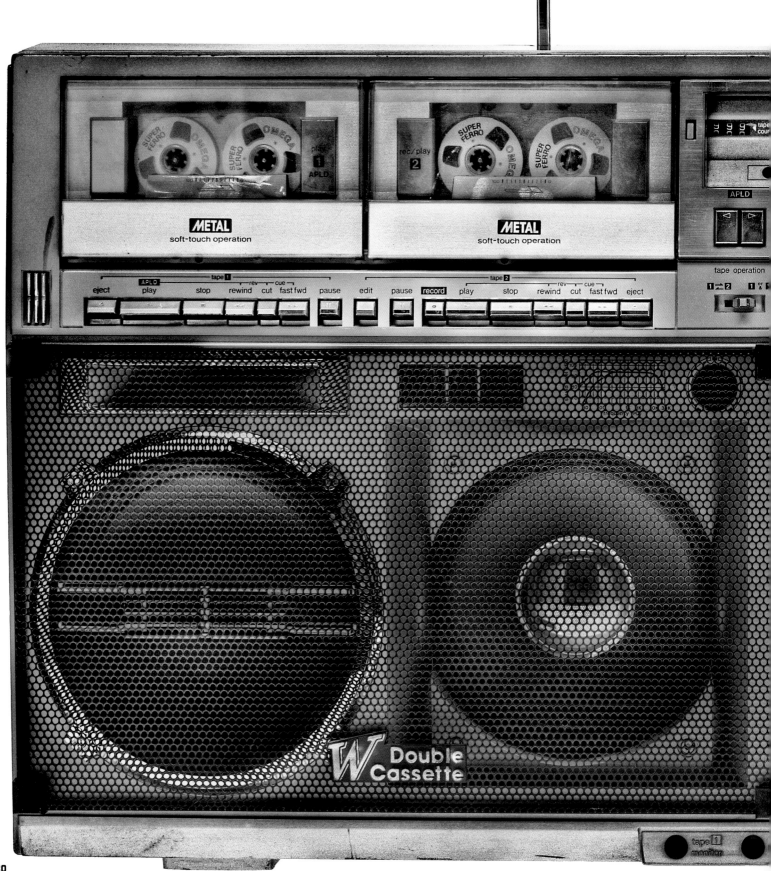

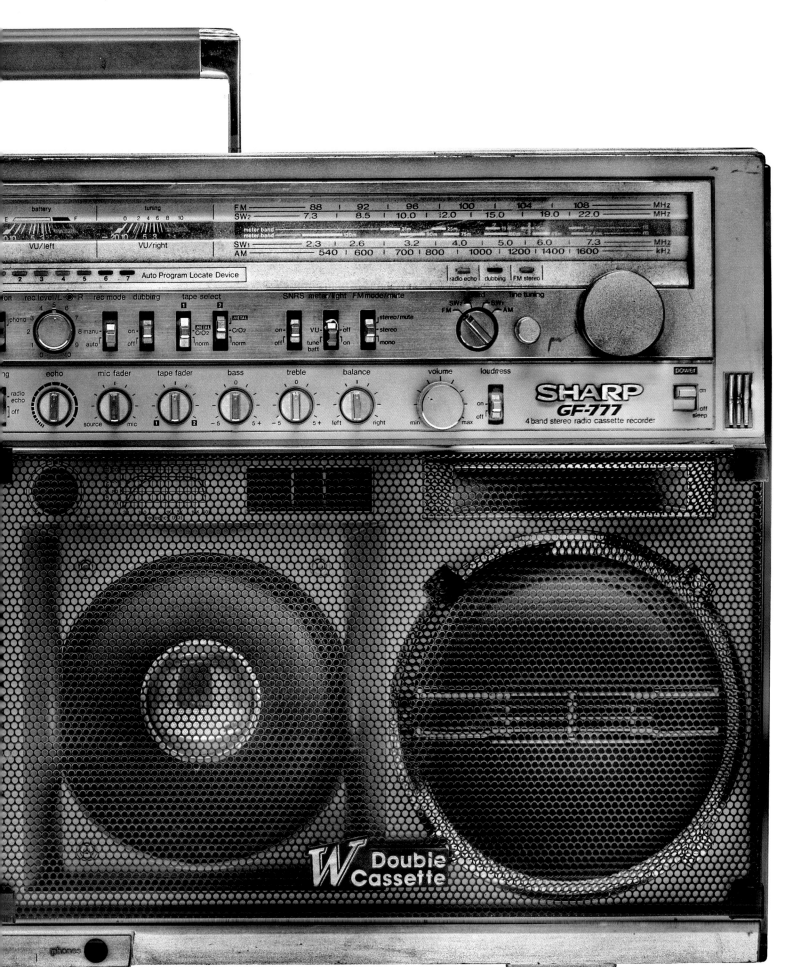

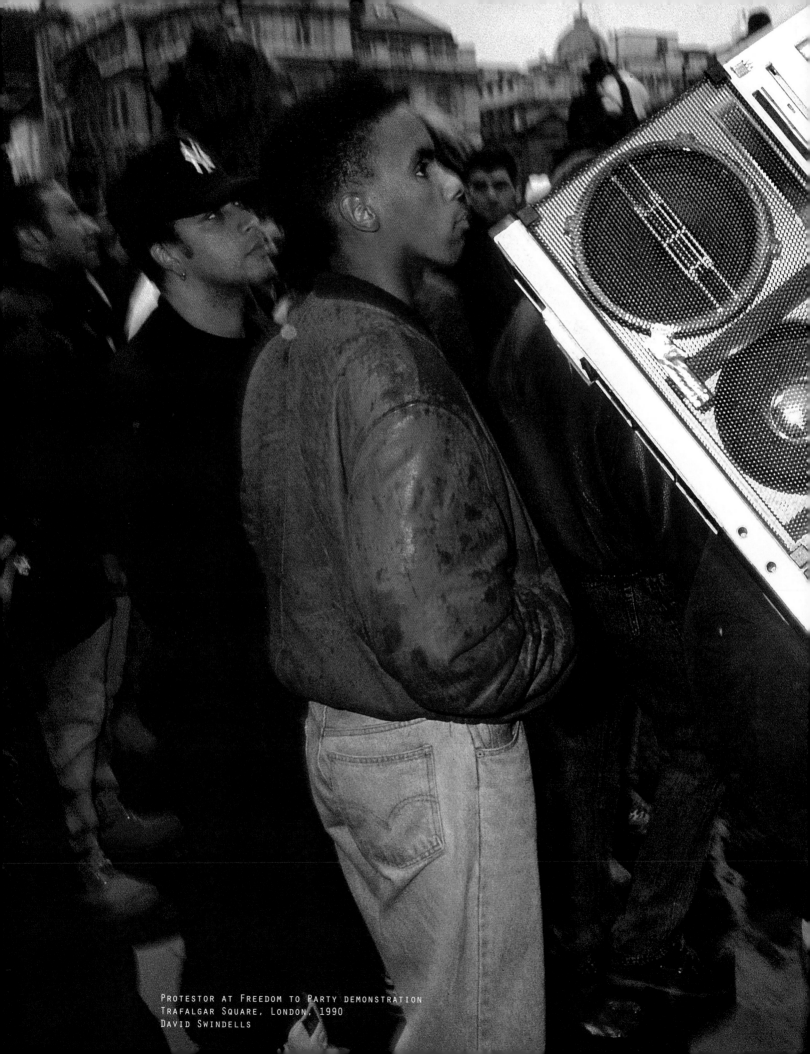

PROTESTOR AT FREEDOM TO PARTY DEMONSTRATION
TRAFALGAR SQUARE, LONDON, 1990
DAVID SWINDELLS

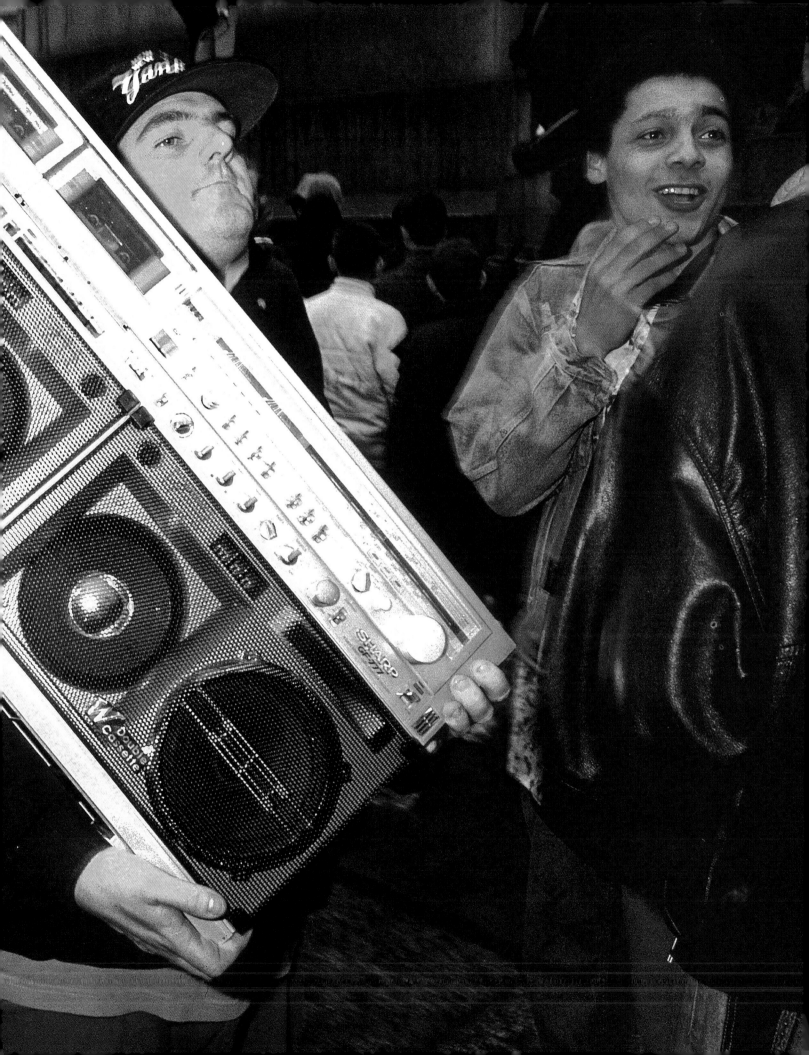

SIZE DOES MATTER

"MY RADIO, BELIEVE ME, I LIKE IT LOUD
I'M THE MAN WITH A BOX THAT CAN ROCK THE CROWD"
— **LL Cool J** *(RAPPER / ACTOR)*

Back in 1985 when LL Cool J released his debut album, *Radio*, and the hit single "I Can't Live Without My Radio," street culture in the U.S. was alive with the sound of what was colloquially termed the boombox or the ghetto blaster, depending on where you were from. The cover of LL's album reiterated the prominence of his hit single by depicting a close-up of a JVC RC-M90, one of the biggest and best-performing radio cassette players of the day. I collect boomboxes and have found a hobby bordering on obsession, learning as much as I can about them as well as playing with them and using them in my everyday life. I have a personal bias toward JVC, but this is simply because in my youth JVC was the best brand available in my community, and I still feel a strong connection to many of their products. But please do not misunderstand; there are many radios and many brands that are excellent.

JVC, or the Victor Company of Japan, launched itself into the portable radio cassette player/ recorder market in the late seventies when it released the amazing RC-550. Dubbed "El Diablo" by the Latino community, this giant monobox was devilish. It had a single 10-inch woofer, a 4-inch midrange, and a 2-inch tweeter, separate bass and treble controls, and a big strong handle as well as a shoulder strap. It had roll bars on the sides that extended forward to protect the speakers, and even had shortwave bands as well. This unit was built for the streets and signaled a change in the mindset of portable design. Although not a stereo player, this unit was BIG!

When I was in high school, I had a small boombox. It was a Panasonic. And I used that thing so much that the encasing started chipping, pieces of it started coming off, some of the detailing started coming off. And then, rather than stop using it or trying to get it fixed, I just decided I would see how much of it I could take off, how much of this machine I could actually remove, how much of the material I could actually take off and have it still work. And I got it down to a pretty bare skeleton. Of course, it didn't sound too good without the actual body of it to amplify the sound. But that was a boombox experiment of mine.
— **Stretch Armstrong**
(DJ / RADIO HOST)

JVC followed up the success of the RC-550 with another great radio destined to become the classic model for most designs: the RC-M70. This radio was a stereo player, with four speakers, two 6-inch woofers, and two 2-inch horn tweeters. All the slide controls and buttons were on top, including a click-down music search function and a loudness button. A great sounding (40 watts of power), cool-looking unit, it had tremendous build construction (a JVC trait) and great bass response at a time when bass-heavy music, funk, and R & B were merging their flavors to begin the rap / hip-hop movement. This radio also had a special seat belt–styled click-in shoulder strap and a special carry bag as well.

JVC was not done yet, as they introduced their top of the line RC-M90, the radio that inspired the LL Cool J song. This was it: 8-inch woofers, 3-inch tweeters, a full-logic two-motor cassette deck (meaning computer chip–controlled as opposed to mechanical buttons), eight radio bands, a more sophisticated LED-lit music search, and huge dimensions, 26-inch x 14-inch. This was perhaps the best-performing, loudest radio of its time. It also had Super ARNS (Dolby B) noise reduction to further refine its sound, as Dolby was all the rage. The unit also had an optional wired remote control with a 16-foot cord to enable long-distance (somewhat anyway) manipulation of the cassette deck.

While JVC made some great boomboxes, they were certainly not alone. Panasonic, Sharp, Fisher, Aiwa, and Toshiba also made valuable contributions both stylistically and technologically as these portable players flooded the market.

In terms of design innovation, one needs to look no further than the Panasonic RX-7200, a beautiful single-decked, logic-controlled player that boasted both a stylistic variant (the upside down design whereby the radio tuner was located along the bottom portion of the unit) and a technological innovation (a digital tuner for the radio with a green LED readout). Sized between the M70 and the M90, it also had wood-paneled sides and could be purchased with a matching record stand that the 7200 could be mounted on to create an unbroken wood panel—this was not a radio for the streets, but a radio for a posh study or library, a beautiful combination of high technology and organic warmth.

Aiwa released several beautiful units, but perhaps the best one was the CS-880. Medium-sized (22-inch long), it had its single cassette deck thrust up in the left-hand corner, and in the middle had a 7-inch passive radiator designed to enhance the sound coming from the twin 5-inch woofers and 2-inch tweeters. The Aiwa had an amazing tape deck: This unit boasted wow and flutter on par with high-end home cassette players, which resulted in amazingly clear sound. Great build quality, elegant, compact design, and amazing sonic performance, Aiwa made a name for themselves as smaller, high-quality players. This was again a unit that seemed more at home in a home; portable yes, but not for the street.

Getting back to the street, we have to include one of the biggest and most famous radios of the early eighties, the Conion C-100F from Coney-Onkyo. This was a beast! Thirty-one inches long and 16-inches tall, it had all the street cred one could imagine, as well as some design innovations. It had two cassette decks, but instead of making them tandem, they were stacked on top of each other with the top deck a horizontal slot for the tape to slide in through a spring-loaded door. It had three pairs of speakers, two 8-inch woofers, two 4-inch midranges, and two 2-inch tweeters—a full range of sound production. With two analog VU meters, and LED meters as well, it was designed not just to catch eyes, but to hold them hostage! As if this were not enough, in case its size, loudness, and killer "bling" looks overcame your morals, it had an incredibly loud

> It's kind of like how men, how boys and men are: We just like to have big, bulky things, like the way we are with cars now. The radio was the same thing. It's just like, the bigger your boombox was, like, just the cooler it was. And it was hard finding the big ones. There was this one brand, Lasonic, used to make the big, big, really big ones.
>
> —**Joseph Abajian** (PRESIDENT, FAT BEATS, INC.)

motion-alarm feature that, when set, went off if someone moved the radio. Despite the political incorrectness of the term, this was a ghetto blaster, a consummate example of its time, and was featured in several films, including *Beat Street* and *Breakin'*. Fisher also got into the game, but a bit late. Their contribution was the massive PH-492, over 30 inches long and 15 inches tall. This unit had two very significant innovations: One, it had detachable speakers so they could be placed farther apart to get true stereophonic sound. The speakers had individual cases so they could resonate with better acoustics, having their own cabinets. The other important feature that Fisher brought to the industry was a 5-band equalizer to further refine sound to the individual taste. With an EQ, it essentially had a pre-amp and enclosed speakers, so the Fishers were great-sounding, large, heavy units that reeked of quality.

Fisher also made a very unusual unit called the SK-300, a cassette deck with detachable speakers and a removable synthesizer keyboard! You could adjust all aspects of your synth sound— pitch, tone, and length of notes. You could change the sound so it could emulate almost any instrument as well. You could also use the onboard beats to provide a backdrop while you play the keyboard over top, and record the whole arrangement using the cassette deck! Other companies made keyboard synthesizers as well. Not surprisingly, Casio made the KX-101, and Sharp made the GF-990 with a double deck and a pop-out "music processor."

Sharp was again a leader in both design and innovation with the VZ-2000, a massive, heavy, unique player that had a single cassette deck, radio, and a dual-stylus linear tracking turntable. This unit allowed one to play BOTH sides of the record without turning the record over, essentially an auto reverse feature, but with a record! Sharp also had the famous GF-777, a giant 4-inch-woofer and 2-inch-tweeter monster with twin decks in the upper left corner and removable speaker grilles. The other innovation was that the main woofers had individual bass controls as well as a general bass control and a loudness button. The GF-9696 was a beautiful looker that had individual bass controls as well, but also had pitch control to adjust for different tapes.

> The first time I saw a boombox was in Knickerbocker Park in Bushwick. There was a bunch of cute boys with a boombox. We were all scared to, like, go over there, and then they were looking at us, and we were looking at them. We thought they were so cool.
> — **Rosie Perez** (CHOREOGRAPHER / ACTRESS)

Toshiba also produced a monster very similar to the GF-777 called the WX-1 Bombeat RT-S983. This unit had a very unusual configuration for detachable speakers, dual decks, woofers, tweeters, and passive radiators similar to the one in the Aiwa. This is perhaps the heaviest radio in existence, also with pitch control and a bass booster system, great looks, and a great name: Bombeat! Toshiba again showed their innovation with another model, the RT-S933, which had one of the most significant technical and design innovations: a built-in wireless remote control that ejected from the unit with the push of a button.

Other companies also weighed in, and perhaps the most famous boombox of its time was made so by director Spike Lee. *Do the Right Thing* was a seminal film about the boiling cauldron of race issues in the U.S. embodied by the microcosm of Bed-Stuy, a Brooklyn neighborhood. The object that sparked the riot on the hottest day of the summer was the giant boombox belonging to Radio Raheem. He strutted the streets, conquering all those he met with his ultimate weapon—a volume button. The radio he used to slay all comers was a Promax J-1 Super Jumbo, a monster with a ten-band EQ and three pairs of speakers including 8-inch woofers. In reality, the cheaper build quality of this radio was less than impressive, but its black case and crazy light display certainly won it points for style.

As portable radio tastes changed, so did their design. JVC was back in the driver's seat with the multipiece PC, or portable component, systems. The PC-5 divided into five pieces with a separate radio, tape deck, and amplifier. This radio was promoted by the Harlem Globetrotters. JVC followed up with another superb "executive" component system, the PC-55/550. These units were portable, but in actuality they were meant to be separated and used at home as high-quality mini stereos. The PC-55/550 had many special features: Dolby B and C, a five-band EQ, speakers with ceramic woofers, wooden speaker cases for better quality sound, and, most innovatively, an illuminated LCD panel display that showed the many functions and options of the unit. Although ever so slightly bass-shy, this multicomponent unit sounded wonderful for all sorts of music, and had one of the best tape decks ever constructed in a portable.

When you consider the eighties and portable radio culture, I realize how different the world is today. The world of sharing music in parks and on city streets now resides in cyberspace as we share in anonymity online. The boombox that marked this change from public music "broadcasting" to private consumption was the JVC PC-100, a mini unit with a detachable headset. Now you could share your music in the public sphere, or keep it private by ejecting the cassette deck and plugging headphones into it. In many ways it is the ancestor of the Walkman of today, the consummate MP3 player: the iPod. Indeed, all the radios I have mentioned here were built with the ability to plug a portable media player into them, so you can easily plug your iPod into these radios and mix the digital age with the warmth of analogue amplification and sound. Today, when you think that the iPhone is the best thing to happen to music and communication ever, remember that twenty-five years ago playing your music was a public phenomenon. We blasted our favorite jams and drowned out the competition, or went to a party and rocked it with a few tapes, a big radio, and maybe even decks plugged into it. That was how we injected the public sphere with music and soul, back in the day.

— **James Phillips, June 12, 2007, Vancouver, B.C.**

I always lusted after the expensive Hitachi triple-whatever . . . the ones from Fourteenth Street with the lights and the speakers; you put that in a trailer, it became like a party no matter who you were—even if you were just warming up for the biggest band, everyone would seem to gravitate towards your trailer because you had this kind of instant, you know, kind of like discotheque in a briefcase.

— **Josh Cheuse** (*PHOTOGRAPHER / ART DIRECTOR*)

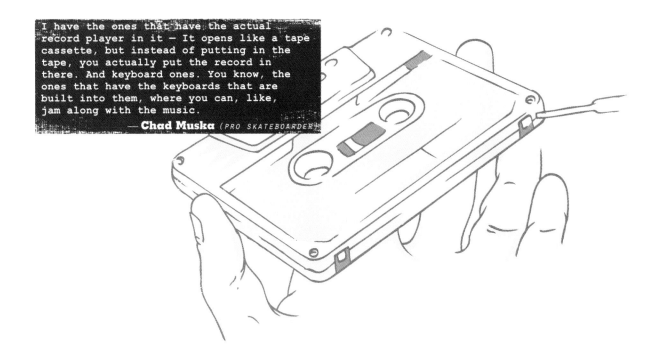

I have the ones that have the actual record player in it — It opens like a tape cassette, but instead of putting in the tape, you actually put the record in there. And keyboard ones. You know, the ones that have the keyboards that are built into them, where you can, like, jam along with the music.

— **Chad Muska** (*PRO SKATEBOARDER*)

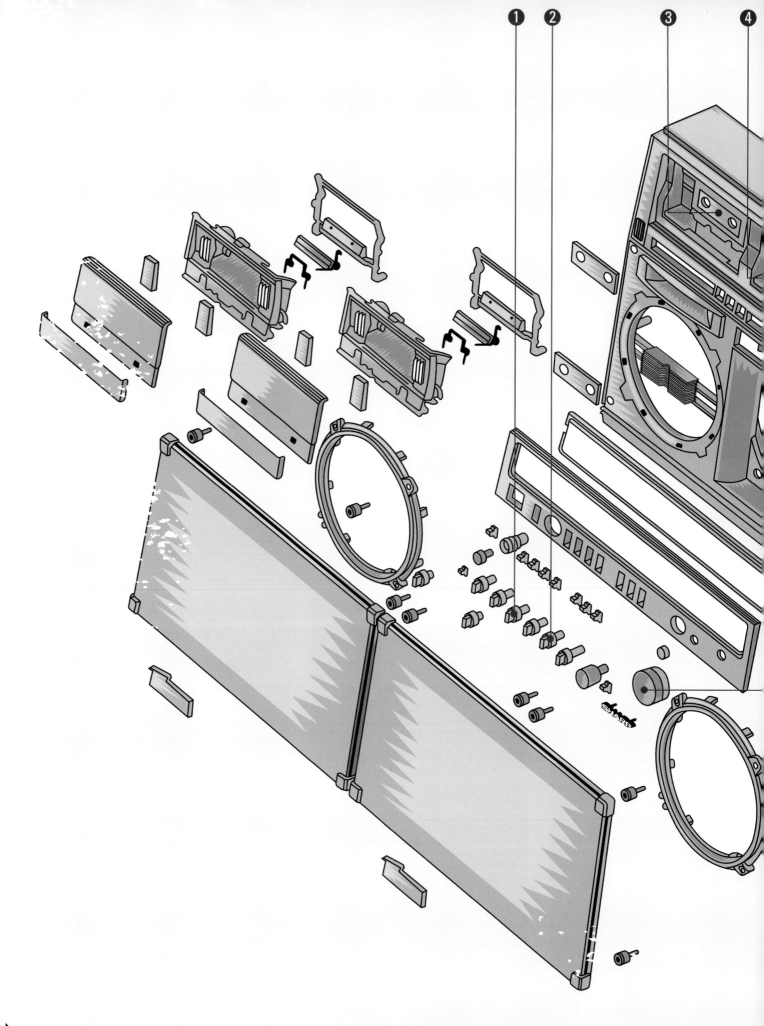

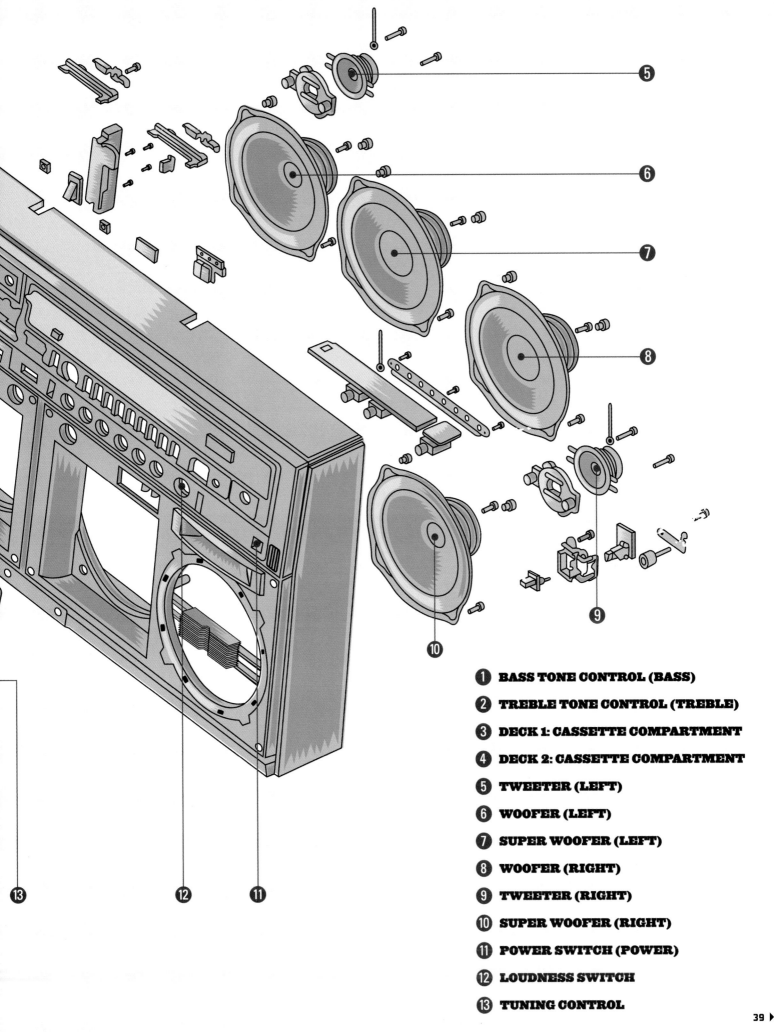

1 BASS TONE CONTROL (BASS)

2 TREBLE TONE CONTROL (TREBLE)

3 DECK 1: CASSETTE COMPARTMENT

4 DECK 2: CASSETTE COMPARTMENT

5 TWEETER (LEFT)

6 WOOFER (LEFT)

7 SUPER WOOFER (LEFT)

8 WOOFER (RIGHT)

9 TWEETER (RIGHT)

10 SUPER WOOFER (RIGHT)

11 POWER SWITCH (POWER)

12 LOUDNESS SWITCH

13 TUNING CONTROL

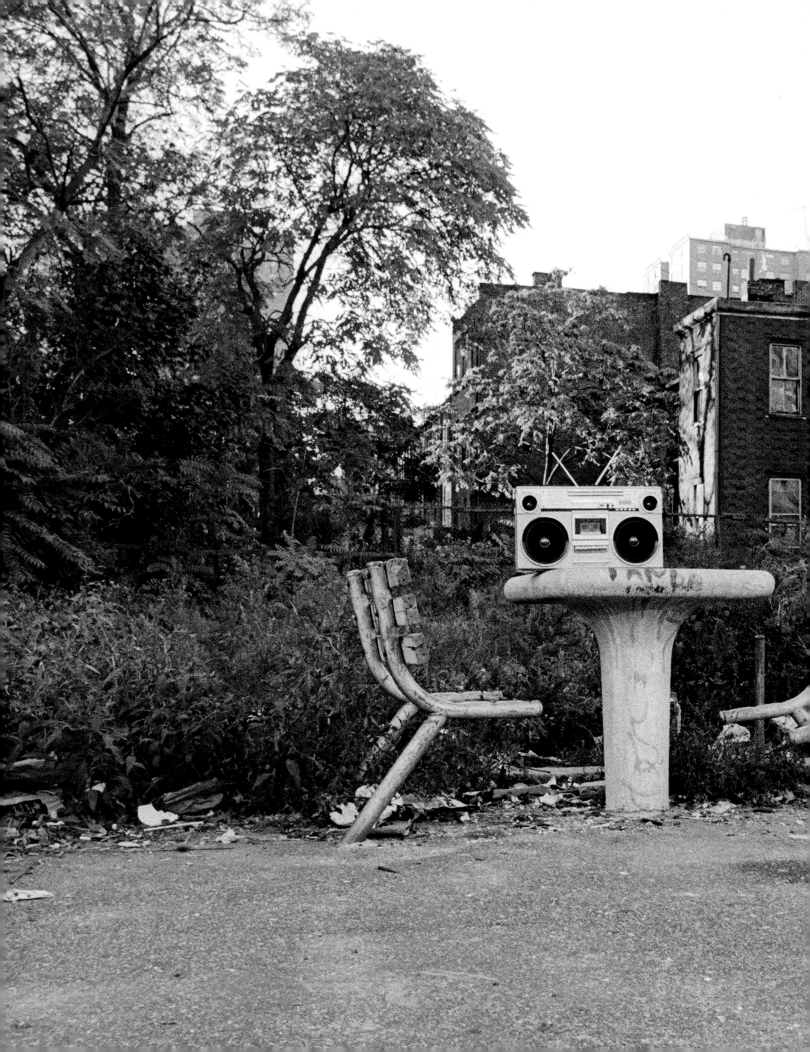

New York City, 1981
Lisa Kahane

There wasn't a lot of choice when they first came out, so you just grabbed any old thing that was around. It was probably an Akai.

But as soon as I started to embrace the whole thing, we were constantly trying to find the new and the best one. I'd keep changing them every, like, three or four months. I've got an Aiwa (is it 990?) that I had that was my main piece back in New York in '80, '81. It's even got George Clinton's signature scribbled all over it as well. But I've still got that and that was a solid, heavy motherfucker. It's got two crash bars on the front and it's mono—one big fuckin' 10-inch speaker, a woofer. It's the daddy; it's definitely the daddy.

A classic hip-hop one is the Sharp Searcher. It was really popular because you could—you could press play and search at the same time and it would skip to the next track, which was revolutionary. Before you had to keep winding, stopping, winding to find your tracks—that's assuming you had a gap between the track because obviously when you're playing the mix tapes from WBLS or KTU there were no gaps.

—**Don Letts** (DJ / MUSICIAN / DIRECTOR)

I had several different boxes. The most famous box for me—besides my box that now sits in the Smithsonian in Washington—is a Sharp box. Then there was a Sanyo that I had earlier on. And I had a JVC box or two.

—**Fab 5 Freddy** (PIONEER GRAFFITI ARTIST)

I had that double cassette, pink, long Panasonic. I was in, like, sixth grade, and I begged for it. I really wanted the aqua one, but I got the pink one . . . Remember the boombox with the keyboard? Different ones had different effects and stuff . . .

Some say bigger is better—personally, I liked the small, slim ones so I could put it on my shoulder and roller-skate.

—**Claw Money** (GRAFFITI ARTIST / FASHION DESIGNER)

I remember getting this sort of strange, square-shaped Panasonic boombox—the speakers were actually pretty small on it, but for whatever reason it just had a really great bass sound.

—**Jonathan Daniel** (MUSIC HISTORIAN / BAND MANAGER)

SUBWAY RIDER, NEW YORK CITY, 1981
EVE ARNOLD

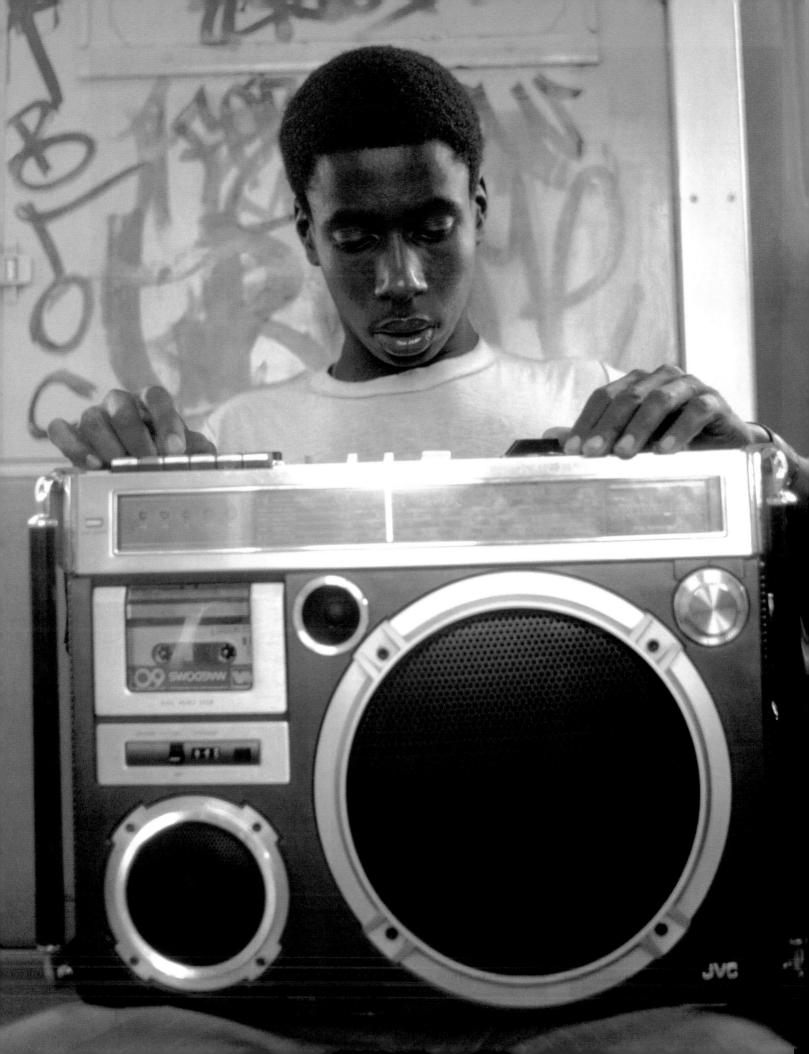

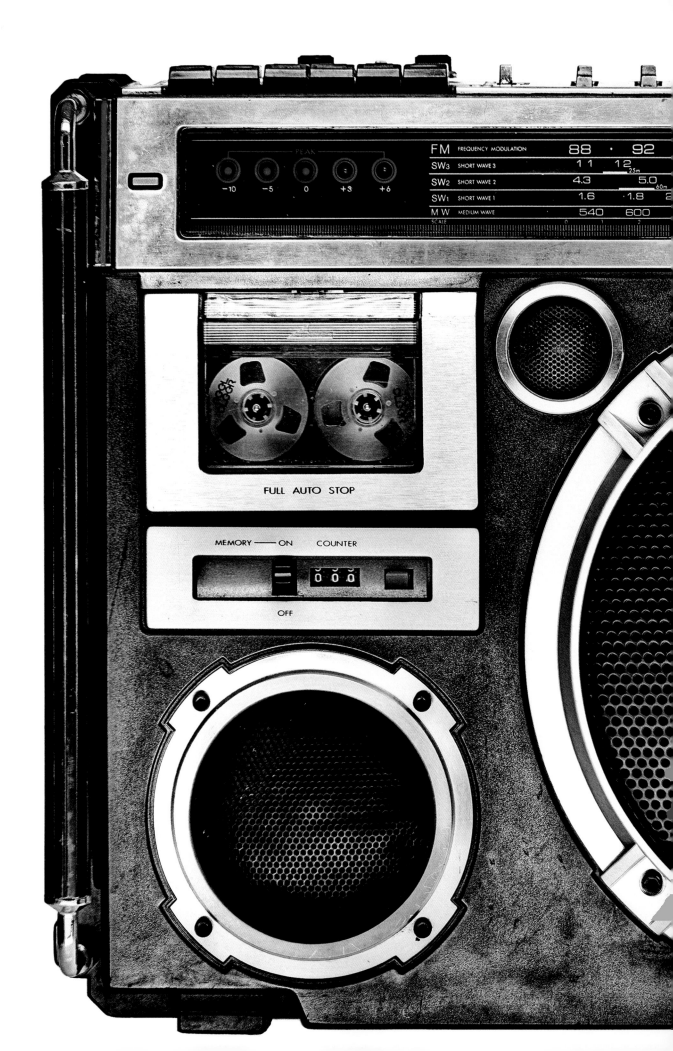

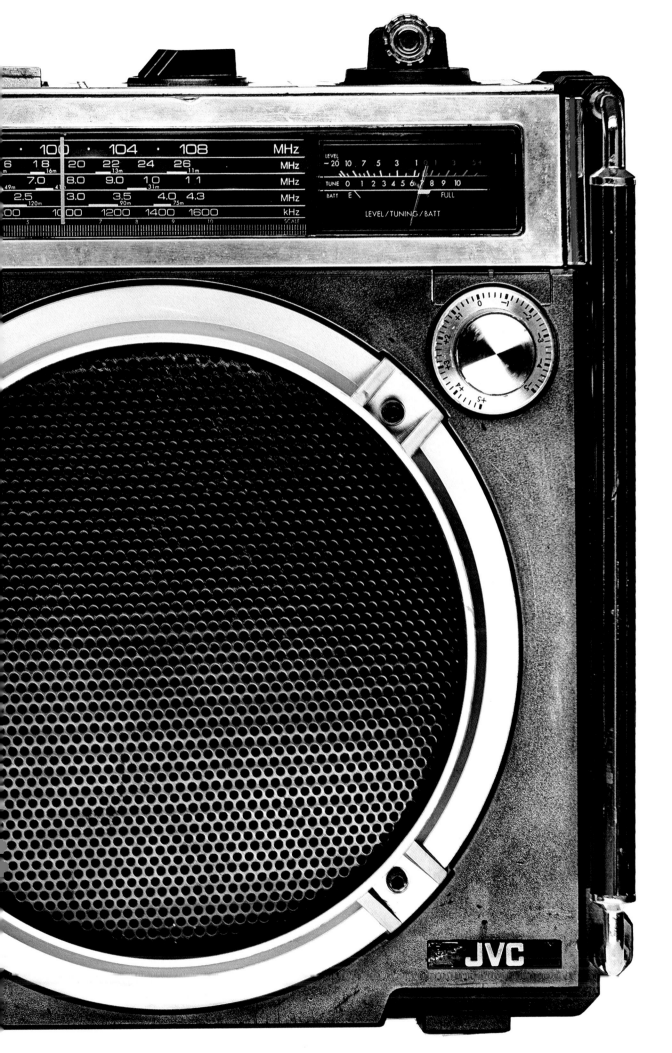

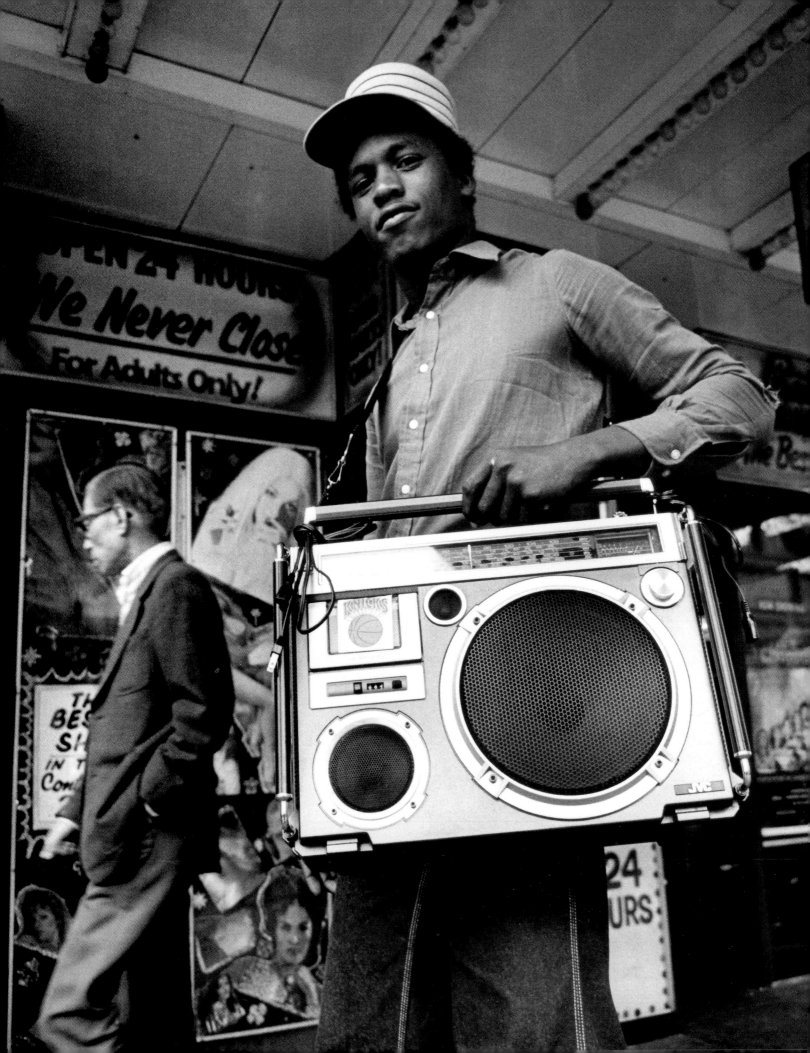

Carrying around the box and then going on tour around the world with the thing was crazy. And that's why I swore off boxes with detachable speakers . . . In the late eighties, I had a Fisher. And that's when I really got my pause-tape work in. That's when I really honed my skill, because this particular box had really good action on the pause button, the record button.

The box I carried around on tour, I didn't put any artwork on that. That was my, like—that was my classy box. Do you know what I mean? I wouldn't put stickers on it. It was too nice.

But then my box set was like my studio box. So I had my record player plugged into it, and my drum machine, and so I would do all these mixes on there. (For our record *Hello Nasty*, I did all of my demos on cassette.) That was my home one. It was just us living together. Me and the box. So that one had all kinds of stickers and drawings.

— **Adam Yauch** (MC / BEASTIE BOYS)

I remember around my block—I can't remember his name, but it was a cool guy, you'd always see him. He'd just be walking along with his box and we'd hang out with him. And the real funniest thing about it is batteries. Batteries is like the biggest shit with boxes because it takes a case of batteries. And nobody wants to give up money, so he'd be like, "Yo, give me some money for batteries; give me money for batteries." Nobody would give him money so he'd just go cut it off and be like, "Yo, peace out," and start walkin' away.

And it would be like, "No-no-no—fuck that! Come back! Come back!" It was like pullin' teeth tryin' to get money for batteries. I just remember that. I just remembered huge arguments: "Fuck that! Yo, you muthafuckas gotta give me some money for batteries. Yo, fuck you. I'm goin' home, man, fuck this." It would be an hour of fuckin' negotiation to get batteries.

— **Trevor Clark** (HIP-HOP CLOTHING DESIGNER)

Some of the boomboxes even had little spaces where you could carry a few tapes in the beatbox itself. It was a home stereo with a handle. A lot of people used them at home because they were so much more affordable than buying a component stereo. And the sound was so good for so many of them—like, inexpensive, really good sound.

— **Bob Gruen** (ROCK 'N' ROLL PHOTOGRAPHER)

The boombox would be the only way you would actually hear hip-hop. So, for anyone that loved hip-hop—especially in the mid- to late '70s—that was your conduit.

— **Kool Moe Dee** (PIONEER HIP-HOP MC)

42ND STREET, NEW YORK CITY, 1980
PETER ANDERSON

PAUSE II

2. PAUSE ▌▌

The pause button on a boombox was the magical gateway to creative power. ▌▌ This simple little switch truly sprouted an artform. ▌▌ The impact of the pause button was that it allowed you to think about things for a second, to freeze the action and reflect, or to position things before leaping forward again. ▌▌ If you hit pause, you could cue up a recording before adding the next song on a mix tape, or you could use it as an intermission agent to leave the room for a minute and come back to that song you were grooving to, or on an even more complicated scale, use it to make a rudimentary looped beat for unleashing rhymes over the top of. ▌▌ Whatever a person's employment of the pause button was used for, its main purpose was to hold the flow of time. ▌▌ In this chapter we pause the flow of time to observe the presence and impact of the boombox around the globe. *LO*

HOMETOWN

New York was the place that the boombox truly made its indelible mark. It also happened that in the late seventies and early eighties New York was breaking down at the seams and falling apart—not only socially but literally. While the urbanscape was crumbling, the audio sound track of the boombox cut through the crime and the grime, calling out for change. Recognition of that call's urgency echoed around the world. The streets, the sentiments, and the stories all locked in solid step with one another to create a bass-laden rhythm paving a path into new frontiers for creativity and expression. *LO*

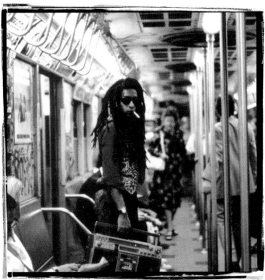

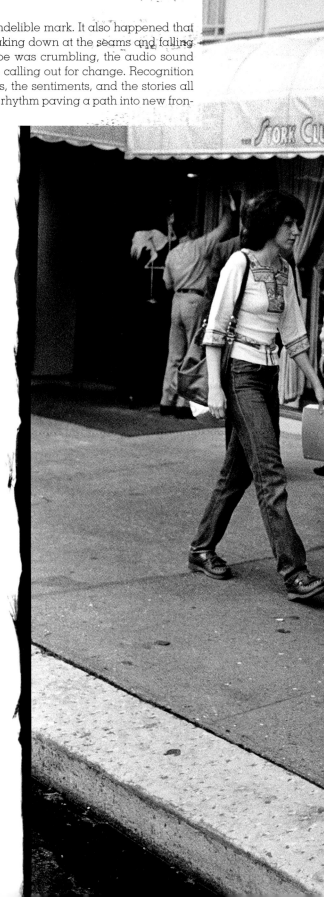

You could really see New York street culture in the seventies— the swagger of individuals on the street who probably, compared to now, had a lot less but made less work more.

— **Fab 5 Freddy** *(PIONEER GRAFFITI ARTIST)*

I first started collecting boomboxes because I'm a stylist and they're a great prop to bring on a shoot, to visually explain the kind of picture or the kind of story that you want to tell. It's about music and it's probably about urban music. And, being from New York, it was very New York culture—boombox culture.

— **Claw Money** *(GRAFFITI ARTIST / FASHION DESIGNER)*

Don Letts, New York City, 1981
Lisa Beck

Boomboxes had a town; that town was definitely New York City. That's where that thing really came into its own. Nowhere did it really rock the joint like New York City.

—**Don Letts** (DJ / MUSICIAN / DIRECTOR)

I grew up on the Upper East Side, right on the edge of Spanish Harlem. And I think the first time I ever really heard bass was watching guys walking around with their boomboxes strapped to their shoulders, playing hip-hop or maybe even, like, salsa or whatever. I could never get my eyes off of a boombox if I saw one. Classic case of rubbernecking. I'd be walking down the street with my mom, holding her hand, and my feet would just stop and I'm just staring at this guy walking by with a boombox.

—**Stretch Armstrong** (DJ / RADIO HOST)

The boombox was a theater of sound; the city itself was a sonic collage.

—**Paul Miller / DJ Spooky** (MUSICIAN / ARTIST)

The boombox was like a major, major piece of art that you had to have. When I first saw a boombox, it looked like a New York skyline. It was bigger than any music system I'd seen . . . The boombox spoke so New York—and New York being as loud as we still hear it today. Even the lights strobing on the thing, its shape, its design, its sound was having your own piece of New York.

— **Earle Sebastian** (DIRECTOR)

The boombox was everywhere when I was growing up, and it was a kind of modern lyre; people from all races and classes united in Manhattan against the backdrop of its hip-hop beats . . . Plus my friends and I thought carrying one made us a little cooler, since we were usually embarrassing ourselves—writing bad graffiti and trying to talk to girls.

— **Nicholas Jarecki** (DIRECTOR / PRODUCER)

We always saw a boombox on my street corner. Central Park was my biggest hangout when I was young. There was always always a boombox. The kids used to walk around with the boomboxes and their own piece of linoleum floor so that they could break-dance. So it was huge. If you didn't have a boombox, you just were not in . . . You were not in. And the music. To be in the streets, especially during the summer, in Hell's Kitchen, in the city, it was wonderful because you always heard, on every street corner, a different style of music. And it was always coming from a boombox.

— **Lisa Lisa** (SINGER, LISA LISA AND CULT JAM)

BRUCE SPRINSGTEEN
CENTRAL PARK WEST, NEW YORK CITY, 1978
LYNN GOLDSMITH

A GLOBAL PHENOMENON

Growing up in Germany, everything in America seemed bigger and better (the beats, the bass drums, the butts, sneakers that seemed to give you instant game, right from the very second you strapped them on). They had the best sound systems, a totally different dancing culture, and, of course, the latest import records. To get hold of a magnetic audiotape distilling these experiences would cause greater rushes than stumbling across any random grail in some Saharan oasis.

Boomboxes, and their smaller cousins, the Walkmen, weren't biased toward hip-hop only. In fact, many a tape would feature the latest Def Jam album on one side, some fast-paced thrash metal or distant planet—searching Chicago house on the other. If you ever rode a skateboard in the Dead Kennedys' heydays, you know what I'm talking about. No matter what music one was listening to in the end, long before rechargeables would become affordable, it was the secret stash of NATO-supply batteries in stylish olive green that kept us rockin' in the free world. BTW, that blue box is still here, next to my desk, now filled to the rim with tapes from all corners of our planet, each of them highlighting musical universes galore.

— **Torsten Schmidt** (CO-CREATOR, RED BULL MUSIC ACADEMY)

My boombox really was sort of an initiation into manhood. It really gave me my independence and the ability to have my music with me when I wanted it. I could have it in my room and play it . . . I wasn't forced to hear what my father may have been playing. I could take it outside and play it. I could put the linoleum down and we could all b-boy to whatever mix tapes I may have been able to get third generation from a friend or family member in New York that'd been dubbed a countless number of times and made its way down to Florida.

I vividly remember being at the beach, up on the deck where they had concrete, and throwing down some cardboard and b-boying to—it was 1983 at this point—some early Run-DMC that was pretty much blowing everybody's minds at the time. These tapes were very difficult to come by and it was kind of the only way that you'd be able to experience this stuff: through a boombox and through someone having a copy that they'd eventually been able to procure. That enabled us, as kids down in Florida, to sort of experience this music and then spread it even wider to a group of people down here that may not have been aware.

— **Andre Torres** (EDITOR, WAX POETICS)

What would growing up in Sweden have been without a boombox? . . . To not be able to headbang whenever and wherever you may feel like it? It was a bitch to carry it around, and as a matter of fact I think my left arm is a bit longer than the right, and my hearing on the left side is a bit screwed up, but it was totally worth it. I encourage this behavior among our younger citizens today . . .

— **Jonas Åkerlund** (DIRECTOR)

TOP: TEDDY BOYS, HARAJAKU PARK, TOKYO, 1985, BY JOSH CHEUSE
BOTTOM: JESSE LETTS, LONDON, 1982, BY DON LETTS

DAVID BYRNE, YUCATAN, 1980
LYNN GOLDSMITH

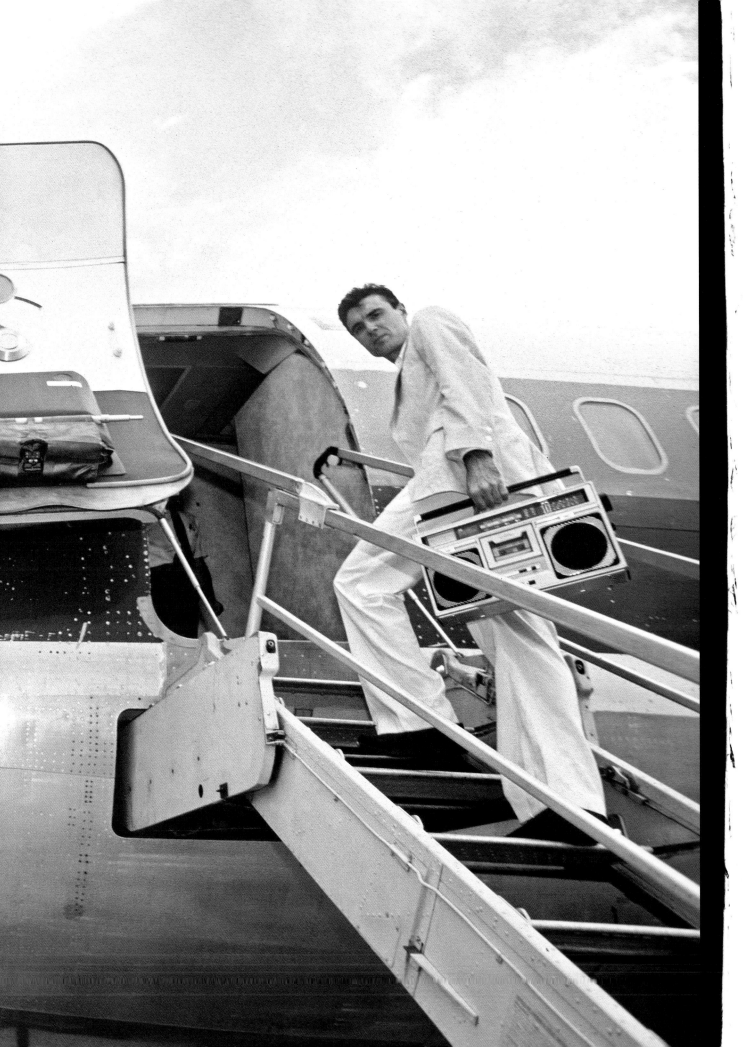

当時の若者の自己表現のツールであり、情報の源であり、
　　人とのコミュニケーションのツールでもあったboomboxは
　　文化や生活と切り離せない物として位置付けされていたと思う。
　　フィールドレコーディングの道具として、
　　コンパクトなホームオーディオとして、
　　野外パーティーのサウンドシステムとして、
　　また、ラジオのエアチェックをし、翌日には友人と録音したTAPEの交換をる。
　　現在のPCと同じ役割を果たしていると思う。
　　まさに『夢の箱』であった。

At that time, the boombox was used to connect culture and
living because it was a tool of self expression and commu-
nication and resource of information among the youth.

It was used as a tool of field recording, handy home audio
system, or sound system for outdoor parties. Also even to record
the radio and exchange the tapes with friends the next day.

I think the boombox was used as PC is nowadays.

It was just like a "Dream Box".

— **Shogo Turuoka** (BOOMBOX COLLECTOR / OWNER TURBOSONIC)

In Africa or in Jamaica where it's, like, 96 degrees in the shade, if
a bit of sun catches a record, it's all over. So when the beatboxes
came in, everybody ditched their vinyl. I mean, the sound systems still
used vinyl. But on the streets and in people's homes, it was always a
boombox. And that was really because vinyl . . . you can't deal with
vinyl in those kinds of temperatures.

— **Don Letts** (DJ / MUSICIAN / DIRECTOR)

For a kid growing up in a coastal town in Australia
in the late seventies and early eighties, the break
dancing and ghetto blaster culture from the U.S. seemed
like eons away. From seeing this urban culture for
the first time I was captivated. It was the music that
was the spark for me. This incredible new sound,
unlike anything I'd heard previously—it just blew
my mind, and this part of the culture became my
passion. For the first time the machine playing
the music was in a perfect symbiotic relationship
with the music itself. A big radio for even bigger
beats. The power of the music with the power of it
being broadcast. On a personal level, this concept
was the real essence of what appealed to me.

— **Rick Thorpe** (BOOMBOX COLLECTOR)

I can assure that the boombox has changed my life. It was the key
to a mysterious portal that showed me a world way different from
mine (but inexplicably making much more sense to me). Besides
creating the sound track to some of the most important parts
of my history, it taught me more about language and American
culture than all the hours of tuition and all the books I ever
read. On a curious note, when I saw Do the Right Thing for the
first time and realized that I WAS Radio Raheem.

— **André Czarnobai, a.k.a. Cardoso** (DJ / MUSICIAN)

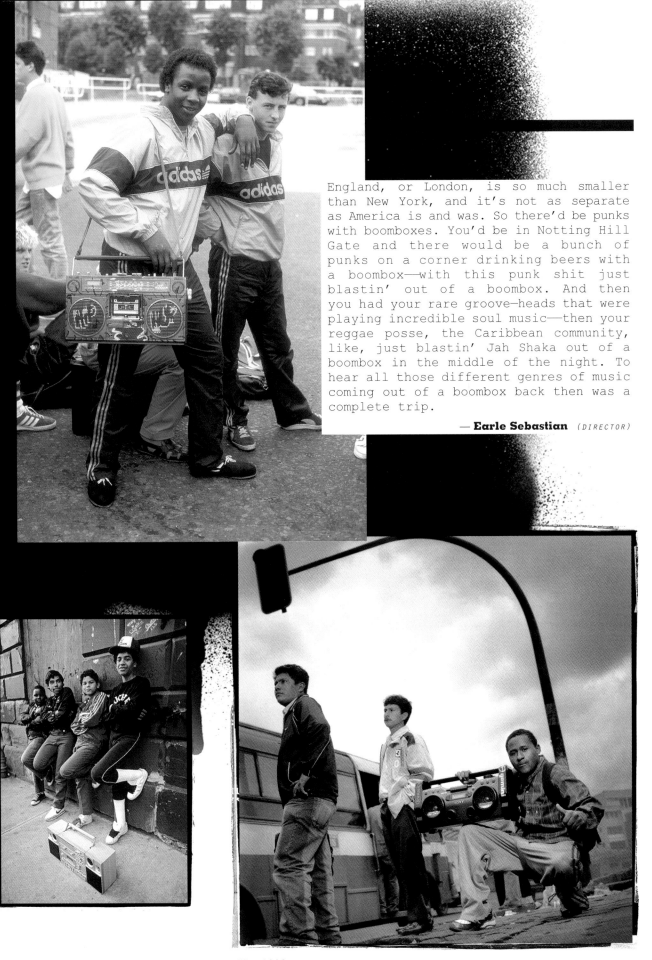

England, or London, is so much smaller than New York, and it's not as separate as America is and was. So there'd be punks with boomboxes. You'd be in Notting Hill Gate and there would be a bunch of punks on a corner drinking beers with a boombox—with this punk shit just blastin' out of a boombox. And then you had your rare groove—heads that were playing incredible soul music—then your reggae posse, the Caribbean community, like, just blastin' Jah Shaka out of a boombox in the middle of the night. To hear all those different genres of music coming out of a boombox back then was a complete trip.

— **Earle Sebastian** (DIRECTOR)

UK Fresh Hop event, UK, 1986
Paul Harnett

New York City, 1988
Steve McCurry

Street Singer in Quito, Ecuador, 2008
Kurt Hoerbst

SOCIETAL CONTEXT

I grew up in the South Bronx on Fox Hill and Longwood Avenue. So it was very natural for me to start photographing the things that I saw every day and to document what was happening in the South Bronx. A lot of elements of my early work has people just hanging out, chilling out on the corner, chilling out on the roof . . .

Having music in the background was always part of that experience, and getting high. Everybody always had some weed during that period of

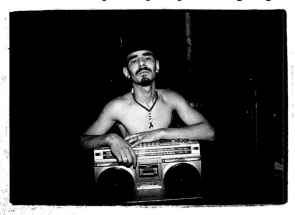

time, so everybody got smashed in one shape or another. You didn't have to have money to walk down the block and get high because either you would have it or your friend would have it or somebody else would have it. And everybody had a boombox. It didn't matter whether it was the big traditional ones or smaller versions. Always somebody had a radio, and a radio with a tape deck in it.

Over time, I became more and more aware that there were profound changes taking place. Building after building went vacant: Landlords didn't want to make the tax payments or they didn't want to pay the insurance on it. Some landlords actually began to burn down buildings just to make some insurance money until they started arresting people doing that type of thing.

In a sense, the hip-hop and dance and break dancing and stuff was one way of, you know, kind of verbalizing at least for us what was going down in our neighborhood. The nation had pretty much turned their backs on the residents of the South Bronx during that period of time. They had cut back services, cops rarely showed up. You know, the only people—the only government agency you could actually rely on to show up—was the firefighters, and that was about it. We knew that always when you were in trouble, you called them and they would show up.

There's almost a romanticized vision of what actually took place during that time. But basically we were just fighting to survive, trying to figure out a way out of the place. The music was part of that drive, and by extension, the boombox was the natural prop for that. There's something about jamming that box in the middle of an abandoned street, you know, where block after block is, like, completely abandoned, and that music is bouncing off those walls. And you know, you have Sugar Hill Gang playing, or you have Kool & the Gang playing, and they're playing that theme from *Rocky* in the background.

We couldn't vocalize what was happening to us. Why was the city turning its back on us? Why was building after building being systematically abandoned? Why was building after building being burned down?

That was the context in which music, and by extension, the boombox, was a source of beginning to figure out what was taking place there . . . The boombox was as necessary as the air we were breathing, growing up.

— **Ricky Flores** (*PHOTOJOURNALIST*)

Johnny and the boombox, Fox Street
South Bronx, New York City, mid-'80s
Ricky Flores

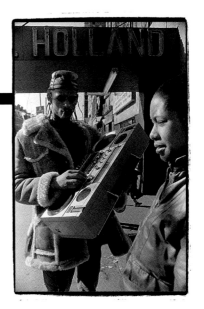

The boombox democratized sound. It made sound available wherever you were and made the street a theater of whatever soundscape you wanted it to be. Anybody could set up and just press play. But democracy is noisy, loud, chaotic—and opinions have consequences. If people like one style and don't like another style, it's gonna get blasted out

— **Paul Miller / DJ Spooky** (*MUSICIAN / ARTIST*)

In almost every ancient society, but definitely in the ancient African tribes and clans, there was always the keeper of the drum. And the drums were used to signify so much: harvest, war, life, and death. Celebration.

And I always felt that Radio Raheem—and I don't know whether Spike Lee did this deliberately or not—was to represent the keepers of the drum in our communities: They carry boomboxes. So when he died, it was so tragic, not just because of the usual things that were already happening in New York with blacks and whites, the racism, violence from the police department. They hadn't killed anybody from the community. They had killed the keeper of the drum. The keeper of the drum is the one that always reminds you what time it is, whether you want to hear it or not. You may disregard him at certain times, but you know you need him.

The boombox subculture was—still is—a huge rebellion against society and everything that it represents. And I was proud to walk down the street with my ghetto blaster. I was representing my tribe.
— **Earle Sebastian** (*DIRECTOR*)

So even his intrusion was something we looked forward to. "Radio, will you turn that damn music down!" But you like that, you know what I mean? That's part of your day, hearing what Radio Raheem was giving to the people. He symbolized a lot to me. When I go down the street and I see anybody with a boombox, I still see the keeper of the drum.

— **Adisa Banjoko** (*HIP-HOP HISTORIAN*)

You had to have enough juice, so to speak, enough courage, enough heart, enough reputation to even walk around with a boombox, otherwise you were risking getting robbed if you walked out of your neighborhood with it or you were on the train with it or whatever. So it was also a statement of tough—adolescent toughness.

— **Kool Moe Dee** (*PIONEER HIP-HOP MC*)

The boombox defined my teens. It helped shape an important era in music, fashion and culture. It was our sonic reply to the invention of the color TV.
— **Dzine** (*ARTIST*)

JUNIOR AND DORIS OUTSIDE THE HOLLAND HOTEL
NEW YORK CITY, 1984
SOPHIE ELBAZ

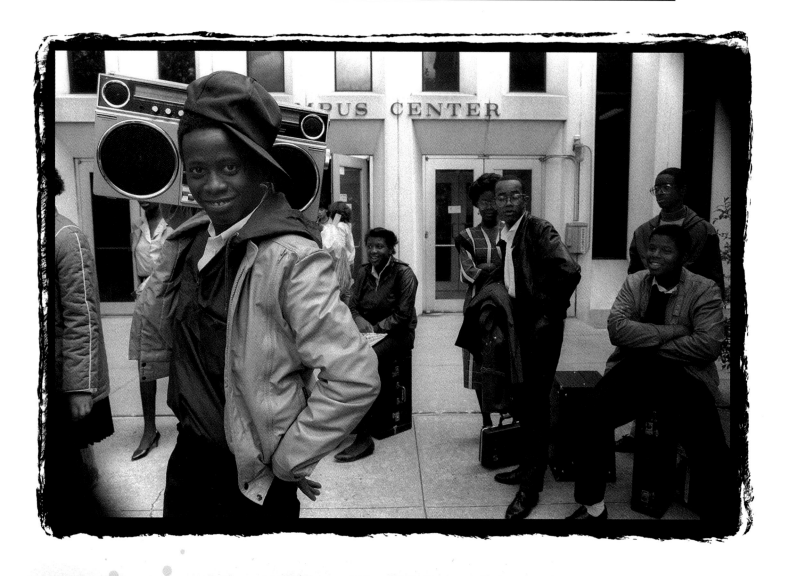

In the neighborhood, everybody has their role. So-and-so is the bug-out; so-and-so is the tough guy; so-and-so is, you know, a good dancer or whatever. And then there's the boombox guy. And you hang around with him because he has a boombox.

— **Trevor Clark** (HIP-HOP CLOTHING DESIGNER)

TEENAGER IN HARLEM, NEW YORK CITY, 1984
OWEN FRANKEN

Hip-hop in the seventies developed into this wild force in the streets of New York City in the deepest, deepest, like, inner city hoods. A whole tribal communal thing going on in the parks. Gathering around DJ setups with a massive altar of speakers. It was really like worshipping.

Why was this phenomenon so hardcore at that time? It was the rebellious nature of those times—taking over campuses all over the place; people picketing, demonstrating, fighting; people growing their hair long, picking their afros out, throwing their fists in the air.

And there was a lot of uplifting and significant music, like "Ain't No Stoppin' Us Now." Records that kind of uplifted you. We needed to hear those records.
— **Fab 5 Freddy** (PIONEER GRAFFITI ARTIST)

I remember if a good song came on, and you were on the train or if you were on the beach, everybody was like, "Oh! That's my shit! Turn it up!" I never saw girls my age carrying boomboxes. But my older cousins, my female cousins, they always would carry boomboxes. They'd bring the boomboxes to the park. Not Knickerbocker because then you'd blow up your spot. They would take it to a small park, like a handball park. Go to the park, put the boombox down, roll your shit up, spark it up, and then we would dance in the park. We would dance in the park, and being Puerto Rican, we would, like, hustle, you know, and just do it all.
— **Rosie Perez** (CHOREOGRAPHER / ACTRESS)

One of the things that the boombox meant for me was that if anyone came to school with one, that was our cue to cut class. [LAUGHS] It was wonderful. It meant at lunchtime we would leave the school and run to Central Park. That was our cue: One of us will come in with a boombox. Sadly to say that we cut class. Yeah, but, we went to Central Park to dance. To learn, you know, all the different moves. Somebody always had something new, and that's what I remember. That's

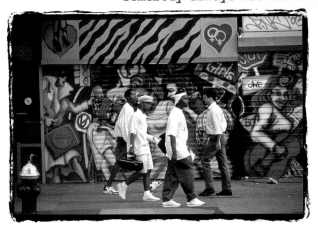

what I mostly remember. Oh, boy, was it— it was great. It was great.
— **Lisa Lisa** (SINGER, LISA LISA AND CULT JAM)

The boombox was a way of claiming some territory—even if you, as I say, pissed off a couple of people on the way, well, that would bring a smile to your face as well. We spend a lot of time—whether we realize it or not—trying to claim some space; stake a territory and say, "Yeah, we're here." And the boombox was the ultimate expression of that. It was empowering.
— **Don Letts** (DJ / MUSICIAN / DIRECTOR)

42ND STREET AND BROADWAY, NEW YORK CITY, 1993
THOMAS HOEPKER

RECORD

3.RECORD ● One of the most liberating parts of a boombox is the record button. ● This single mechanical attribute was the ignition button for many aspiring rock stars, rappers, and guitar heroes. ● Countless teenage anthems were first recorded by an upstart musician unleashing a thundering gallop of three-chord angst into the built-in condensor microphone of a boombox. ● Some of these anthems ended up on a dusty tape forgotten in the back of a closet; others fought their way out of obscurity to blare out of radios around the world. ● The empowerment of simple and fast recording allowed many aspiring rappers, punks, rockers, and poets to have their first stab at immortality. ● They became a major part of a creative process. ● Without a boombox recording the thoughts, chord progressions, and word flow of a generation, many songs might not have made it out of the small corners of the world and on to the global stage. *LO*

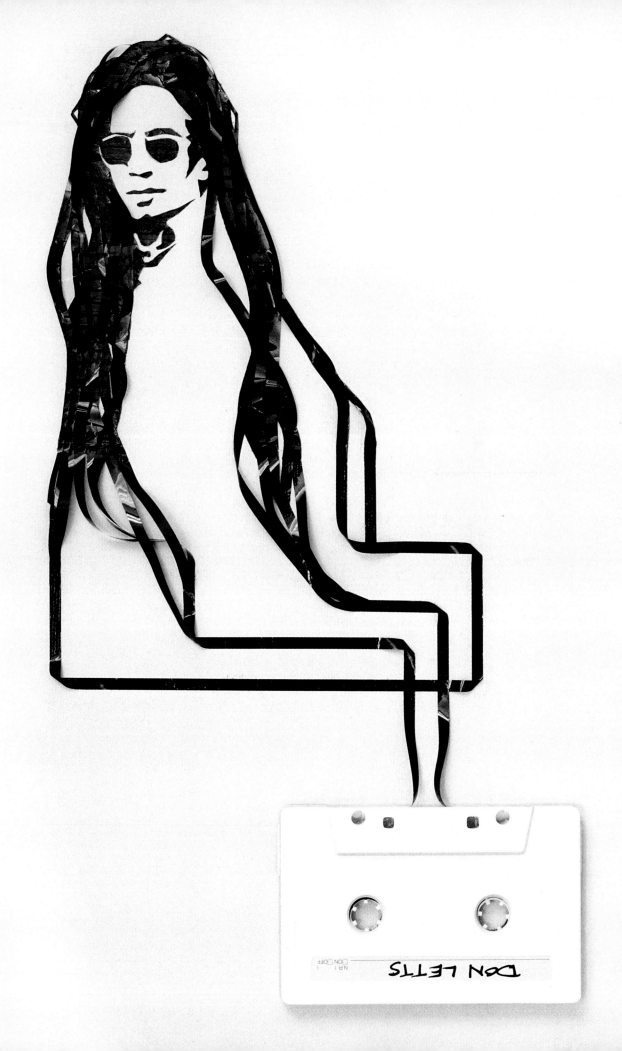

RECORD

Over the years they've been given many names—boombox, ghetto blaster, beatbox, Brixton briefcase—but whatever you call them, they've provided a soundtrack to a major part of my life, whether sitting on a beach in Jamaica with Johnny Rotten and Lee Perry in the late seventies or watching break dancers with the Clash in early-eighties New York. In my world they represent a time when reggae, punk, and hip-hop met and music was about changing minds and not just your sneakers.

They came on to the scene in 1977, a crucial year in many respects, and would go on to become *the* icon of urban culture during the eighties. Before the beatbox, your personal sound was tied to your bedroom, with your parents constantly telling you to "turn it down." The advent of the beatbox gave you a sonic freedom previously unheard of as you and sound track were now mobile. You could share your sound and create an instant party!

They spawned a subculture of mix tapes (serious currency back in the day) and cassette cover art. My thing was the Jamaican and UK reggae sound system C-90s. Indeed, it was a mix tape of Mikey Dread's *Dread at the Controls* radio show out in Jamaica that I gave Paul Simonon, which led to him tracking Mikey down to work on their triple album *Sandinista!* And the commercial-free master-mixes courtesy of WBLS, KISS, and KTU out of NYC were the bomb.

In the early eighties, many of the music videos I directed would feature a beatbox somewhere in the frame (e.g., Freeze's "I.O.U.," the Clash's "This Is Radio Clash," Bob Marley's "Waiting in Vain").

The Clash was never without one (actually, make that four). Indeed, the blaster became a major motif for the band by the time they hit the States. For a while, Mick Jones's guitar roadie found himself responsible for an additional piece of "kit" as Mick couldn't carry his! Joe Strummer would be rocking old-school R & B on his while Paul Simonon would be pumping dub reggae, and on Mick's the emerging hip-hop sounds that were coming out of the Bronx. You'd go into their dressing room and it was like walking into Carnival. These brothers would be cranking their individually chosen sound track—all at the same time. While they were in NYC in 1981 for their legendary run at Bond's, we became friends with the up-and-coming graffiti artists (such as Futura), and it wasn't long before their art covered our machines. Futura did a mean series of customized blasters for the Clash and Big Audio Dynamite.

During my time in NYC, we'd spend a lot of time looking, searching for the perfect beatbox in Times Square and Forty-second Street, or if you were looking for a bargain, down on Delancey. Finding the perfect machine became a holy grail, looking for the classic aesthetic shape, radio preset, line in and line out to connect to your turntables / microphone, and most importantly, bass response. We even got into market research to find out which batteries were best, which was important as some of these suckers would need up to ten D-size batteries (oh yeah, it's Duracell). I remember Topper Headon found a JVC RC-550 on Forty-second Street. Built to last (it even had crash bars) and one of a select few equipped with a 10-inch woofer. I recently picked one up in Turbosonic in Tokyo. By the way, if you're lucky enough to find yourself in Japan, a trip to Turbosonic is an absolute must, as to my knowledge it's the only store in the world that specializes in old-school beatboxes (sale and repairs).

In the mid-eighties as a member of Big Audio Dynamite, I was inspired to even write a song about them ("C'mon Every Beatbox") and they would continue to feature heavily in our music videos and artwork (check "Just Play Music"). I remember when we got Schoolly D to support us on a tour of the UK and we had to buy him an extra plane ticket for his blaster 'cause it was so big. The bloodclaat beatbox had its own seat!

Over the years I've had mini-discs, DAT machines, and of course the proverbial iPod, but nothing can touch the aesthetic beauty and sound of my beatbox. The boombox facilitated a sound. The design of them seemed to speak volumes about the kind of technology and the aspirations of the time . . . My first test for a beatbox was always how it held the bass—especially at low level. Bass is fundamental, like your heartbeat. And the emphasis on bass is a black thing. No getting around that . . .

The digital thing is definitely too clean, too crisp. I mean, you're actually losing a lot of frequencies there, a lot of the mid-range frequencies . . . You're missing the organic part, whether you realize it or not. The digital age has taken out all the mistakes of technology and, in fact, that's the stuff that I got off on.

But a kickin' bass line will still move the crowd—whether it be hip-hop or reggae. And I don't think it will ever go away, because bass is fundamental. And when I'm talkin' about bass, I'm really talkin' about frequencies. These days a lot of those bass frequencies are actually provided by a bass drum or a kick drum or a keyboard or a sequencer. But when real bass isn't there— man, do you miss it.

— Don Letts, Summer 2009, London

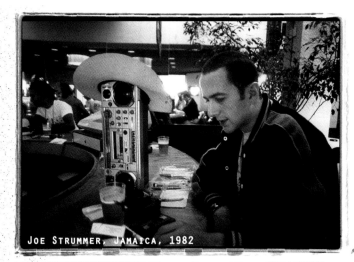

JOE STRUMMER, JAMAICA, 1982

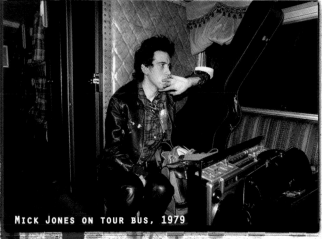

MICK JONES ON TOUR BUS, 1979

PHOTOS ABOVE BY BOB GRUEN

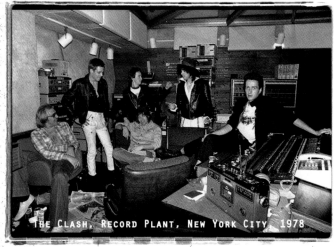

THE CLASH, RECORD PLANT, NEW YORK CITY, 1978

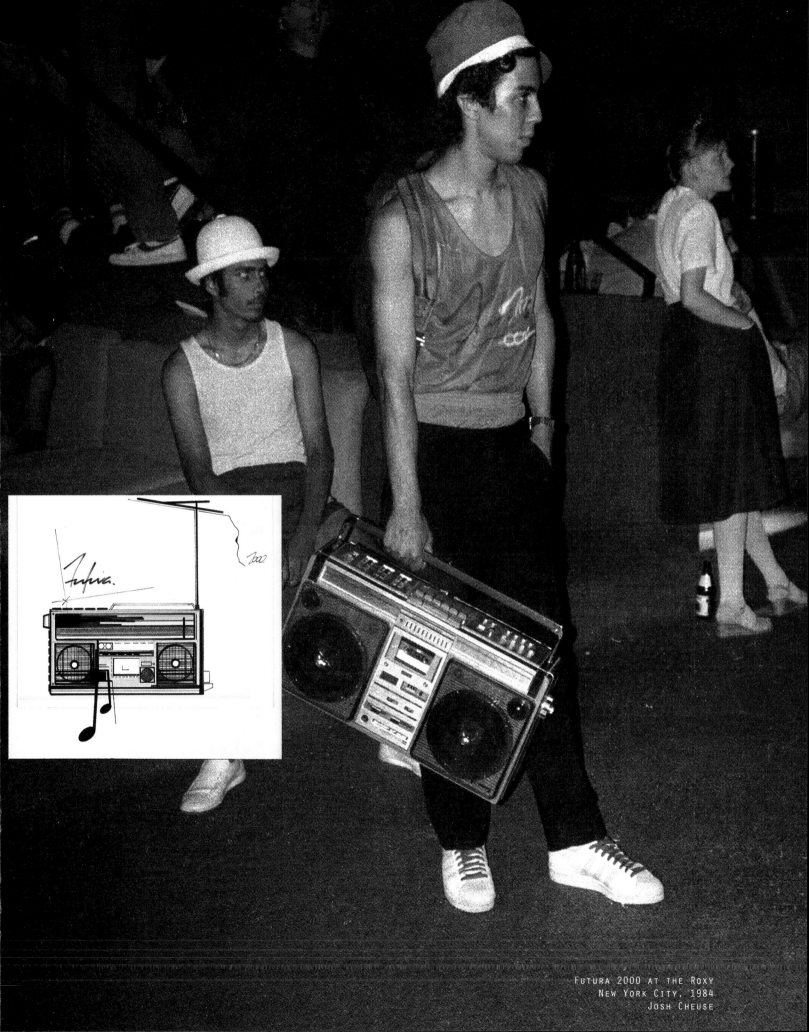

This is my boombox. There are many like it, but this one is mine.

When you're holding a boombox, it's vibrating. It was almost like having a speaker that vibrates. [Similar to] the actual Jamaican bass bins that make you want to move your bowels because the bass is so heavy.

— **Josh Cheuse** (*PHOTOGRAPHER/ART DIRECTOR*)

I have the ghetto blaster that I had when I was a kid ... It's a Hitachi, and it was one of the first ones with a graphic equalizer on it ... When we're mixing, we have these great big walls of speakers ... But then I go to the ghetto blaster and say, "Yeah, but what does the record sound like on this?" When it sounds all right on that, then I know it sounds good.

— **Noel Gallagher** (*OASIS*)

When BLS came on, this is what they would do that made you want to hear this shit correctly: It would go: "W-B-L-S." When you were able to hear that, the alternate letters coming out of the left and right speaker clearly, yo, B, that was the equivalent of having HDTV right now, or Blu-ray. This speaker to that speaker? We used to be like, "Yo, the W's over there and the B, yo, this shit is crazy!"

— **Fab 5 Freddy** (*PIONEER GRAFFITI ARTIST*)

The week before I flew to L.A. [to produce *Nevermind*], Kurt [Cobain] sent a cassette, which was done on a boombox. It was really terrible sounding, really distorted. You could barely make out anything. But I could hear the start to "Teen Spirit" before the band kicked in, and I knew it was an amazing song.

— **Butch Vig** (*MUSICIAN / RECORD PRODUCER*)

Orchard Beach was in the north section of the Bronx, a beach where everybody would just come down and hang out. There were particular sections: Most of the younger blacks and Latinos hung out around section four. That's where all the music would be at. Everybody would have a radio and people would be break dancing, listening to salsa music, jamming on that. Fifteen, twenty people would have a radio, and they would all be on BLS, they'd all listen to salsa, and you could just walk the entire section and not miss a beat at all because everybody was jamming on the same thing, on the same station.

— **Ricky Flores** (*PHOTOJOURNALIST*)

We was making tapes off the radio, pressing record. That was when 98.7 KISS played all the rap. When WBLS was poppin'. There wasn't no HOT 97 at all. Hot 97 was a Spanish station, do your history. You think I'm lying? That's how long ago the boombox was poppin'.

— **Jim Jones** (*RAP ARTIST*)

Career, Punk Rock

1. Make up some songs.

2. Get instruments.

3. Remove cassette from answering machine, insert into boombox.

4. Depress record buttons on boombox; play instruments until you stop.

5. Borrow five dollars.

6. Buy blank cassettes down at the store.

7. Duplicate cassettes using dual cassette on boombox.

8. (Simultaneous with step #7) Draw tape cover art. Use pen.

9. Go photocopy cover art (this will be free—someone in your band works in a copy shop, invariably) and insert into cassette cases.

10. Distribute cassettes. Repeat until you sell out and get a four-track.

—**Michael Ruffino** *(MUSICIAN / WRITER)*

I used to really just walk down the street with my radio and really had my boombox and, you know, had the nerve to be walking around with it because it was like a stick-up kid's dream back then. I would just be walking around with my radio, skinny. Walking with my radio, not caring (and you know I can't live without my radio). I used to listen to all my rap music on it. If I wanted to hear Mr. Magic, if I wanted to hear Marley Marl, if I wanted to, you know, listen to HBI I think it was, Original Concept and all of them. Bill Stephany's crew out in Long Island and Hank Shocklee and them and Chuck D and Flavor Flav and all them on the station, you know I used to listen to it on my boombox.

—**LL Cool J** *(RAPPER / ACTOR)*

Any kind of music was a conversation. A style of dance was an expression, so it was always something that the boombox helped us with. We expressed being minorities in Hell's Kitchen, having to deal with all the fights, left and right, in the schools. Dealing with our parents, either we had both parents or just one or we were living with an aunt and an uncle because of our poverty. And the music coming from the boombox; it was an expression for us. It was a way of getting all that shit out.

—**Lisa Lisa** *(SINGER, LISA LISA AND CULT JAM)*

Scratch Master Bucket, he was the local town hero, and he was doing, like, all the events at the USA Skating Rink and the clubs. And he also was guest deejaying on some of those radio stations. But as a guest DJ, so he wasn't the person you'd hear all the time. The other dude, the one that was on URI, was Vaughn Johnson. He was more like the host of the show. As far as great radio personalities, I would say Vaughn, and then regarding actual official DJs to mixing, I would have to give that to Bucket.

—**DJ Eclipse** *(DJ)*

At first hip-hop was really a New York thing. So you had to be in the tristate area to get a taste. And they weren't playing hip-hop on the radio in the daytime. They only played it on Friday nights and Saturday nights: Longee More, Mr. Mack Jig, the Cooks, Red Alert. BLS would play it at night and KISS FM. So we'd tape the mix shows and play it for the whole week. That's how the whole Roxanne Shanté battles started, U.T.F.O., Slick Rick—and we used to play it on our boombox. That's how you taped it, and then we would replay them, replay the mixes. That's how we fell in love with hip-hop. And we couldn't wait till Friday and Saturday.

—**Pras** *(HIP-HOP ARTIST / MUSICIAN / THE FUGEES)*

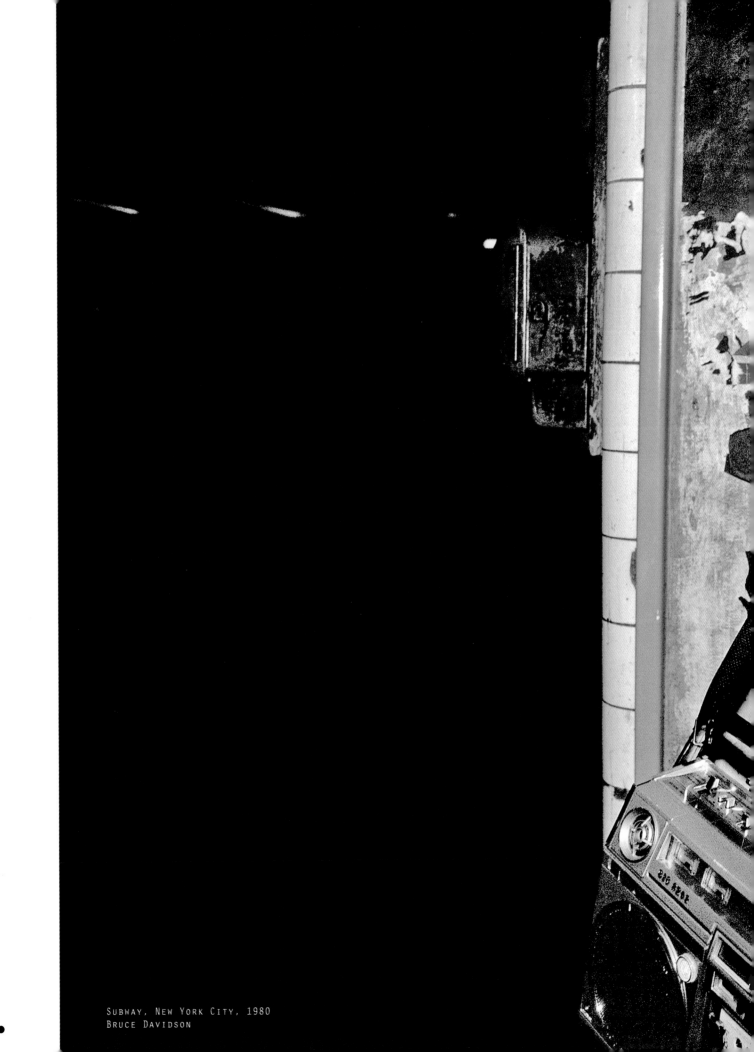

SUBWAY, NEW YORK CITY, 1980
BRUCE DAVIDSON

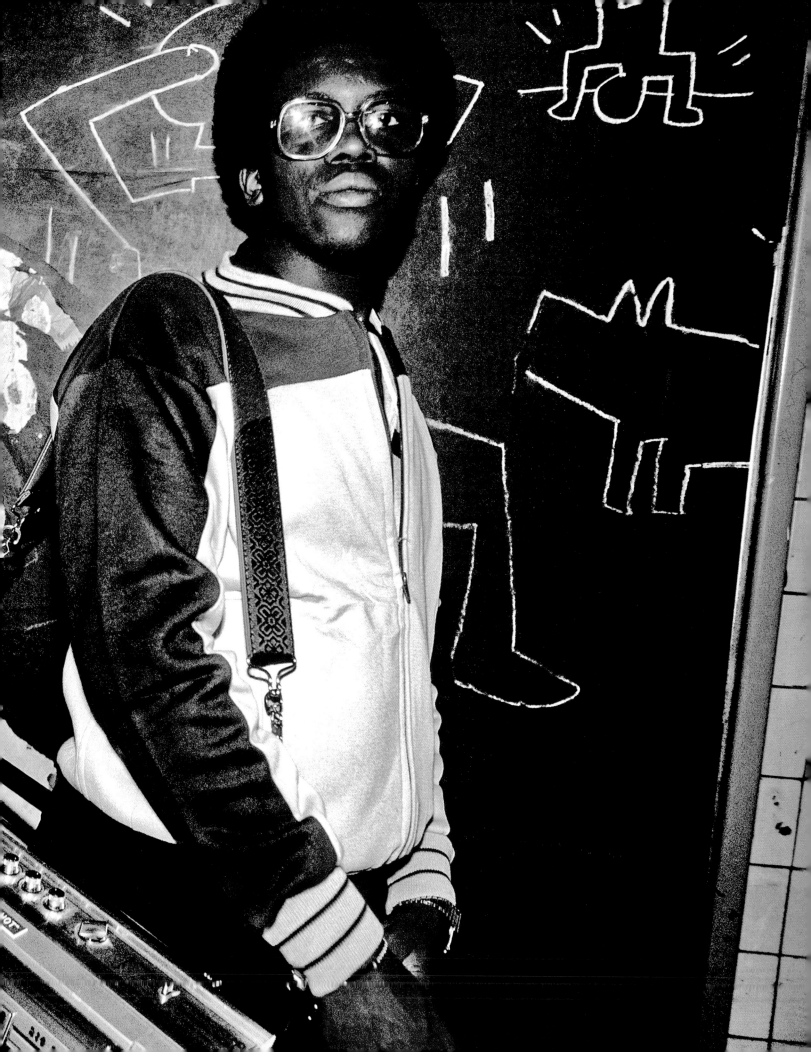

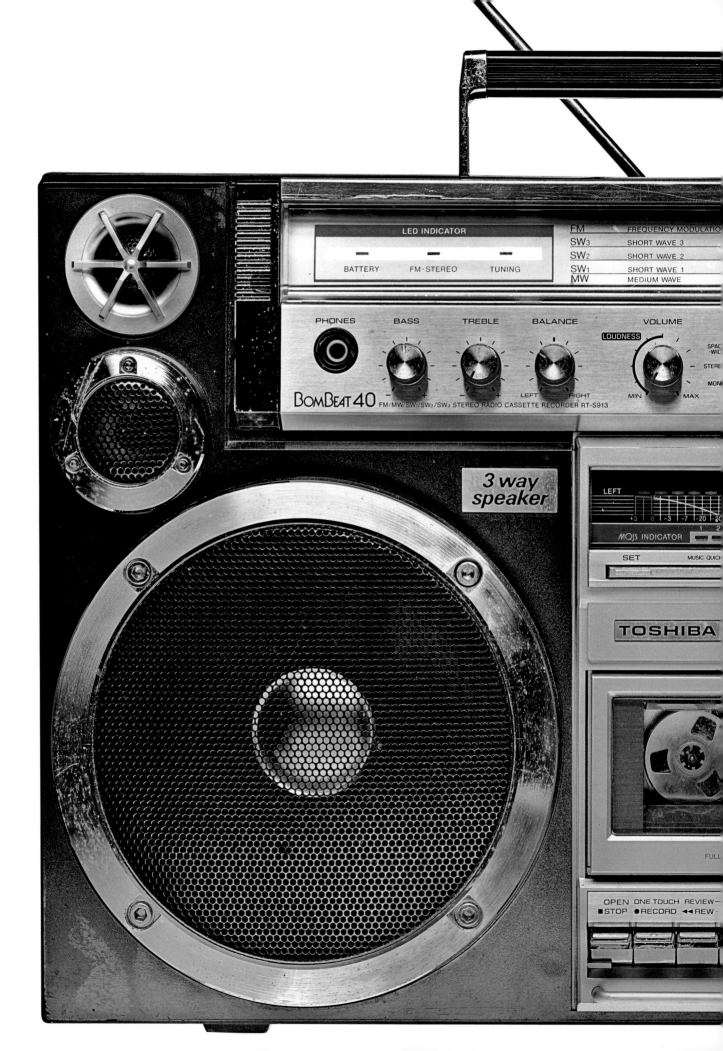

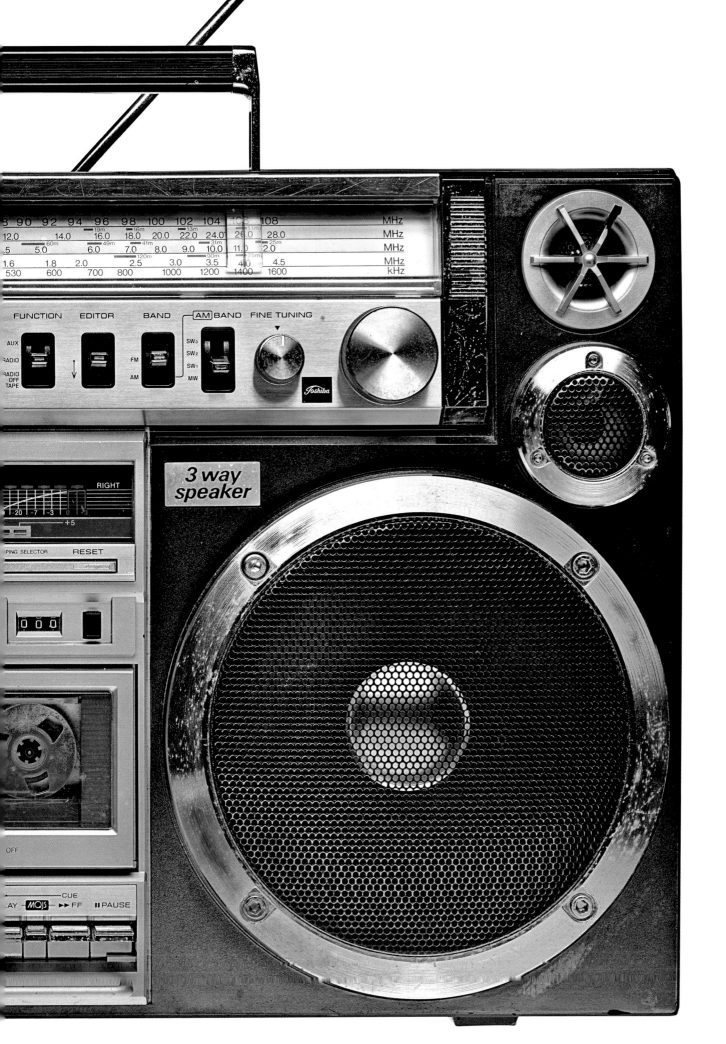

CASSETTE CULTURE

Mix tapes, pause tapes, recorded radio shows, and compilations were all tiny weapons of change and expression—once music could be broadcast ("while on the move," from a boombox), a sonic revolution began in the hands of the people. This wave of sound was not so loud at first, but once the sonic barrier of personal taste and self-expression was broken, hip-hop, punk, garage rock, and new wave leapt up to be noticed and forever heard from . . . *LO*

The boombox was the home recording studio. It was where the demos were made The ease of use was great because you could just, you know, bring the boombox to rehearsal, set it up in the corner, hope that you got a good balance, and then you could just listen back to it or give it to girls or whatever, you know? That instant gratification is important, especially when you're young.

— **Jonathan Daniel** *(MUSIC HISTORIAN / BAND MANAGER)*

DJ Hollywood, Kool Herc, Bambaataa, all those great DJs from the early seventies are the architects of hip-hop. And the boombox is basically where we would be able to hear what was going on in those other neighborhoods because guys would make cassette tapes, and cassette tapes would travel around. It was two steps away from the pigeon taking a note from one town to another back in the days when there was no telephone. It's the same kind of thing, you know, listening to hip-hop music. And unless you were old enough to go to the party, you'd have to wait until the summertime, till they came out in the park and you could sneak out to hear it for free.

— **Kool Moe Dee** *(PIONEER HIP-HOP MC)*

TINA WEYMOUTH AND GRANDMASTER FLASH
LOWER EAST SIDE, 1982
LAURA LEVINE

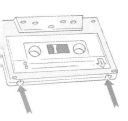

For pause tapes I was looking for raw music I guess. The crazier sounding, the better the pause tape. It's just like edits, just tons and tons of edits with as much crazy stuff as possible. But then the mix tapes differ because then you have to have a sort of flow to a mix tape . . . it wasn't just a collection of songs, it was a collection of ideas through the songs and the music itself, and through the artwork, even how you put the titles on the cassette. It was curating a whole sort of experience.

— **Adam Yauch** (MC / BEASTIE BOYS)

There was, like, an organic feel with the reel-to-reel and tapes and boomboxes . . . the confidence of putting the music onto the tape, even the physicality of when your favorite tape would break (since you'd play it over and over again). Then you'd try and repair it . . . a lot of the early recordings would be the tape-to-tape dub-over, where you'd record on one side, and then you'd record it to the other side, and then record again . . .

— **Tyler Gibney** (ARTIST)

Back then, whether it was a custom-made tape you'd made yourself or albums that you bought in the store, they were playable all the way through. Whatever your new tape was at the time, you would just put it in and let it play . . . to the world. And that was kind of what that era was about, you know, with cassettes. An album is basically peaks and valleys, so if you're walking around with it, you can just be in the zone of that artist, whether it's an LL Cool J album, a Run-DMC album, an EPMD album, whatever it was, you were locked in with that artist for an hour. Like you don't really see that kind of continuity with listening to albums these days. It wasn't like iTunes, where there's two good songs on the album and you just download those.

— **J-Zone** (HIP-HOP ARTIST)

My stereo was big and silver with EQ and detachable speakers. It was the center of all my activity growing up in the foothills of the Canadian Rockies with nothing around for miles. While fixing motorcycles, waxing skis, or doing whatever it was that we did then, it was always around, omnipresent and tuned to the one vaguely received AM radio station in the area, CKXL. Mix tapes were the holy grail from a dungeon of top 40 radio monotony; when a new song came on, someone would race over, hit the record button (which then involved holding down both the "record" and "play" buttons simultaneously) and make a copy of the song. Due to the minuteman-type dash to hit the record button, all "mix tapes" of that era were missing a portion of the beginning of the song (which wasn't necessarily a bad thing, because the DJs tended to talk over the track all the way up to the first vocal). Long live the boombox.

— **Custom** (MUSICIAN / FILMMAKER)

DJs were breaking these new sounds to a receptive group of kids. Early on they began recording these sets; they began recording live performances by guys out in the park; and then, of course, making [cassette] copies of those . . .

There was an art to making a cassette mix. You needed to know your tracks and how long they were and be intimately involved in the process of actually putting this thing together and getting it to fit. Because the last thing you wanted was the song to cut off midway at the end of the tape; that was the ultimate mix tape faux pas. So it was all about how you were gonna create a flow of music but also get it down in a way where, by the end of that last track, you were gonna hear *click* and it was gonna be time to turn that tape over and rock on to the other side . . .

— **Andre Torres** (EDITOR, WAX POETICS)

There was a real excitement and exuberance around the music at the time. I don't know if you've ever heard about pause mixing. There were certain boxes—I want to say it was a Sanyo. This became big when you had a double cassette because you'd record, let's say, "Mr. Magic's Rap Attack," "The Supreme Team." These were local New York radio shows that came on once a week for a couple of hours that played the beginnings of what we know of as rap-slash-hip-hop music. You'd want to pause out the commercials and not have the filler; you want some good music. So if you have the right box, you can pause and then when the commercial's over you can wait. If you really had it down, you could come in on the right beat and the pause mix would be seamless. There were cats that prided themselves on being nice at that [LAUGHS] and then being able to go from cassette to cassette and kind of remix and remake stuff. That was huge.

—**Fab 5 Freddy** (PIONEER GRAFFITI ARTIST)

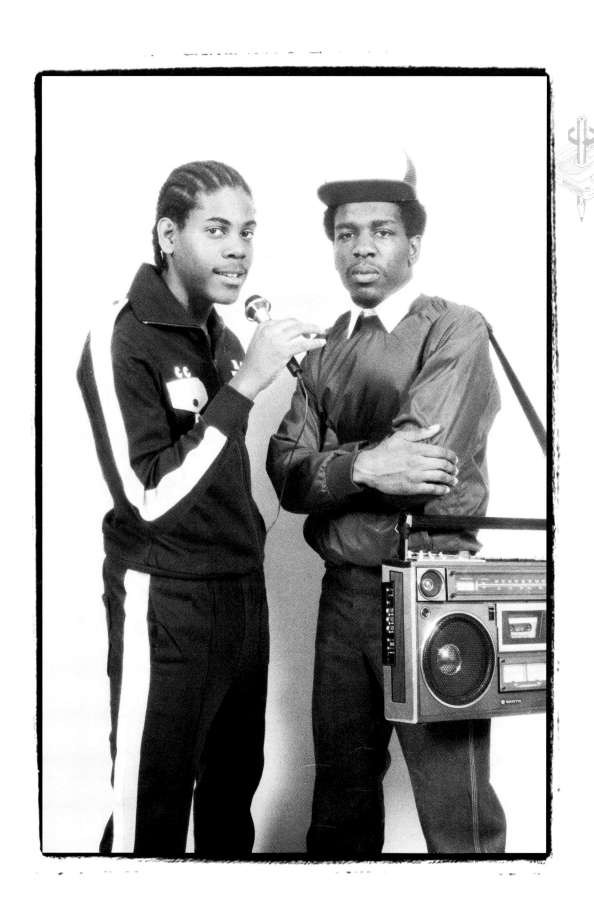

EZ AD and Tony Tone
The Michaelangelos
Bronx, New York City, 1980
Joe Conzo

THE DJ AND THE MC

Hip-hop began as an uptown and outer-borough phenomenon that drew distinctive presence from its creator's desire for personal expression and innovation. The ability to incubate in the way it did, initially untouched by mass media, allowed the movement to gain the strength and posture that fed in to its indelible spirit and eventual staying power. While hip-hop was developing during the late seventies (and as breaking evolved as a dance style), DJs were creating the soundtrack to this new movement by taking the rhythmic breakdown sections (or "breaks") of dance records and looping them one after the other, over and over. This provided a rhythmic background for improvising and mixing, while simultaneously allowing the dancers to display their skills during extended musical interludes.

> It created an almost DJ mentality—knowing you were gonna be using this [tape] for a group of people to listen to. We all sort of became DJs in a sense—and the art of filtering and editing is the sort of seminal part of being a DJ. This was a reflection of who you were, for everybody else to hear what you had to say, because you were speaking through the music in a sense.
> —**Andre Torres** (EDITOR, WAX POETICS)

The pioneering DJs of this movement introduced what became the most elemental part of b-boy music. That was the common denominator of musical breaks formed out of samples taken from previously existing songs. In fact the whole genre of early hip-hop existed on a healthy dose of appropriated musical elements. Using audio clips (later known as "samples"), a sonic chain of sorts was looped together by the DJ. The tempo of this chain was generally beat-heavy, yet skillfully crafted into a smooth percussive pattern. Spine-rattling bass was usually the deft signature of this auditory tool. Urban history credits DJ Kool Herc, a Jamaican transplant in New York, with the invention of this concept, which quickly became termed "the break beat," honoring its genesis as an ad infinitum interlude. These "breaks" or "loops of fury" innovations aimed at the dancers' favorite part in a song became the blueprint for modern hip-hop music. However, what occured in a DJ's mix booth did not translate so quickly to the music industry oligarchy. Some of the most influential tracks from the early days of hip-hop are now hard to find simply because the samples proved too hard to clear rights for once the genre ran rampant (Schoolly D's "The Signifying Rapper," which used "Kashmir" by Led Zeppelin, or Boogie Down Productions' heavy use of AC/DC on "Dope Beat" are some early samples of the break beat pushing the genre and stirring the ire of the recording industry). Other pioneers of this movement included Grandmaster Flash and the Sugar Hill Gang, who all reached into their record bins for funk beats to loop rather than use a live band to create the sounds they needed for their songs.

Following the rise of the DJ's stature as the preeminent sonic voice of the streets was the arrival of the MC. Born in the late seventies, the initial function of this individual was to hype the DJ's presence. The role quickly grew in prominence, incubating as a flow of words and style. Once accepted in front of the DJ's decks, the moniker MC (master of ceremonies) established a meaningful responsibility in hip-hop culture both as a visual centerpiece and as the "chairman of the board," so to speak. Initially the MC (or rapper, as they became known later) used rhyming verses of his own poetic creation to introduce and praise the DJ he was fronting. In the early days, the DJ was the head honcho, with the role of the MC to simply pump up the crowd with a shotgun blast of oration (it wasn't long before taunting one's own stature, commenting on the ills of society, or dissing another MC's style became the basis of this platform). As hip-hop progressed, the title MC became associated with a number of terms, such as Microphone Controller, Mic Checka, or Music Commentator. It also gained populatiry through the lyrics of songs such as KRS-One's "The MC": "Who am I? The MC, la-di da-di. I don't wear Versace, I wear DJs out quickly at the party;" or MC Lyte's "Stop, Look, Listen": "M.C.—Master of Creativity / Rappin' is the activity." Whether the "master of creativity" or the one to "move the crowd" (as stated in the track "Eric B for President," by Eric B and Rakim), just as a master of ceremonies introduced boxers from opposite sides of the ring in a prize fight, the MC in hip-hop delivered a verbal discourse for all to take notice and listen, or if challenged, to jump into the fray and do battle with him. *LO*

Guys that felt that they were great MCs wanted everybody to hear them, you know, drop it. Guys would have their microphones with them, plug it into the box and just freestyle, drawing people so that the box became like that magnet that would bring people together. Then you had others that made tapes so hot they wanted everybody to listen to it. So the box helped enhance the whole spirit of your circle. Whoever had the box was the man back then. If you had the box, you had the power. Everybody wanted to be around you because you had the music. The women wanted to be around you because you're playing the tunes. The MCs wanted to be around with you just because they could show their skill.

— **Jamel Shabazz** (PHOTO DOCUMENTARIAN)

I'm a freestyle DJ. I like to play something that the radio should be playing that they're not playing.

— **DJ Kool Herc** (DJ / GODFATHER OF HIP-HOP)

DJs used to have a power to break a song or break a band because their personal taste overrode the station manager's playlist.

— **Jonathan Daniel** (MUSIC HISTORIAN / BAND MANAGER)

The rapper originally was just there to talk about the DJ. If you go back into West African culture, in West Africa—in Mali, they have what's called the griot. He says, "Hey, yo, this is what's goin' on; this is what's happenin." And this guy is the best, the most fabulous, the most interesting, the wealthiest, the most generous, the best lover, and the most beautiful man in his town, and he is here tonight to sit at this table and then for all of us to enjoy his presence at our party.

And they've been doing that in that culture for hundreds, maybe even thousands, of years. That's a form of a rapper.

— **Fab 5 Freddy** (PIONEER GRAFFITI ARTIST)

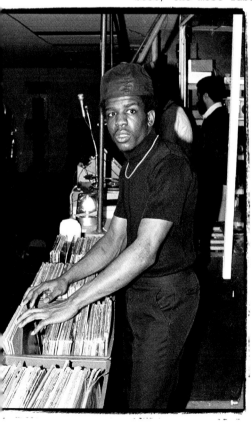

Radio stations had shows on certain nights of the week, so I would just sit there and record, not even record the whole show; I'd sit there with the record button on pause and wait until I heard something that I wanted to hear, and I'd just record that. Then from there, it expanded. You'd have friends that had boomboxes as well. So now what you do is you want to get songs that the other guy had and vice versa. You start making pause tapes. And that's really, I guess, what probably set me up for wanting to get into deejaying, the effect of having two radios next to each other, playing songs on one, and pause recording on the other, taking bits and pieces and trying to, like, compile your own little megamix of a medley.

— **DJ Eclipse** (DJ)

Tony Tone deejaying at the T Connection
Bronx, New York City, 1979
Joe Conzo

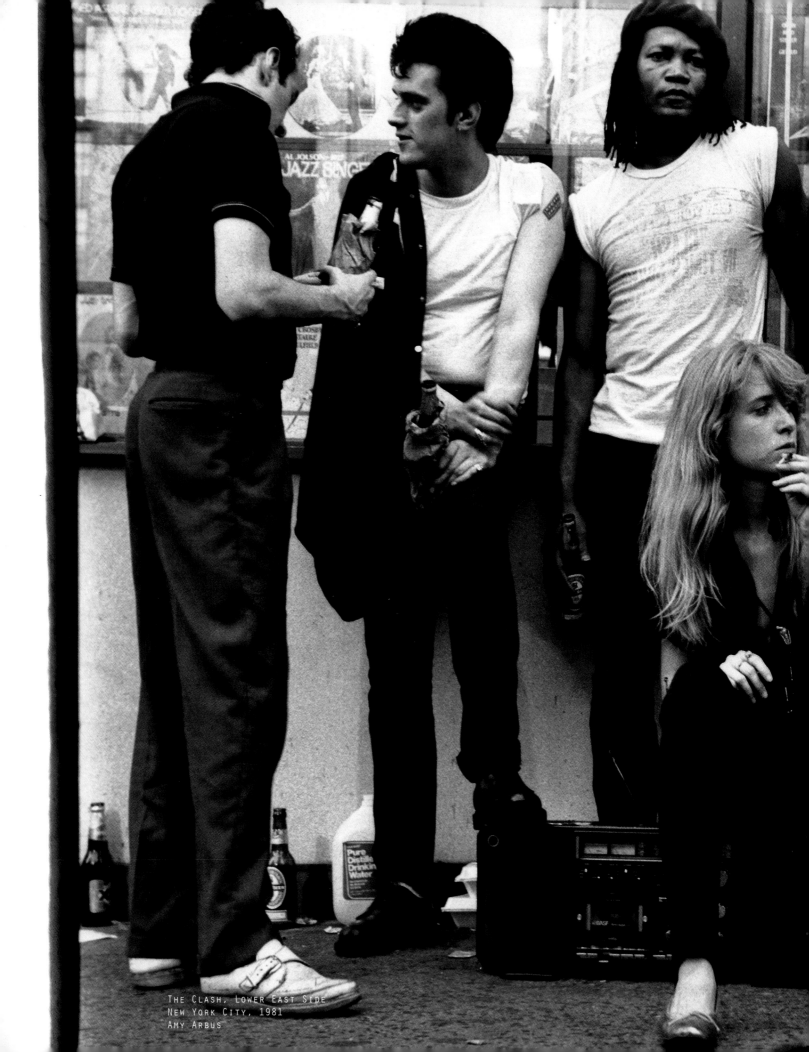

The Clash, Lower East Side
New York City, 1981
Amy Arbus

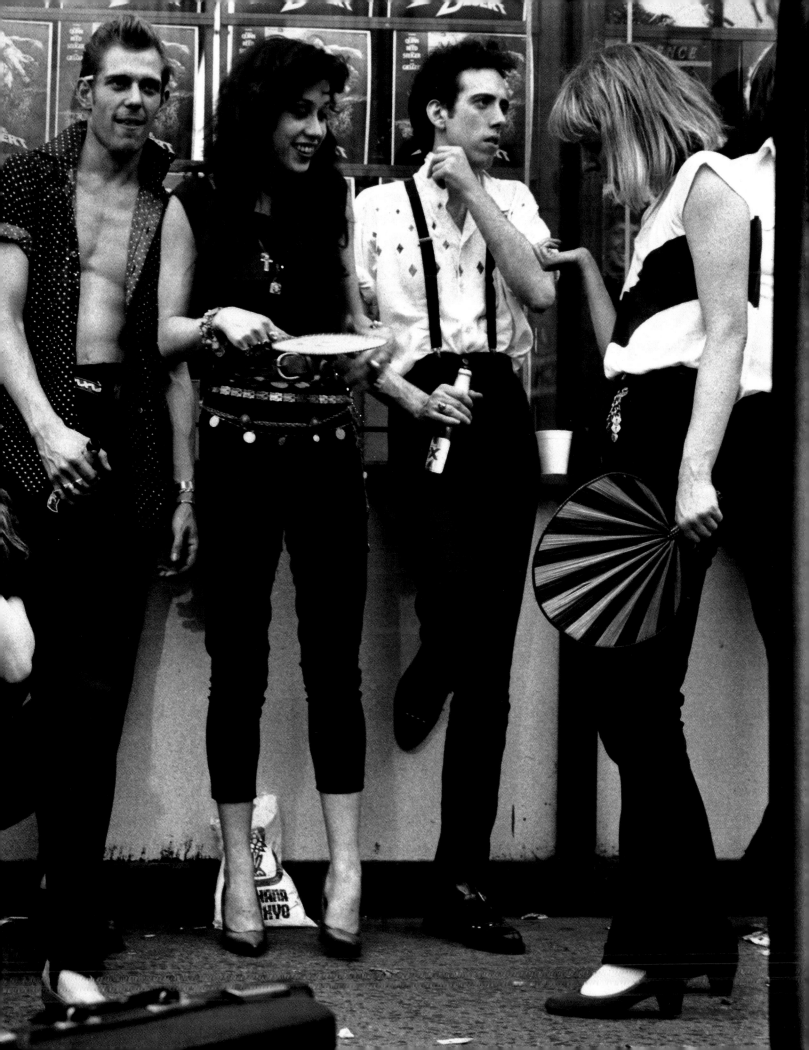

THE SUBCULTURES

A subculture is a group of people within a culture (whether distinct or hidden) who seek to differentiate themselves from the larger context in which they exist. It's this distinction that defines them and set's them apart from the greater whole. Characterized by a persistent opposition to the dominant culture, a subculture may even be described as a counterculture. Observing the divergent culture of the boombox (defined either as a subculture or as a counterculture), we see many elements coming together as a penetrating aural revolution that infiltrated the status quo—walls were forever shattered by voices and beats being mixed together that gave birth to a new form of articulating the desire to be seen and heard with validity and distinction, e.g.: hip-hop, punk, new wave, speed metal, etc. Symbolizing a subculture's rise to significance, the boombox is a primary metaphor of voicing societal and cultural change. It's why their distinctive image still lingers amongst us today. LO

The music was the backdrop. And you could hear it for miles around. You walk down the block and you hear that constant rhythm, that kind of musical flow.

We were feeding on a lot of different types of musical cultures. It's no surprise that Run-DMC would wind up using Aerosmith to do their take on that stuff, you know, because we were using a lot of that stuff in our communities.

— **Ricky Flores** (PHOTOJOURNALIST)

The boombox was also a fashion accessory. There was no MTV dictating our style or our taste. We kind of dictated that to them. Looking back, it's pretty amazing that someone says, "I'm going to wear sneakers and sweatpants and a Kangol, and I'm going to make it look really fly, and I'm going to carry a boombox, and it's going to be even more fly." If you really think about it, that's insane. Like, that's an insane notion. It's, like, really brilliant, you know? And you knew who was from where based upon their style. Like you know, "Oh, that's so Brooklyn. That's the Bronx. That's uptown, Harlem. That's Manhattan." You know? Poor Staten Island, you just knew because they had no style whatsoever. Thank God for Wu-Tang. Masta Ace, you know, straight from Brooklyn. Eric B and Rakim, straight from Brooklyn. MC Lyte, you know. It was a very specific style. Even Grandmaster Flash and the Furious Five. Straight from Manhattan, you know? Remember they wore those leather outfits? Oh, God, they were horrible.

— **Rosie Perez** (CHOREOGRAPHER / ACTRESS)

I'd take music and use that as inspiration for skateboarding, and skateboarding influenced the music For my generation, the boombox was a strong symbol of hip-hop. It was always part of my life, like graffiti, break dancing, deejaying, and producing music. So for me it was always an iconic symbol of, like, the youth culture. And it wasn't only hip-hop. You'd see just as many, like, crazy punk rockers walking around with a ghetto blaster.

— **Chad Muska** (PRO SKATEBOARDER)

You'll talk to some people and they'll say, "Oh, I don't like hip-hop," but they write graffiti. Or they'll say, "Oh, I'm not into hip-hop. I just like dance." And, you know, they don't understand that it's a four-legged table. You know, take one of those pieces off the table, and the movement might not be what it is today.

— **Cey Adams** (GRAFFITI ARTIST / ART DIRECTOR)

When people used to break-dance, you needed a boombox. When you were in a train station or underneath the subway, you'd have battles. That's what I used to do. You had this one kid, his whole job was just to carry the boombox. He did nothing else. But if he was going to have the boombox, he was going to have the right music. And that was a skill in itself. But he had to be able to carry it. You know, that shit was heavy at one point. It's not like we had cars. We had to walk and catch the trains all over the place.

— **Pras** (HIP-HOP ARTIST / MUSICIAN / THE FUGEES)

When I say that punk and hip-hop—the original hip-hop—were closely related, people look at me like I'm crazy. How could they even possibly be remotely connected to each other? Because they were irreverent. They were anarchic in a way. They were built from protest and dissatisfaction with where they come from, particularly graffiti artists. And even though the music didn't replicate that until "The Message." It really was the first rap tune that actually really thought about where these guys came from. There is a great similarity between the two movements.

And ironically enough, the people like the Clash, Bernie Rhodes, Malcolm, Don Letts, all these people that came from punk—and Bob Gruen—were all involved in rap music, too, and in hip-hop. To me that shows the strength and bond between the two genres.

— **Nick Egan** (ALBUM DESIGNER / ART DIRECTOR)

When I started going out to clubs in Manhattan in, like, 1985, '86, they would play new wave on one floor and hip-hop on the other floor and punk rock on the other floor and disco on the roof. So I think each culture benefited from the boombox. And there were, like, different aesthetics with each one.

— **Claw Money** (GRAFFITI ARTIST / FASHION DESIGNER)

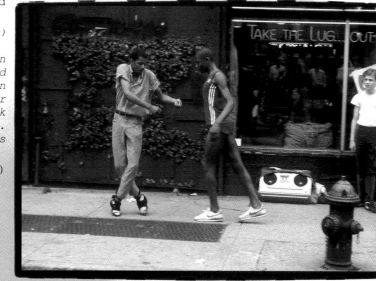

From Kraftwerk and Afrika Bambaataa to 2 Live Crew and Jam Pony Express, the sounds of the revolutionary, phenomenon of the 1980s forever changed and inspired the sound of music today and into the future. The boombox, with its electronic transmission of the beats, becomes manifest through the B-boy's footwork as the message.
— **Jose Parla** (B-BOY / ARTIST)

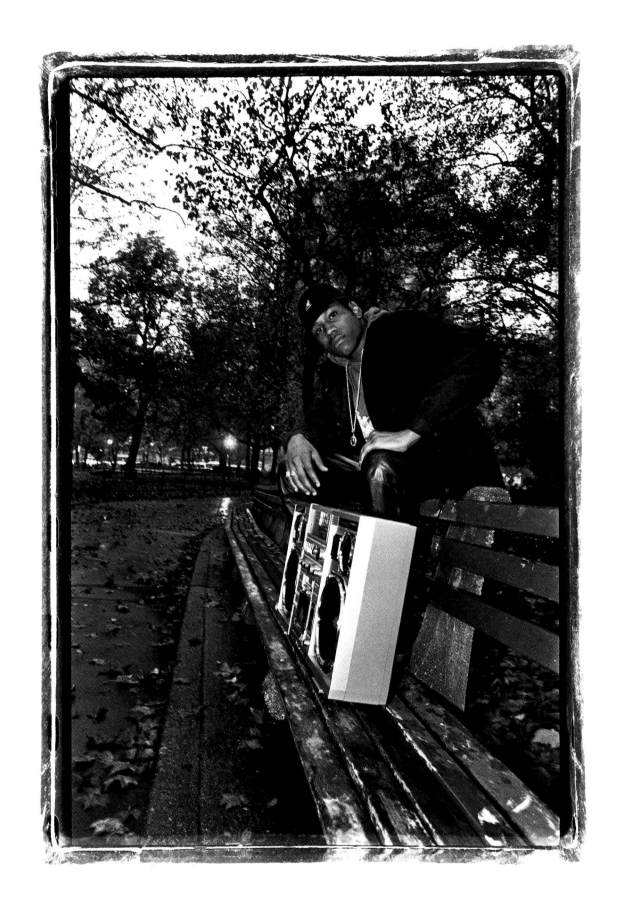

LL COOL J,
MADISON SQUARE PARK, NEW YORK CITY, 1985
GLEN E. FRIEDMAN, FROM THE BOOK, FUCK YOU HEROES,
COURTESY BURNING FLAGS PRESS

RAP

From its early roots in front of the DJ's sound system, hip-hop culture spawned a new musical genre known as rap. From its outset, rapping took off from emceeing (MCing), which first hit the scene through linking up with the DJ—the subsequent urban marriage of rapidly delivered words over break beats led to the birth of the rapper phenomenon. The most prominent form of rapping is a fervent word display delivered lyrically over musical accompaniment. Today the term *rap* is so closely embedded within *hip-hop* that many use the terms synonymously (though pioneers in the movement will be quick to point out the difference between rap and hip-hop).

Initially established as the lead person to hype up a crowd for the DJ, the rapper quickly became defined as an artist, distinguished by a rat-a-tat-tat spoken delivery of rhymes, wordplay, and urban poetry. Once heard, it's never to be forgotten. Delivered as a rhythmic, flowing narrative, rapping is one of the primary components in contemporary hip-hop music. The phenomenon, however, predates hip-hop culture by many centuries. The tradition can be traced back to West Africa and the culture of griots. A griot is a larger-than-life character who can best be described as an announcer or praise singer of sorts. Picture a town crier with tribal robes using his voice as a bell to gather attention at a party. Once attention is gathered, the griot will tell a sing-song-like story about a citizen of rank, praising his virtues and stature. Rapping built upon this oral tradition of an honorable yet loud profession by pushing it in to new realms.

The whole genre of rap is based on extemporizing a subject or personal accomplishment with a high amount of bravado peppered with personal style and verve. However, the use of the word *rap* to describe a signature of quick speech predates the musical form by a long time. The word originally means "to knock or hit" (consequently drawing attention to someone or something). Considering the definition of *rap* is "grabbing hold of something," that it is now used to seize hold of spoken language to seek attention only further solidifies its meaning. In fact the word has apparently been used in British English since the sixteenth century, and has been used to mean "to say" since the 1800s.

The journey to where it is today really began in the 1960s as part of an inner-city dialect, meaning "a conversation." To "rap" was to literally talk things through, to spread the word or news, or to simply state something to a friend. Very soon after, *rap* found its way to its present usage denoting the musical style of rapping. Also known as MCing, flow, spitting, or just straight-up rhyming, rapping has a firm place in pop culture—stylistically, it can be said that the meaning of *rap* occupies a hazy stretch of road linking speech, prose, poetry, and song all together into a spectacle of parlance with break beats as a sonic backdrop. *LO*

Before it became branded as hip-hop culture, nobody called it hip-hop. Hip-hop was just this thing that guys said on the mic as a part of what a DJ's patter was—like, "to the hip, the hop."

— **Fab 5 Freddy** (PIONEER GRAFFITI ARTIST)

Rap is something you do. Hip-hop is something you live.

— **KRS-One** (MC / HIP-HIP ACTIVIST)

The drum and the microphone are two things that really pushed the burgeoning culture of rap forward. The drum was, like, up front. That's what people danced to, people waited for the naked drum break. And the microphone was integral as well, because that's what controlled the crowd. That's what brought out the messages. That's what carried the personality and voice.

The next instrument that was integral to rap was the turntable, because now you have the turntable translating the drum, the recorded drum, to the party people. The turntable in and of itself, it's really not an instrument. The turntable is a mechanism to play music, but then the mechanism to play music becomes an instrument in and of itself because, Theodore, you know, he invents the scratch, and Flash, he gets crazy with cutting records and back and forth. And so now the turntable becomes an instrument.

In the early eighties and nineties, the hype of activism within New York City had to do with police brutality and racial discrimination because it was so common during that time. And that's when you began to see rap music begin to change and have a particular political bent. Public Enemy began to give that thing a kind of a voice which was right on time.
— Ricky Flores (PHOTOJOURNALIST)

So now you have three instruments: a microphone, you have a drum, and you have a turntable. Probably the sound system is the next instrument because the way those guys, like Herc, manipulated sound systems, it wasn't just like playing any speakers. The speakers were important now.

And quite possibly the last instrument is the boombox. It was the next instrument to really promote and translate the music. So you've got a top five of instruments, the early conduits of rap, of the culture. That's why the boombox is revered when people look back at it.

— **Bobbito Garcia** (RADIO HOST / WRITER)

Back in the day, the tape recorders were pretty huge, with the cassette. I had the tape recorder and a friend of my mother's had given me the boombox with the microphone. I used to do the beatbox on the microphone, and tape myself beatboxing on the boombox. I would layer beats back and forth, so I would play back the beat I recorded onto the boombox, and then switch tapes again and keep layering and create a whole symphony with just my mouth, the boombox, and a tape recorder . . . people were like, "No. I mean, you didn't do this in your house." I'm like, "Yeah, I did."

— **Rahzel** (HUMAN BEATBOX / THE ROOTS)

Hip-hop started with the boombox. When I was maybe ten, I was in the park, and these maybe, like, seven, eight guys approached me and they started to beat up on me, jump me. And as this was happening, we heard this sound, you know. I think we all heard it at the same time, but we didn't know what the hell it was. It got, like, louder and louder, and they stopped and wanted to see where this sound was coming from. Finally, this guy comes walking by with Pumas on, and the tight Lees on. He had the Kangol hat on. And he had this boombox on his right hand, on his right shoulder. And all we heard was boom, bap, bap, bap, boom, bap, boom, bap, bap, boom, bap, bap . . . And we were like deer lost in the headlights, we couldn't believe how that incredible sound was coming from this box. We didn't know it was called a boombox. We just knew it was like a radio. And we just stopped and watched this dude walk past us as the music was being played . . . When he got out of earshot, they continued to beat me up, but I felt so good that day because I'd never seen it or heard anything like that before in my life. I felt like my life had changed. That's how I got into hip-hop, believe it or not.

— **Pras** (HIP-HOP ARTIST / MUSICIAN / THE FUGEES)

Back in the days, like 1976, '77, rap wasn't called rap; it wasn't called hip-hop; it was called "droppin' science." And when you got on the microphone, you said things that were relevant. You wanted to show that you was intelligent; that you was studious. You wasn't usin' profanity. You said things that made sense.

And the stuff that we called nursery rhymes, my circle, we stayed away from that. We didn't see the relevance in it. We wanted to rhyme about things that made sense. When I was growing up, a lot of other guys carried dictionaries because they wanted to perfect their vocabulary so they could be better MCs. So it wasn't about being dumbed-down.

— **Jamel Shabazz** (PHOTO DOCUMENTARIAN)

I ain't gonna front, the boombox was crucial. As far as hip-hop, it's very instrumental to where hip-hop is. It definitely played the music in the streets for us, for a lot of years, for everybody to hear. It was a statement, it was sort of the beginning of the revolution. People walked around with their music loud and played it proud for whomever to hear. Till the cops told you turn it down, and as soon as they'd leave we turn it back up again. You can't disrespect the boombox.

— **Jim Jones** (RAP ARTIST)

Bobby Brown's video "My Prerogative" was choreographed to a boombox. And when the A&R director came to rehearsal, he was like, "He has to be sexier. You have him dancing too hard." Then he goes, "I just want him to feel it!" and he went like this [HIP THRUST]. That's how that [hump] move came. And Bobby loved it.

Heart and Soul was the dance group I hired for him; they had perfect synergy on the thing. When they were filming the video it was in front of a live audience. So we told Bobby, "If you forget a step, just hump. Just hump the air if you forget a step." And he did that move—through the whole video.

— **Rosie Perez** (CHOREOGRAPHER / ACTRESS)

I remember when LL Cool J's *Radio* came out in '85. I remember seeing that record cover. Def Jam, Columbia, did an amazing job of doing in-store promo on that record, because I think it was at Crazy Eddie's on Eighty-sixth Street, and the entire window was boomboxes and flats of that record. And I think that was probably the pinnacle of the boombox, being on the cover of that record.

— **Stretch Armstrong** (DJ / RADIO HOST)

I was working with Def Jam and we hadn't put out any albums yet. We just put out a bunch of 12-inches. This was around the time in New York City when radios were getting bigger and bigger; it was ridiculous. I'd just been to our offices to pick up a case of a dance product on the LL Cool J Radio album. I was walking down Fifty-second Street to Fifth Avenue, and there were these two kids—they were probably between ten and thirteen—who had a radio that was almost half their size, and they were carrying it between the two of them, just by the handle.

We were at a light, so I stopped them, looked them up and down. Then I said, "Hey, take this," and opened the box, handing them a cassette. They looked at me a bit suspiciously, like, "Who is this guy? What does he want from us?" They looked down at the cassette, looked back at me. But they took it from me. Well, first they put the radio down on the sidewalk, took the cassette out of the box, put it into the thing, pressed play. And the first track was "Rock the Bells." "LL Cool J is hard as hell." So that was the first track. And then it went "LL Cool J is hard as, enh!" They kind of looked at each other, you know, "Battle anybody. I don't care if you enh! . . . enh!" Then one of the kids picked it up and put it on his shoulder. I mean, it took all his strength to get it up over his shoulder. And they just kind of walked away smiling. They didn't acknowledge me after that point, and it didn't even matter. These kids were so happy, and they just went off, walking down the street, blasting this thing in their ear. At that moment I knew, this record was going to be a monster.

— **George Drakoulias** (RECORD PRODUCER / SOUND TRACK SUPERVISOR)

"My Radio" was really famous because you've got to remember, that was LL's first song. Everybody wanted a boombox and it was all about "My Radio."

— **Pras** (HIP-HOP ARTIST / MUSICIAN / THE FUGEES)

My first boombox didn't play any tapes. It sat on the cover of LL Cool J's Radio. I bought the record at Apollo Records in Buffalo, New York, in 1985. Gary owned and ran Apollo. With his long, dyed-black hair and eyeliner, he looked like Siouxsie Sioux's beer-drinking, chicken wing-eating older brother. But he loved New York City hip-hop and stocked his store with every single new release. He made a handwritten and Xeroxed list of every record that had come out that week, in his order of importance, including a list of tapes of Marley Marl's WBLS radio shows that his friend from New York would regularly send him. I didn't chat with Gary much, but I went into his store and bought records every chance I got. While everyone else I knew was listening to the Grateful Dead, Tom Petty, Van Morrison, or the Clash, Gary introduced me to Spoonie Gee, Schoolly D, DJ Mark the 45 King, Wild Pitch Records, Marley Marl, Boogie Down Productions, Steinski, LL, and Run-DMC. I played "I Can't Live Without My Radio" over and over on my parent's turntable that I had absconded with into my room. The minimalist aesthetic and maximum impact of that song, and hip-hop in general with its time bomb-ticks and booming squeals, crept into my brain and never left.

— **Adam Levite** (MUSIC VIDEO DIRECTOR)

Grandmaster Flash developed this reputation as this amazing DJ. He had developed this technique of the cutting and the back-spinning. And his rappers had taken rap from a nursery rhyme thing to a really narrative form.

The buzz on them was amazing—on the real, real close to the street, under the concrete level. And I remember getting my first Flash tape, tape of a Flash party, and it was third or fourth generation bad dub—but there I had it. And it was, like, the Holy Grail.

—**Fab 5 Freddy** *(PIONEER GRAFFITI ARTIST)*

Rick Rubin's first record—when you do the research, you realize, oh, here's a guy who was into punk and he understood sound.

—**Ricky Flores** *(PHOTOJOURNALIST)*

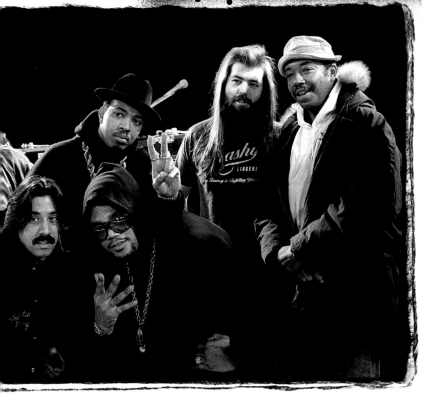

In the mid-'80s I kept a boombox for Rick Rubin at my place in Los Angeles at his request. He was just starting to roll large, so we went to Hollywood Blvd. to find the biggest, best one we could, then he could leave it in L.A. for when he visited. It was something we shared. To insure the covert nature of this box he had the idea to spray paint the entire surface area black. Aside from the LEDs, heavy amount of chrome, and tape mechanism, the entire thing was black. We were the only two people who knew how to use it because all identifying marks, labels, and functions were eradicated off its casing. It was the most bad-ass stealth box you ever saw.

—**Glen E. Friedman** *(PHOTOGRAPHER)*

The whole point of hip-hop at that time was definitely being loud, and against the grain, and mildly counterculture.

—**Kool Moe Dee** *(PIONEER HIP-HOP ARTIST)*

Punk had a lot of nihilistic, kind of semi-fascist over-tones . . . but the good part of it, like Don [Letts] always said, "Everyone had something to bring to the party." And if you had something to contribute, you could be a part of it.

—**Josh Cheuse** *(PHOTOGRAPHER / ART DIRECTOR)*

RIGHT TO LEFT: RUSSELL SIMMONS, RICK RUBIN, AND RUN-DMC, (C) 2000
EBET ROBERTS

Joe Strummer was my hero. I mean, I worked with the Clash and I was close enough to them that they didn't have to be heroes to me, but he still flew the flag for what punk meant to the day he died, without being self-conscious about it, without being opportunistic about it, without being all those things. I look back at what he did and what he said with the Clash. And even when they came to New York and they did the whole thing at the Bond's and "This Is Radio Clash." "This Is Radio Clash" used an illustrative boombox as its cover, as well, which was great.

—**Nick Egan** (ALBUM DESIGNER / ART DIRECTOR)

The Beatles and the Stones and Led Zeppelin—what were they diggin'? They're diggin' black music from the Mississippi Delta. But unless you're a train spotter, you'd never make the connection between Robert Johnson and Led Zeppelin, for instance . . . With the Clash I could hear reggae bass lines right out front; it wasn't disguised in the interpretation. And Joe Strummer would quite often sing about Jamaican artists and characters.

That was tremendously empowering for my generation—being first generation British-born black; black people coming of their own free will to a white country. When groups like the Clash or Slits or John Lydon's Public Image so organically embraced our culture and did something new with it, it empowered us because it made us realize that we had something to bring to the party.

— **Don Letts** (DJ / MUSICIAN / DIRECTOR)

When you went to England you had to stop by and see Don and get a new tape. That was more important than whatever your favorite restaurant or drink or whatever else you planned to do in London—Don Letts was, because he had his finger on all the new Jamaican music.

— **Bob Gruen** (ROCK 'N' ROLL PHOTOGRAPHER)

Big Audio Dynamite was that cross between all musics—punk, ska, reggae, hip-hop—the boombox was celebrated within their artwork.

—**Earle Sebastian** (DIRECTOR)

Big Audio Dynamite—and the Clash did it as well—after you finished listening to it on the big studio speakers, you'd put it on the boombox and ultimately that was the acid test, how it sounded on the boombox—not how it sounded on the twenty-grand speakers the studio had. You were much more concerned about how it sounded on a boombox.

—**Don Letts** (DJ / MUSICIAN / DIRECTOR)

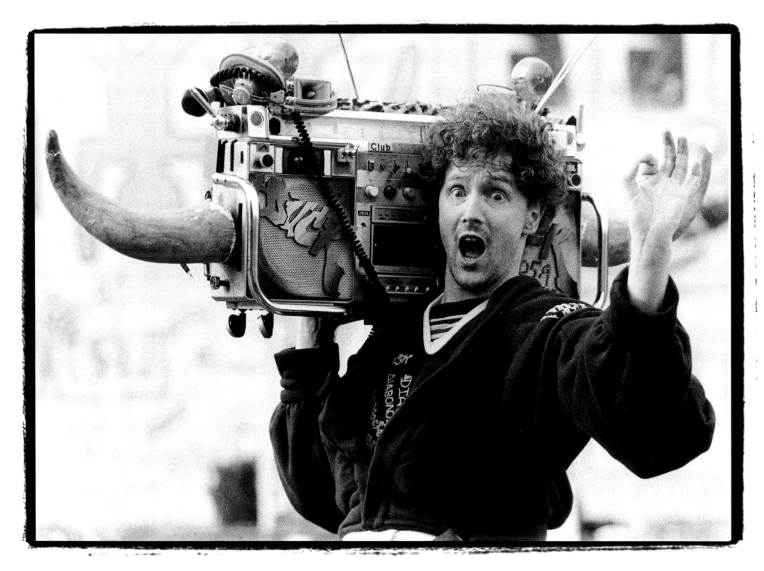

[*Regarding the Duck Rock Boombox*] When Malcolm
was with the Zulu tribes in South Africa. They
honestly thought this was like some kind of
god he'd brought with him.

—**Nick Egan** (ALBUM DESIGNER / ART DIRECTOR)

In the beginning, hip-hop was about that rockin'-ass beat that was just monotonous,
and it was infectious, and it was hypnotic. I remember listening to the World Famous
Supreme Team album. I think that was the first rap complete album that I ever bought.
And it was *Duck Rock*. Everybody who has a boombox or loves boomboxes remembers the
Duck Rock cover because it was a huge radio with the horns and the rearview mirror, and
it had, like, a million antennas hanging off of it, and these little, like, rainbow-
colored graffiti plates on the speakers. It was the hardest boombox ever used on a rap
record ever. I don't even have anything to compare it to. I've never even seen a radio
in person that could touch what the cover of *Duck Rock* had.

A lot of times when we talk about, you know, different urban cultures or different
primitive cultures, we talk about signs and symbols that convey to the masses what words
can't. That boombox said everything that it needed to say. And I remember seeing that
cover and you knew—you didn't know what was on that record, but you knew that record
was for you. Then when you flip it over and you see those Zulu kids sitting around the
radio—for a suburban kid completely disconnected from Africa in his daily life, and
black being beautiful in the home, but then stepping out of your suburban home to be
called a "nigger" on the street, that album cover, especially the back side of it, I
felt like I was immediately reconnected to my homeland off that there. Immediately.

— **Adisa Banjoko** (HIP-HOP HISTORIAN)

MALCOLM MCLAREN, 1989
BOB GRUEN

FAST
FORWARD
▶▶

4. FAST FORWARD ▶▶ We've seen the era of the boombox rise up from the stone age of modern day broadcasting only to slide back in the tar pits of D-cell-battery-powered history. ▶▶ But before the boombox is relegated to the time of the dinosaurs forever or completely wiped off the planet by an off-course comet, it's best to look at the impact boomboxes have made on society. ▶▶ Living in New York City, it's hard not to miss them. ▶▶ They still peek out of store windows printed on to T-shirts, handbags, or CD covers. ▶▶ Look at recent music videos and you'll see them held aloft by the latest bands who were probably in diapers when boomboxes truly ruled the earth. ▶▶ Boomboxes are an important part of our culture as they still signify a certain sense of rebellion, free speech, toughness, and attitude. ▶▶ They also make us smile and remember a time of ingenuity and innocence. *LO*

FAST FORWARD

The mechanism that starts the transport on a boombox to control the acceleration of the operating speed on the tape deck is called the fast forward button. This button increases the rotation of the motor drive to the capstan shaft, which in turn raises the speed of the tape tracking mechanism to provide a hunting feature along the cassette sequence. All this technical jargon means simply "Press the fast forward button and you can search along the recorded parts of a cassette tape to find where you want to listen." A very rudimentary feature when it comes to cassettes, but one that mixes personal choice and control over what you want to experience at that moment. Fast forwarding to the future of boomboxes means we've arrived to the place where they are not so prevalent in our daily lives. Though the memory of them still lingers, they've been replaced with a multitude of media devices and sonic alternatives. Knowing there is a tremendous amount of nostalgia for boomboxes, it's interesting to discuss the impression that the boombox has left on society, as well as the music and motivations of that era. *LO*

For me, the boombox died with the advent of CDs. That's when the shape of the machines physically changed to become sort of flat and more squat and look like rejects from R2-D2 or something.
— **Don Letts** *(DJ / MUSICIAN / DIRECTOR)*

In 1993-94, my generation all wore our hair in afros, but we'll never really understand why our parents wore afros in the '60s. It had a whole different meaning. With us, it was just kind of a fashion thing. But to our parents, at that time, that was the end of the civil rights situation and it was going into, like, a more radical thing . . .

Every generation is guilty of that to a certain extent. Everything goes in cycles, so if you take a look around nowadays, everything from that boombox era is coming back. Now once again it's about capitalism, cocaine is again the popular drug . . . And a lot of people who weren't even born then are kind of advertising those years. But when things come around a second time, they're always altered, and now people are kind of putting a new spin on it. I heard now that they have a boombox that actually has an iPod in it instead of a cassette. Elements of things in the past always come back, and a lot of that eighties imagery, good and bad, is starting to come back in different combinations.
— **J-Zone** *(HIP-HOP ARTIST)*

The boombox was a public sort of thing that people gathered around . . . now, with rise of the MP3 players, it's a sort of cocooning—individuals screening out potential interaction in public places by using portable individual radios, or now MP3 players. And I think it's not just a matter of people wanting to have their music available all the time, but actually advertising their unavailability for social interaction . . . perhaps it reflects the kind of hyperindividualism that our consumerist society generates. Social interaction, particularly with strangers, we perceive as being risky. And mainly because the media have created a culture of fear. And so this cocooning gives us a protection from it by telling people, "Don't talk to me."
— **Tyler Gibney** *(ARTIST)*

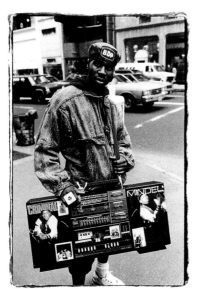

ROCKEFEELER CENTER, NEW YORK CITY, (C) 1980s
BEN WATTS

Not a lot of people have the balls right now to go and pick up a boombox, put a mix tape together, and cruise around listening to something they really believe in—because it's the fear of offending or the fear of being apart or the fear of standing out.

— **Josh Cheuse** (PHOTOGRAPHER / ART DIRECTOR)

The boomboxes that I remember being so impressed by as a kid, you can't find them anywhere. You can find them on collectors' sites, you know, guys that are showing off what they have and whatnot, but to actually get one? Very difficult . . .

The music of today, what kids are listening to, it's making them very aggressive; it's making them very agitated; in a sense it's programming them for destruction. KRS and Grandmaster Flash, they were saying things. But when it started to change, people started to change. Now I hear a lot of music is about "get money, get money." It's like, come on, what about the war? What about poverty, things of that nature—the stuff Marvin and Curtis Mayfield, and others addressed in their music.

— **Jamel Shabazz** (PHOTO DOCUMENTARIAN)

The boombox went away when the trains started getting buffed. And to me, it's like the audio equivalent of graffiti. The average citizen in New York City probably did not like to see young guys walking around blasting hip-hop on boomboxes, in the same way they didn't want to see graffiti all over their trains. I loved to stand at the front of the train or the back and watch the tracks, and then see all the graffiti in the tunnels, see the graffiti on the trains, the tags inside. You know, for a young kid, it was amazing just to sit and read these tags and try to figure out what they were saying, you know, when you're like four and five years old. And the same thing with the boombox. I mean, I loved just looking at them, listening to them. They were these amazingly sexy pieces of machinery.

— **Stretch Armstrong** (DJ / RADIO HOST)

There are some radios now that are out that are kind of like the boombox. I have one—it's called the Xplod by Sony. It has the power drive woofer, and the cassette / CD player. But a lot of modern radios today look like spaceships. I wish a manufacturer could do one run of a collector's-item boombox.

— **Rahzel** (HUMAN BEATBOX / THE ROOTS)

The power you felt walking through the neighborhood and blasting something, a song that just meant so much to you, a song that you could relate to, a song that you wanted other people to hear, that was just the greatest feeling in the world, just walking down that street blasting that music. I think that's kind of like the same concept I apply to deejaying now. I love being able to expose people to new music.

— **DJ Eclipse** (DJ)

Back then all you needed was a beatbox and a guitar.

— **Bob Gruen** (ROCK 'N' ROLL PHOTOGRAPHER)

The boombox was my only way of hearing anything to do with hip-hop—and the boombox was what romaticized it. The reason you loved it is because it was loud and it was against the grain of anything you were hearing.

— **Kool Moe Dee** (PIONEER HIP-HOP ARTIST)

The boombox was a very new development for people and carried the tradition of music being a social medium and bringing people together, more so than any other piece of technology has. It's interesting to see how from that we go, twenty years later, to where we are now, where music is now mobile but private again. Everybody has on an iPod and has on headphones and they're locked again into their own world much like they were when they were sitting in their homes listening to an LP.

But I find that with a lot of younger kids in their twenties, they have a sort of instant gravitational pull to a lot of this early stuff that there's almost no context for in their lives if you were to sort of look at it just at face value . . . or as an icon.

Che Guevara is a sort of perfect analogy. Most of the people who are wearing these images [of Che] are not necessarily revolutionary. Some of these people who are wearing boomboxes on a shirt more than likely were too young to grow up with these things and are obviously not walking around with one today. But the boombox is an icon because it speaks to a certain time and place and social group that younger kids clearly identify with. Wearing that on your T-shirt as a form of self expression—which the T-shirt has certainly become—ties you in to that.

We need to pass it on properly. We can't expect Lil' Wayne to talk about the South Bronx. Is that realistic? Is it fair? How can you bash some of these Bay Area kids because they don't know anything about some of these old-school DJs, like Charlie Chase and Whatnot, when no one's given them access to it? But somehow they're still replicating exactly what they do. They're still throwing their own jams in the park. They're still hooking up boomboxes to turntables to throw their own parties in a parking lot. They're still doing it. Somehow it still got transferred. Maybe not exactly the way we wanted it, but they're doing it for their generation, their way.

— **Adisa Banjoko** (HIP-HOP HISTORIAN)

And there's a yearning for these older sounds which, ironically, become new sounds because they've never been heard before—things that didn't necessarily sell very well twenty or thirty years ago when they came out and were in the cutout bin and being sold for fifty cents. You know, these same records now could be worth hundreds of dollars because now they've gained a new audience . . . it's gratifying to know that in due time everything has its place, almost.

It gives me hope for music being made today. Some of it isn't necessarily of the highest quality and that's because of what's being pushed at us, just as it was twenty or thirty years ago. Now we see a lot of this music from the past popping back up and realize, "Wow, this is great. How come this didn't get popular?" It's the same way right now. I mean, you really have to be looking for it. And if you don't catch it this time around, you may have to wait until the time is right and you're ready and the rest of culture at large. And it has a whole new audience and new ears and a fresh perspective.

— **Andre Torres** (EDITOR, WAX POETICS)

When we had the blackout here in New York, I had a small boombox, and I had batteries. And I remember that night in my court when everyone else was just sitting outside, I had sound because I had my boombox and my batteries.

— **Joseph Abajian** (PRESIDENT, FAT BEATS INC.)

The boombox has a larger visual impact than it does audio. I mean, you can crank it. And you crank the right music, everyone loves it. But once you start trying to crank it higher—and those batteries are expensive, and it's heavy. But the visual impact is unbeatable. If I'm going for sound, a lot of people that I know had portable sound systems. They'd have a car battery with a single speaker, with a little deck or whatever up on the top, and then you'd have it on a little trolley and stuff. Soundwise, it eliminates any boombox. But the boombox is such a strong visual icon.

— **Ben Watts** (PHOTOGRAPHER)

The boombox was this great social tool. And we could probably do with that again at some time in the near future . . . it was much more of a sharing of music . . . even when you're annoying you're still, you know, you're sharing [LAUGHS] —even if you were blasting it too loud.
— **Jonathan Daniel** (MUSIC HISTORIAN / BAND MANAGER)

A subculture always does a 360 eventually and reappears somewhere else. For the generation below us that didn't grow up in that culture and missed out on something—they still want to embrace it as part of their own identity. The boombox has become a visual sample—and if you missed it, this is a second time around to be a part of it.
— **Earle Sebastian** (DIRECTOR)

They're making boomboxes again now——Lasonic is making them with iPod attachments because they are so quintessentially a representation of a generation.
— **Claw Money** (GRAFFITI ARTIST / FASHION DESIGNER)

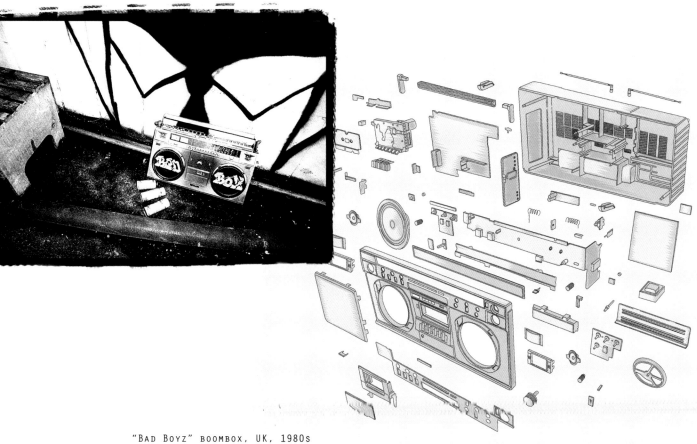

"Bad Boyz" boombox, UK, 1980s
Normski

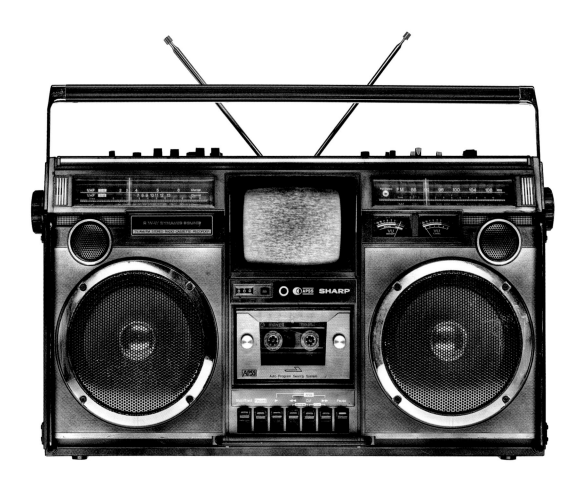

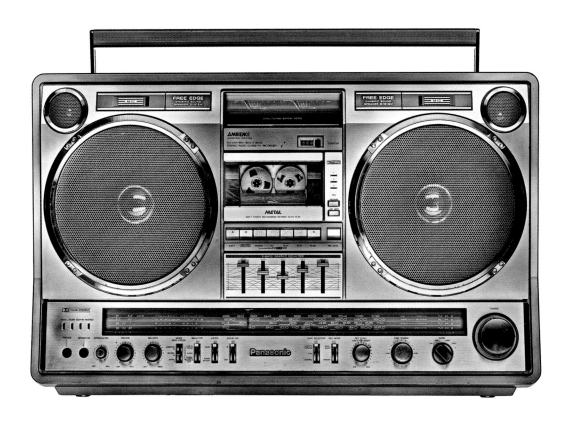

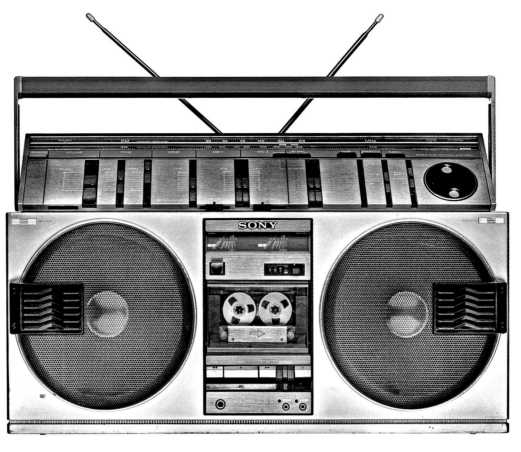

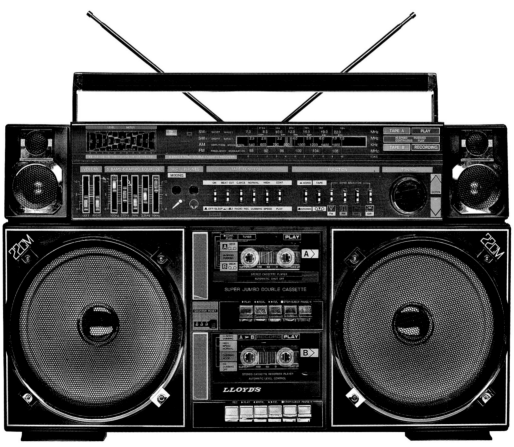

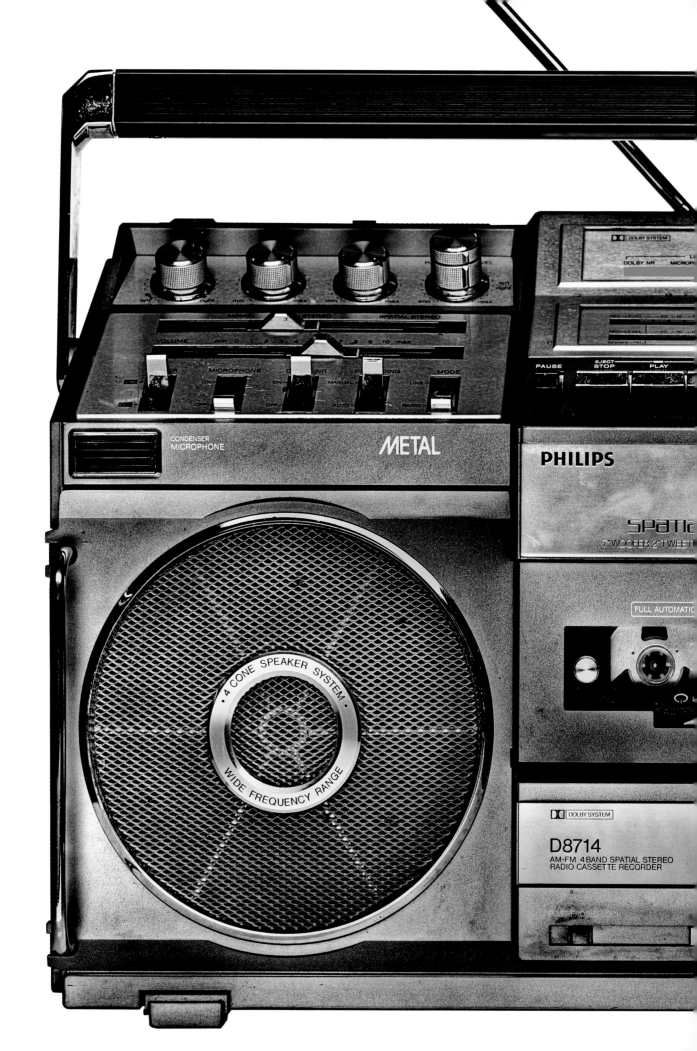

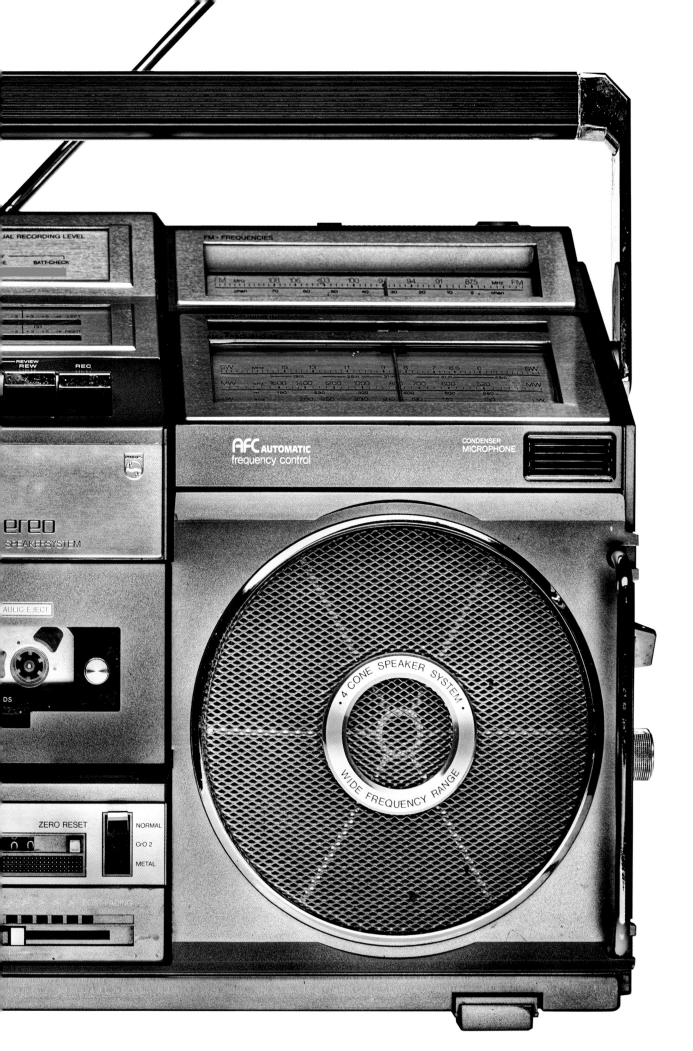

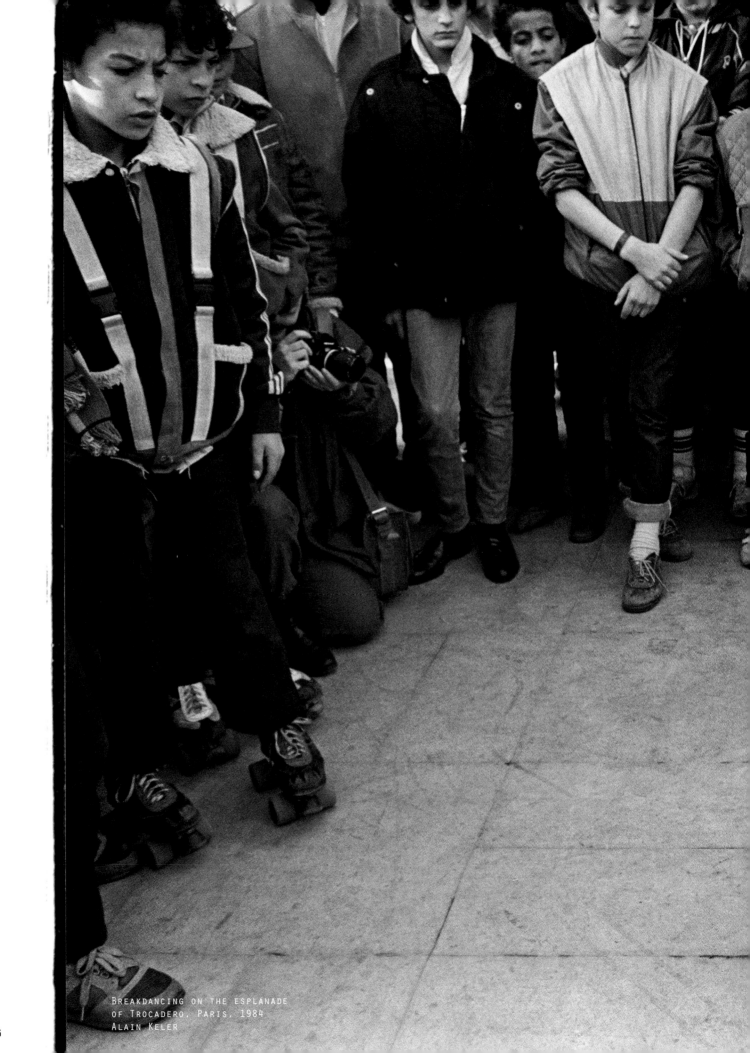

BREAKDANCING ON THE ESPLANADE
OF TROCADERO, PARIS, 1984
ALAIN KELER

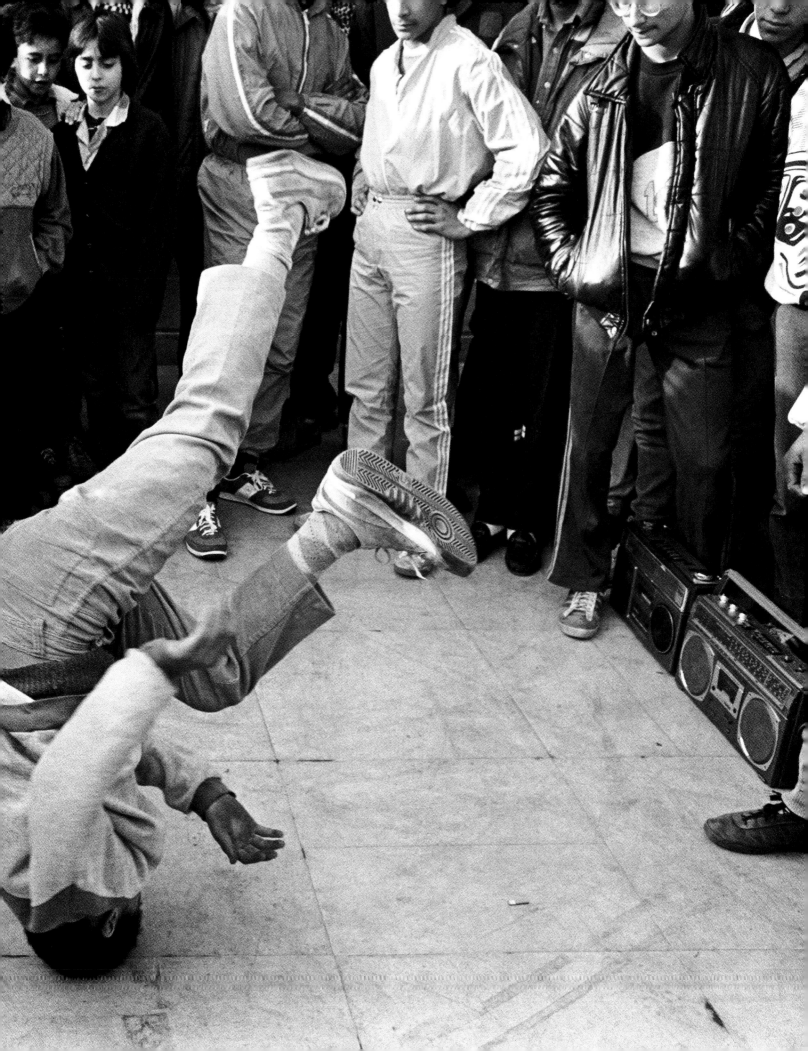

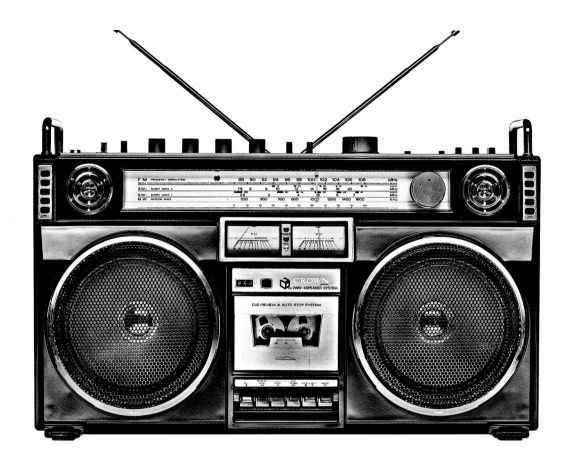

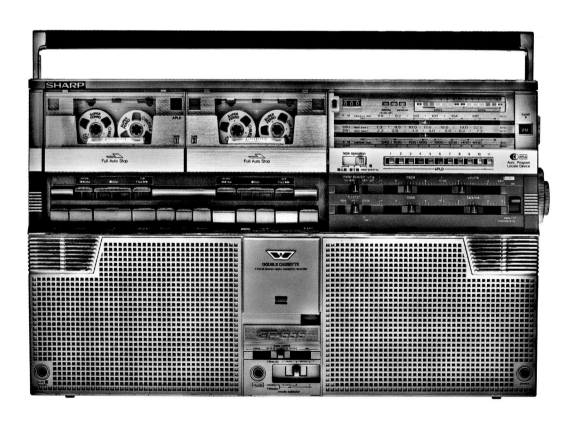

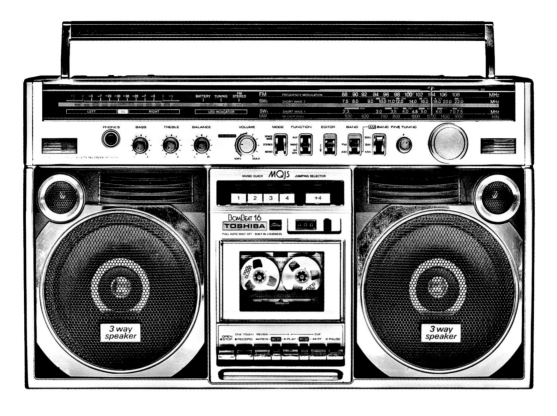

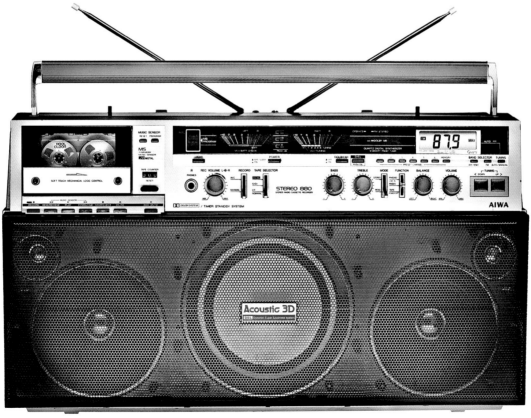

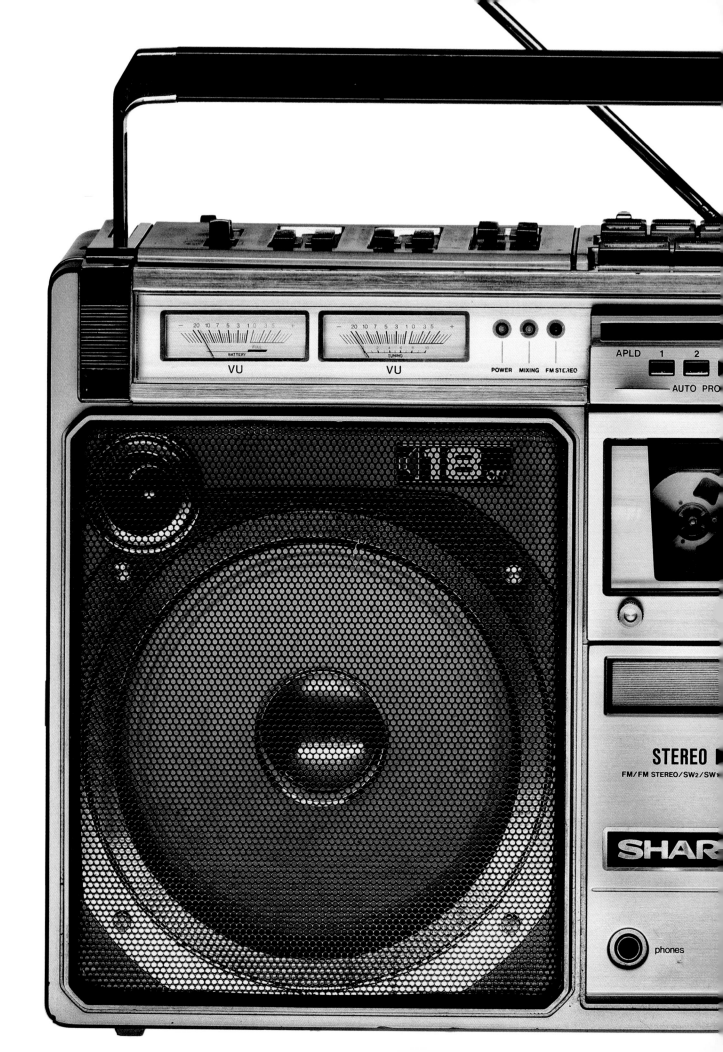

VU VU POWER MIXING FM STEREO APLD 1 2

AUTO PRO

STEREO

FM/FM STEREO/SW2/SW1

SHARP

phones

FM	frequency modulation			88	92	96	100	104	108	MHz
SW2 METER	short wave		7.3	8.5	10.0 31m	12.0 25m	15.0 19m	19.0 16m	22.0 13m	MHz m
SW1 METER	short wave	2.3	2.6 120m		3.2 90m	4.0 75m	5.0 60m	6.0 49m	7.3 41m	MHz m
AM	amplitude modulation			540	600	700 800	1000	1200	1400 1600	kHz

5 6 7

TE DEVICE

C SOUND

SSETTE TAPE RECORDER

F-9494

22w

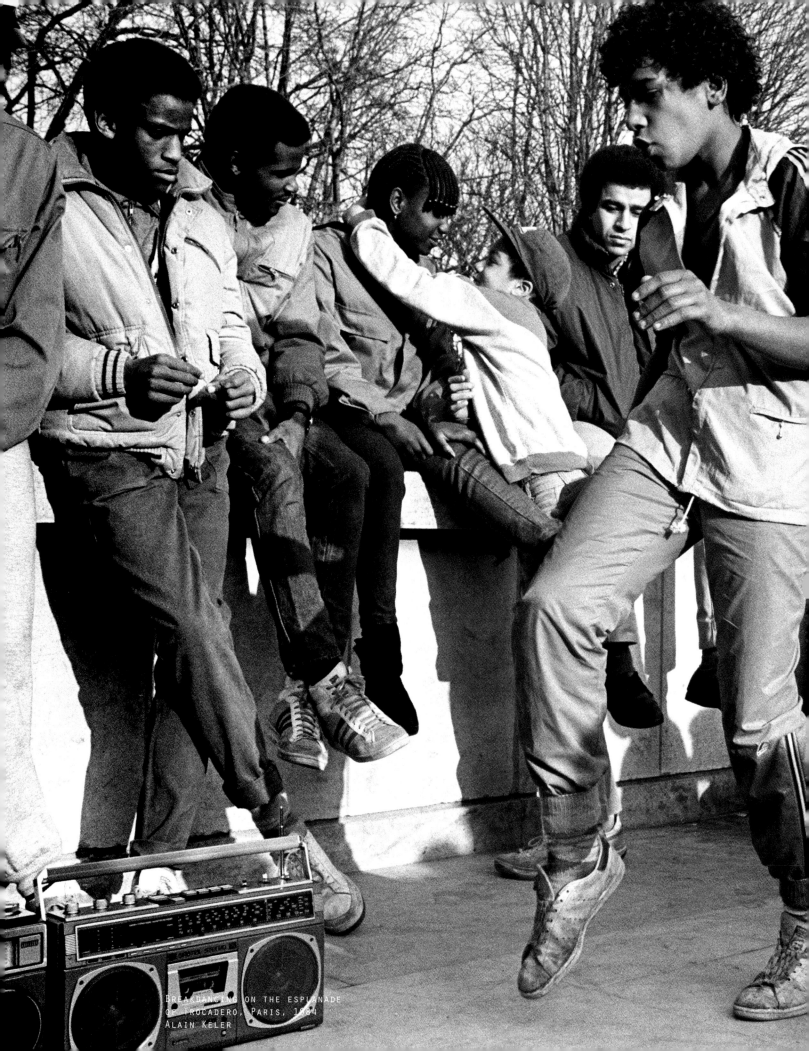

Breakdancing on the esplanade
of Trocadero, Paris, 1984
Alain Keler

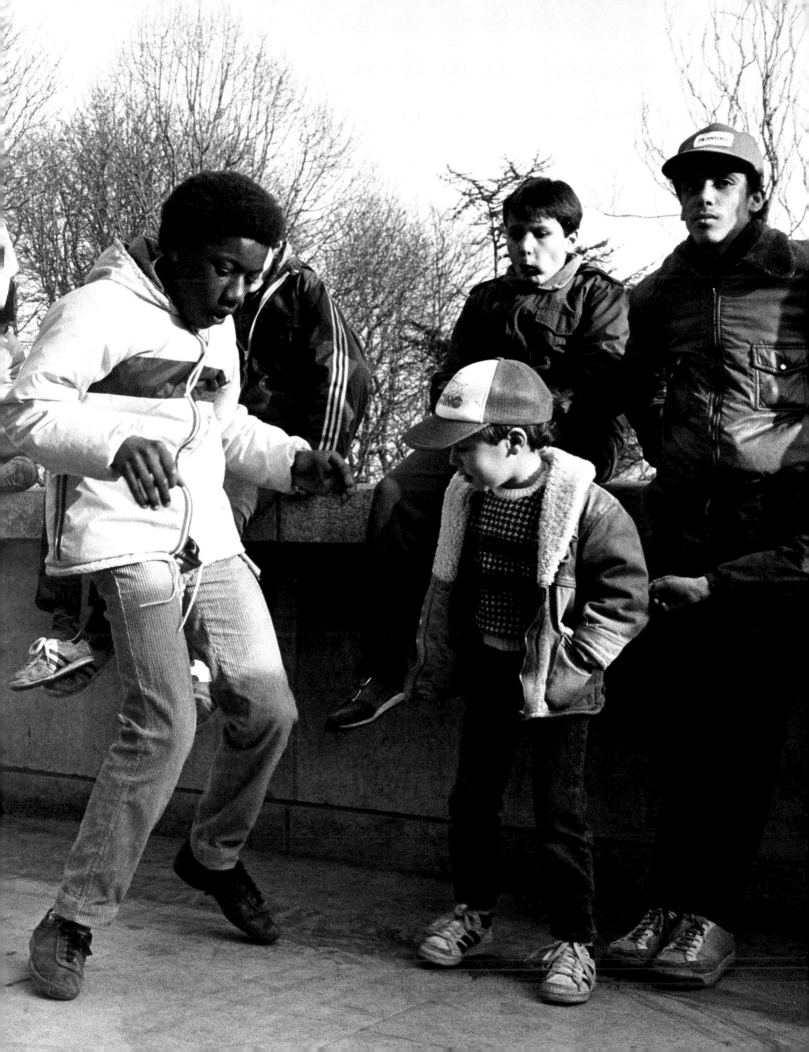

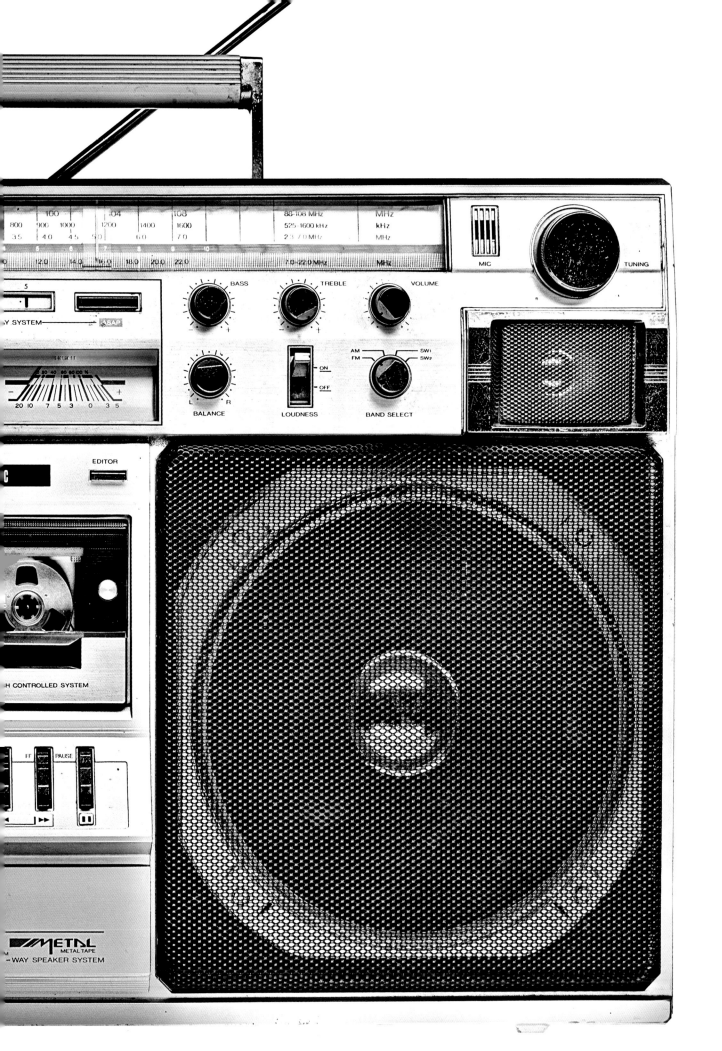

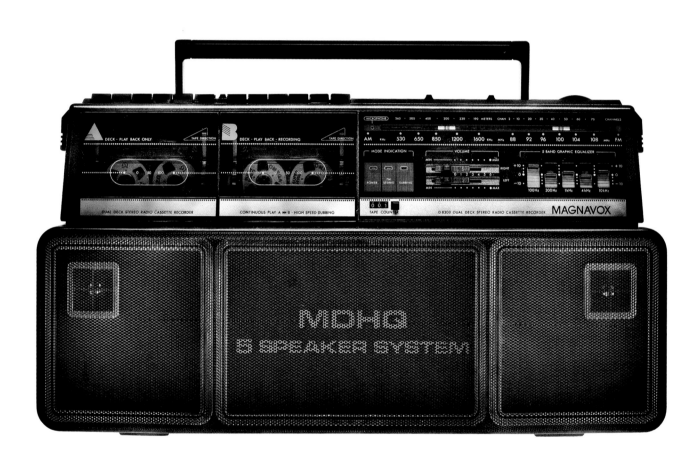

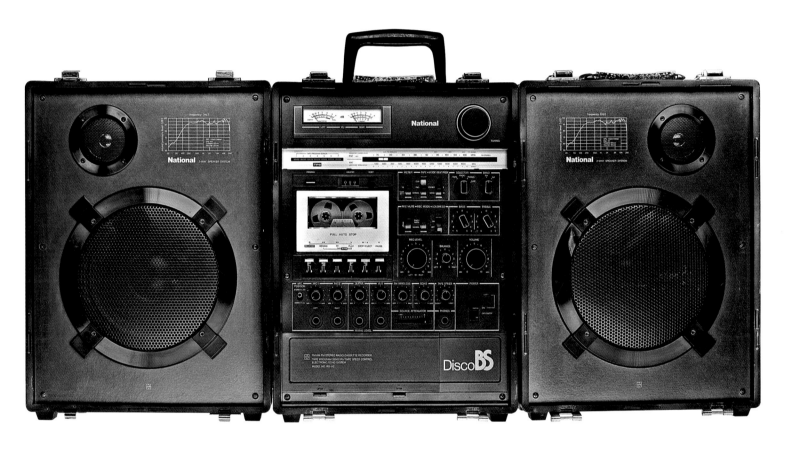

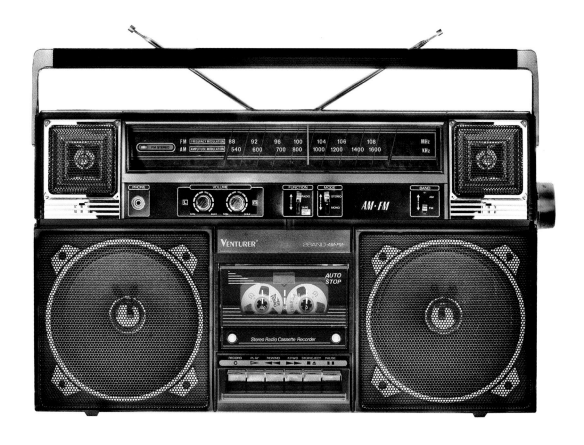

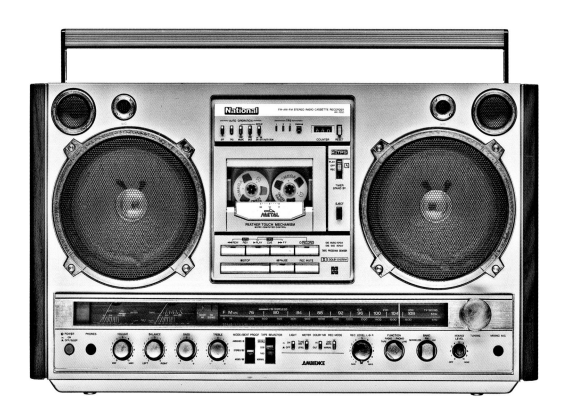

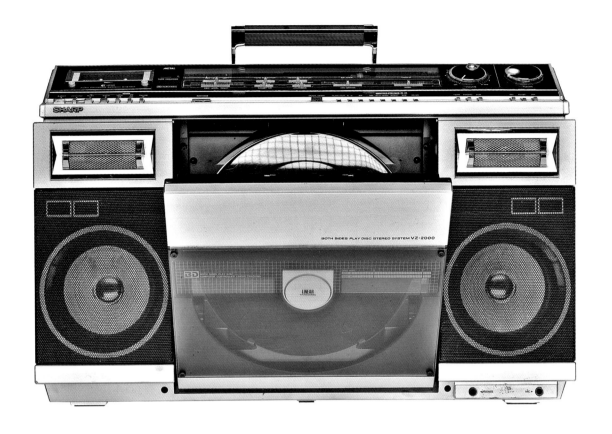

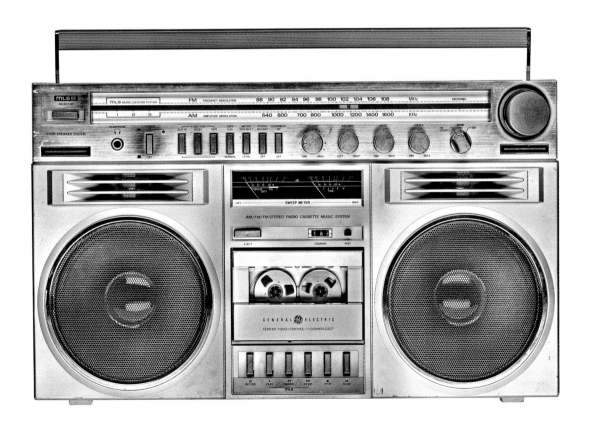

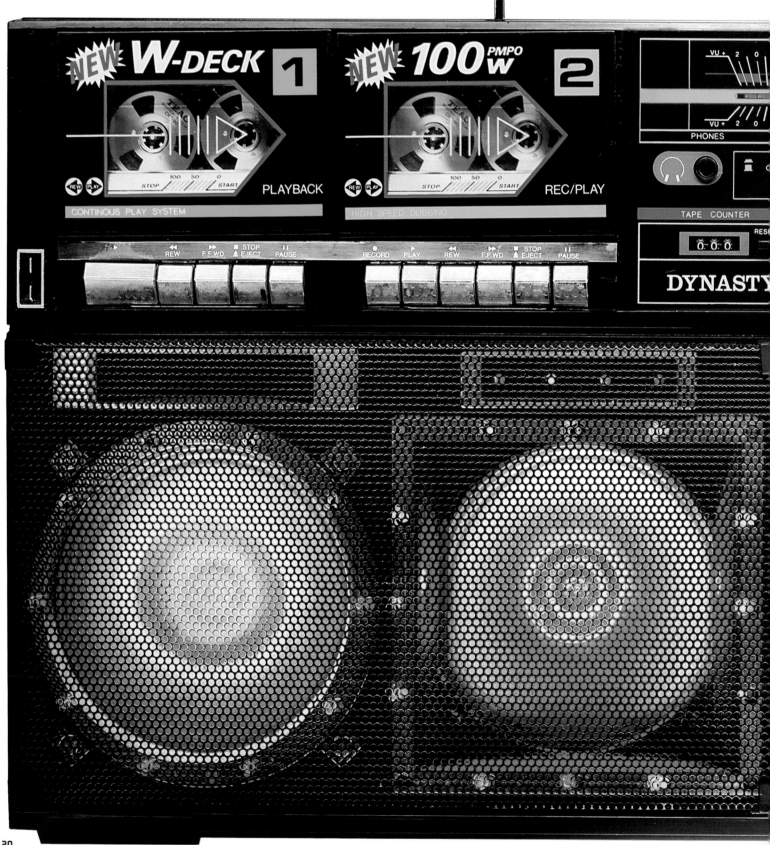

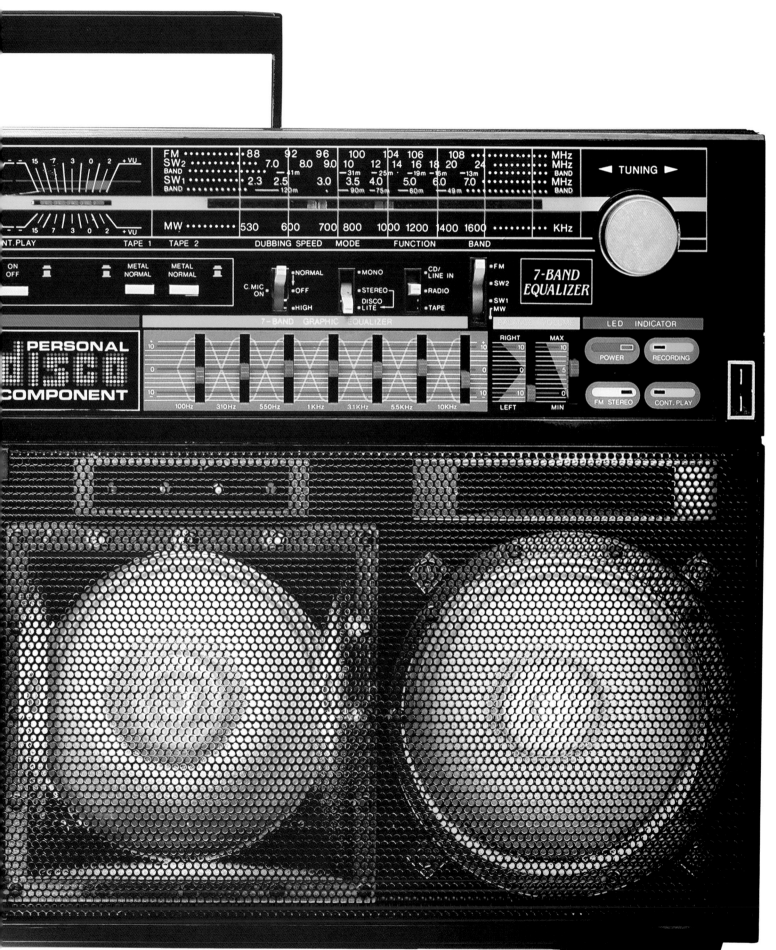

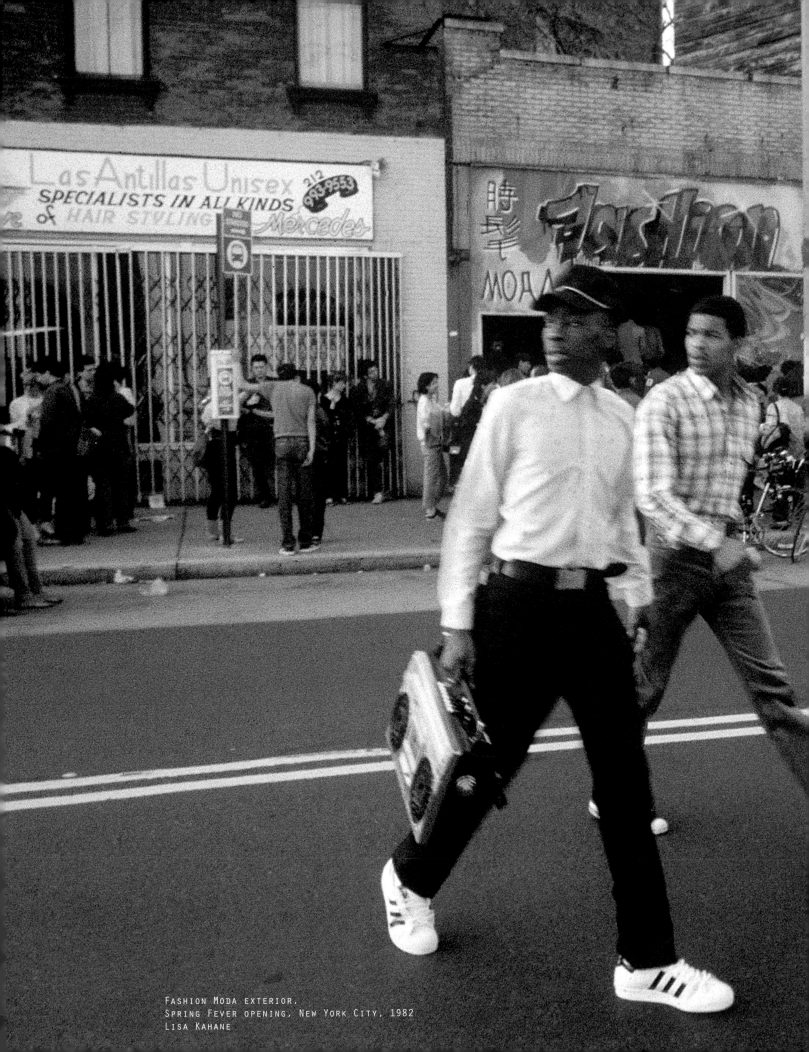

Fashion Moda exterior,
Spring Fever opening, New York City, 1982
Lisa Kahane

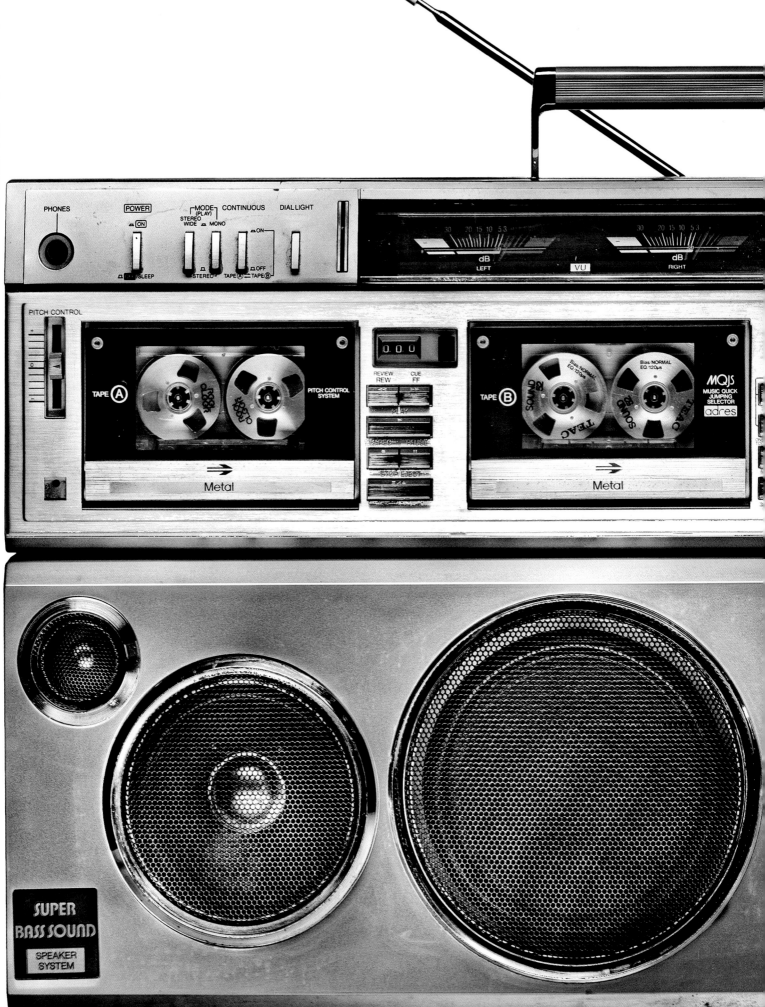

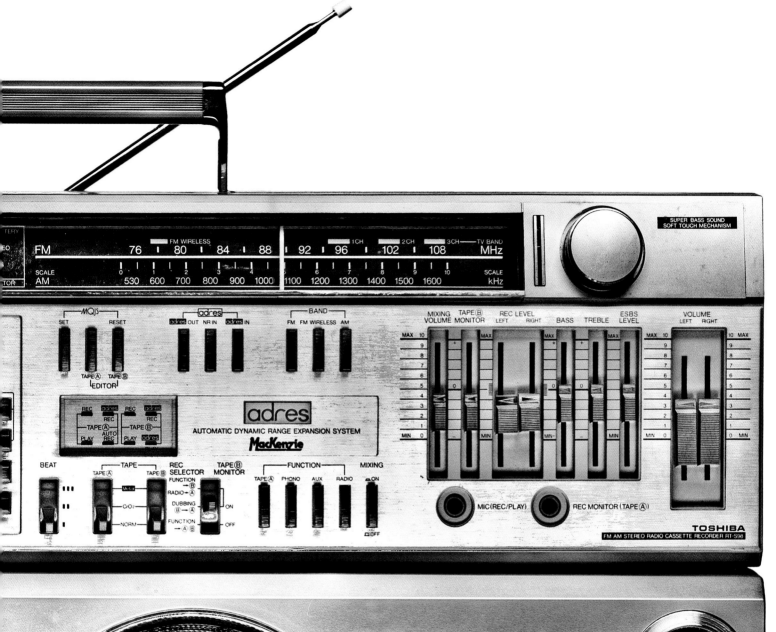

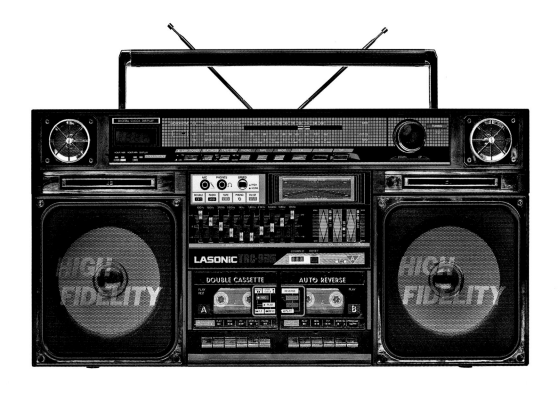

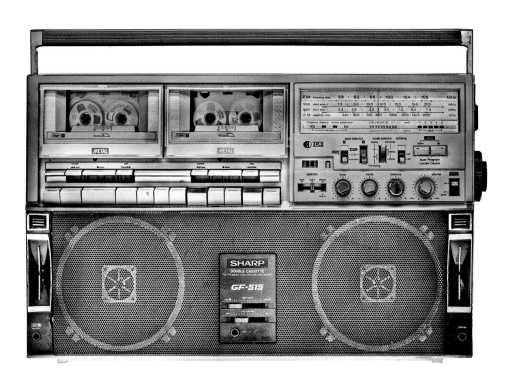

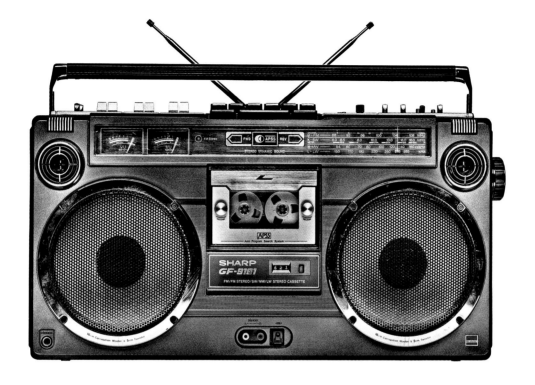

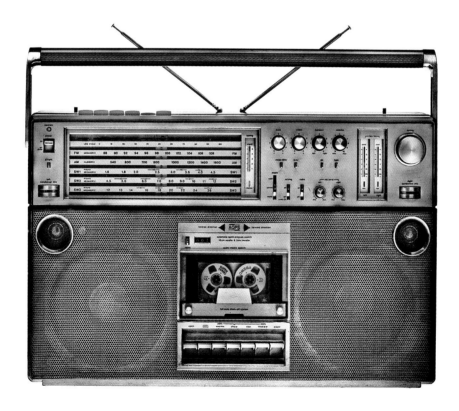

18.5　19　20　21　22　23　24　25　2　MHz
12.0　13.0　14.0　15.0　16.0　17.0　18　18.5　MHz
4.5　5.0　6.0　7.0　8.0　9.0　10.0　11.0　MHz
1.8　2.0　2.5　3.0　3.5　0　4.3　MHz
600　700　800　1000　1200　140　1600　kHz
90　92　94　96　98　100　102　104　106　108　MHz

ER PROGRAM

FM STEREO

5　6　7　8　▶▶
13　14　15　16　REW

MIC

OP

ETTE RECORDER

129

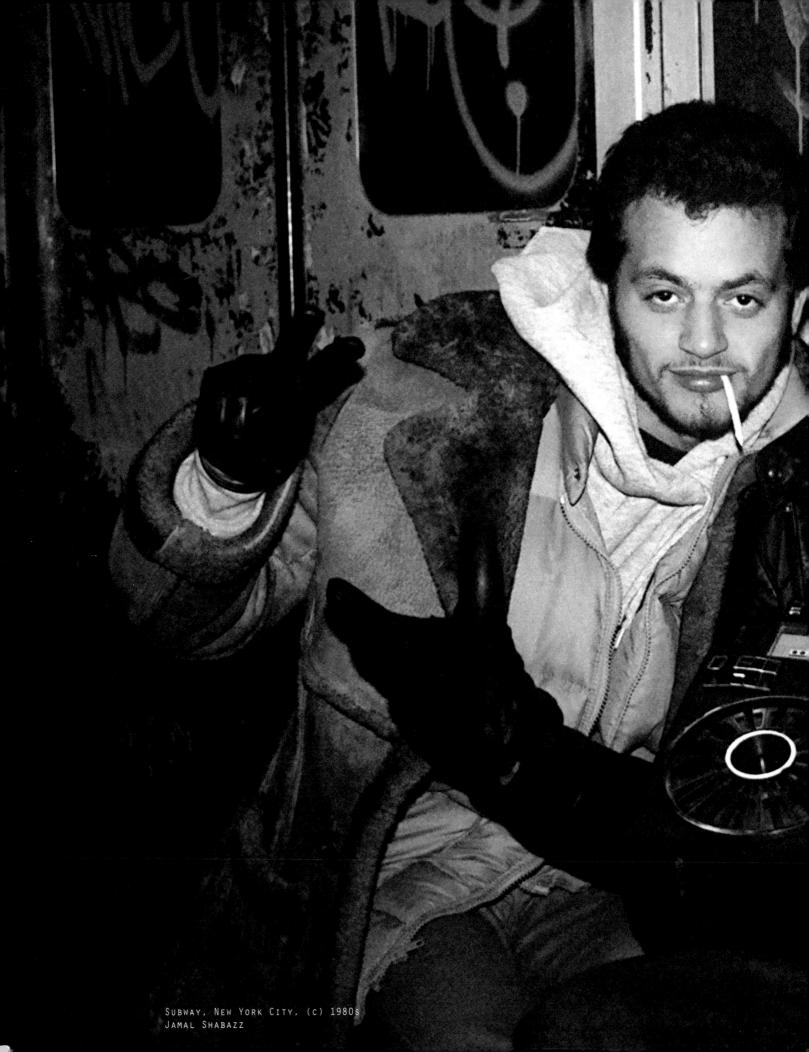

SUBWAY, NEW YORK CITY, (c) 1980s
JAMAL SHABAZZ

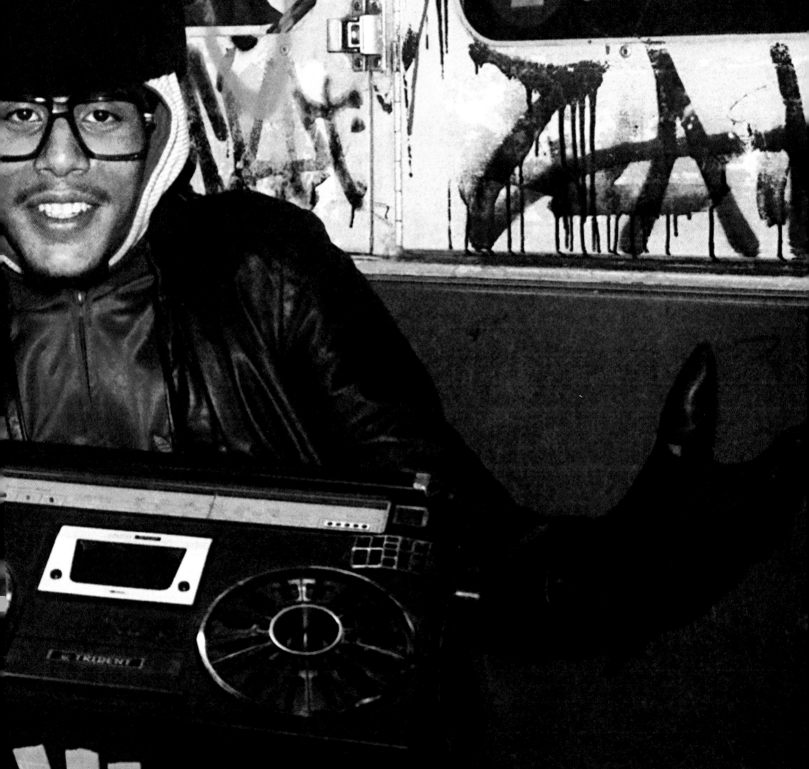

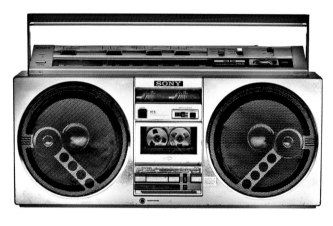

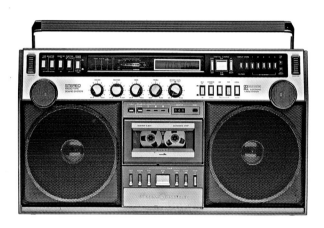

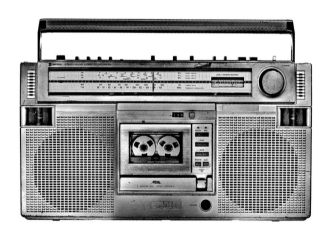

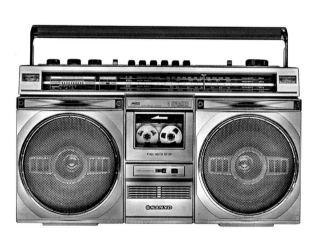

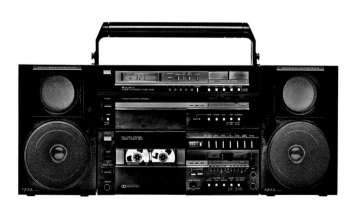

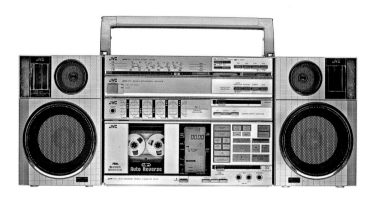

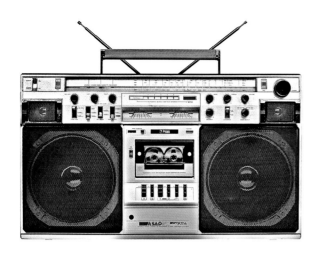
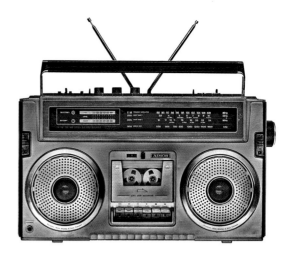
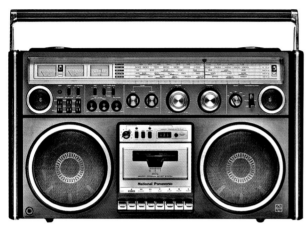
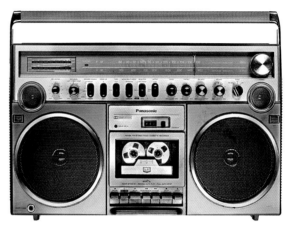
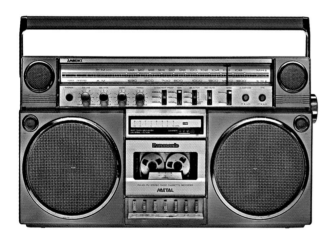
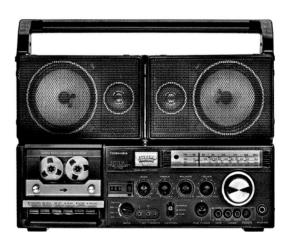
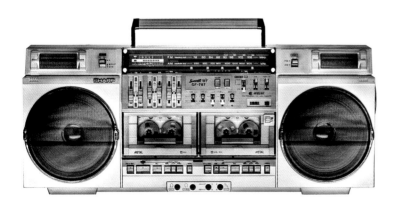
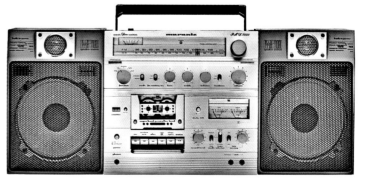

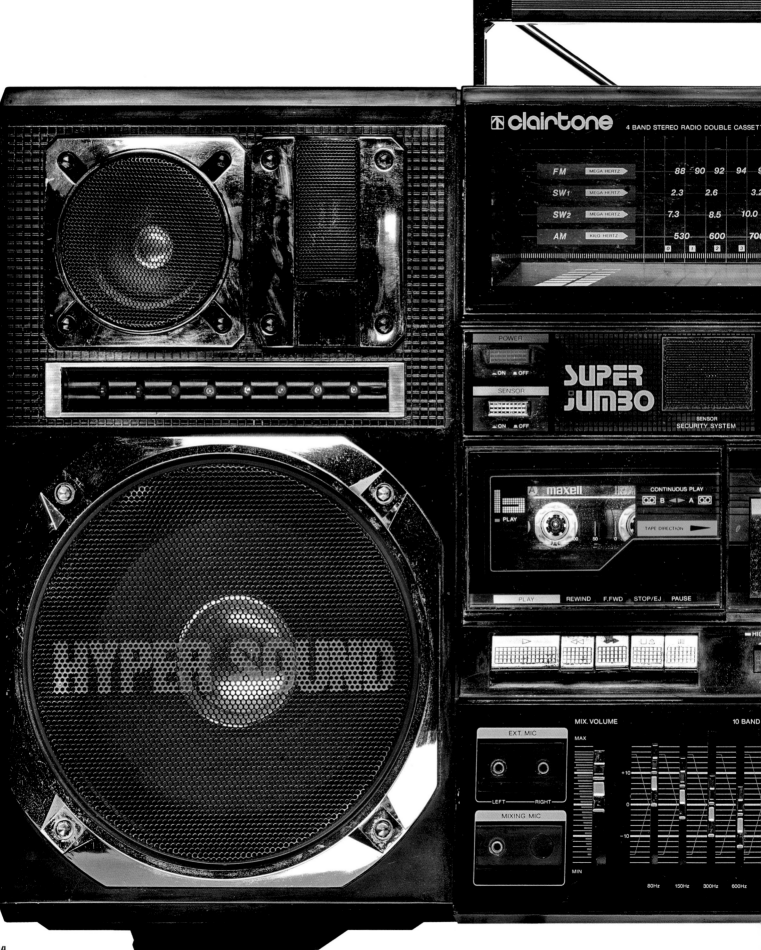

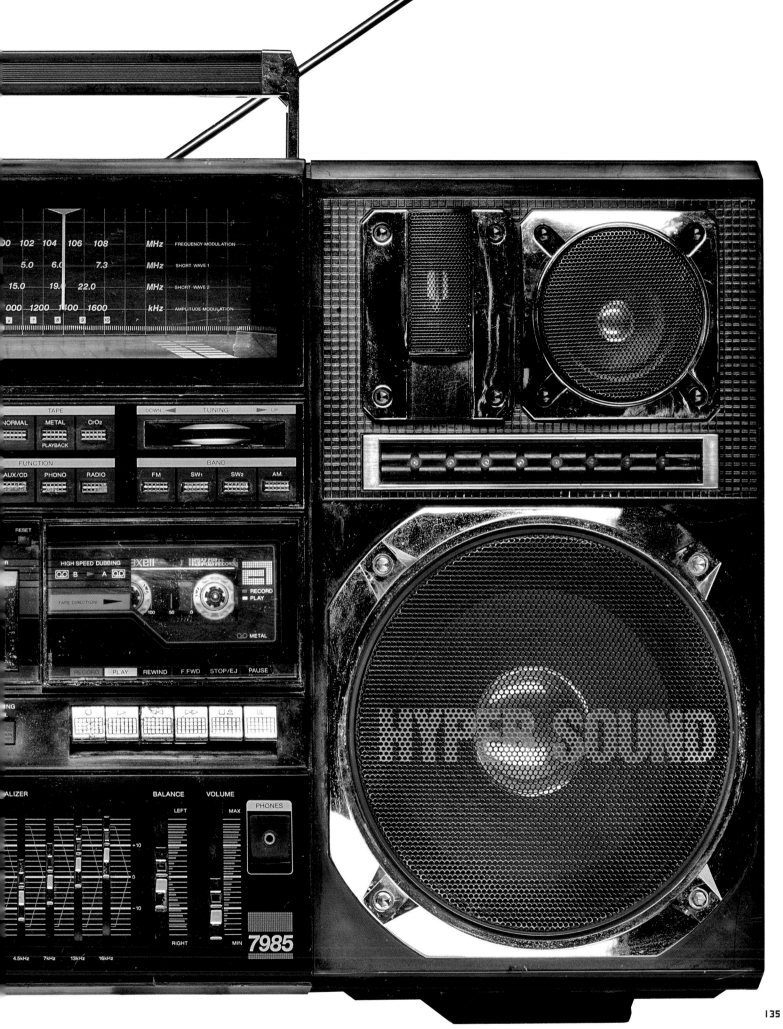

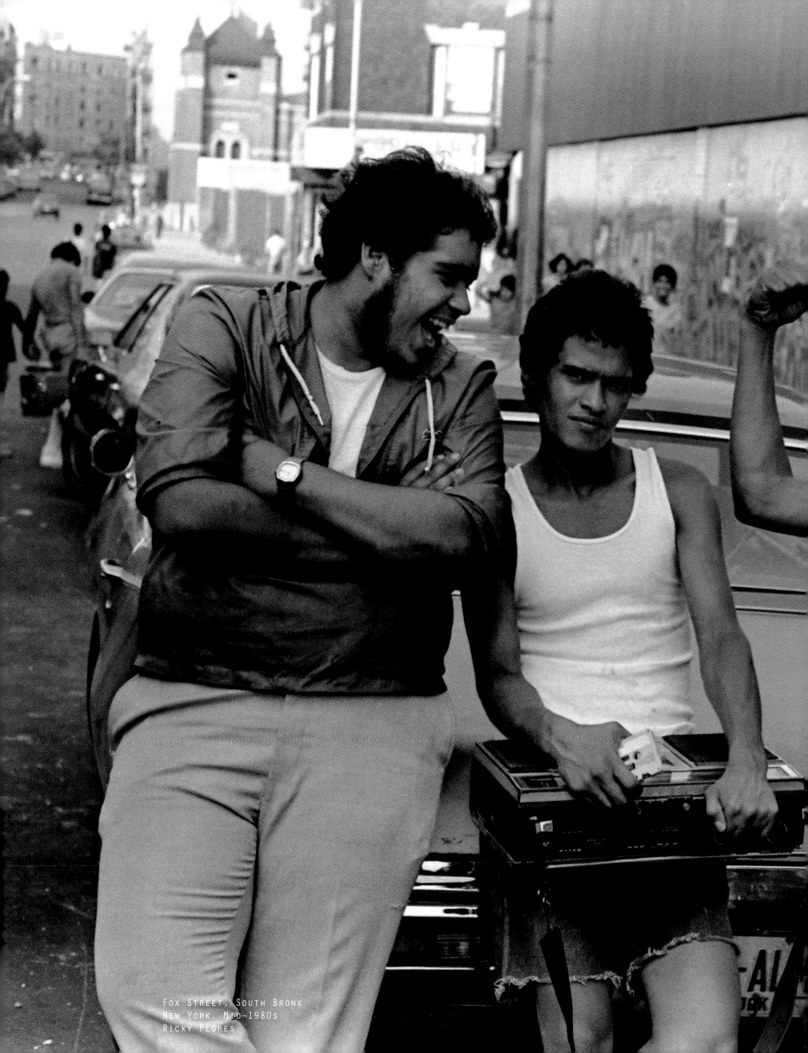

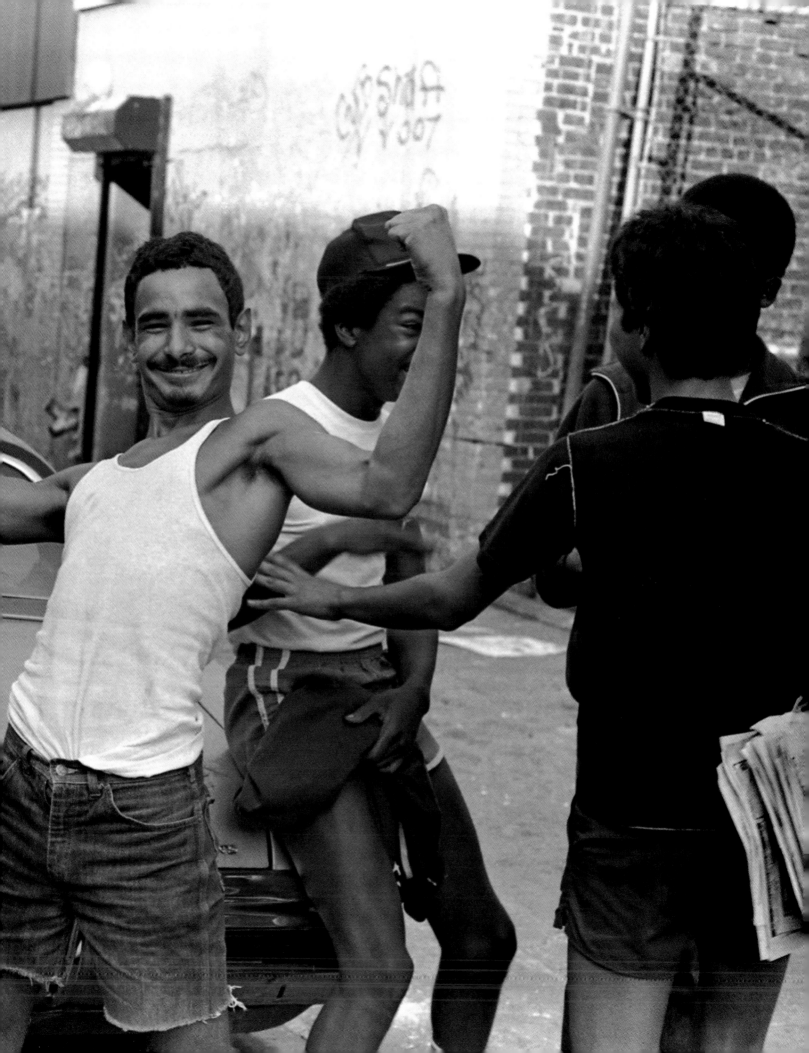

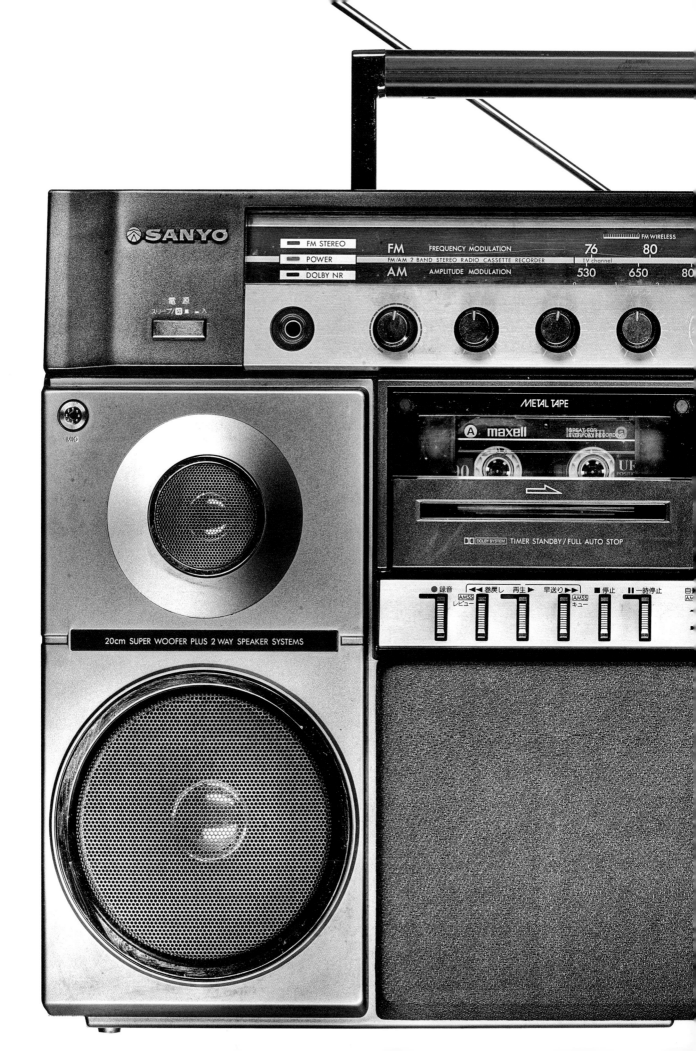

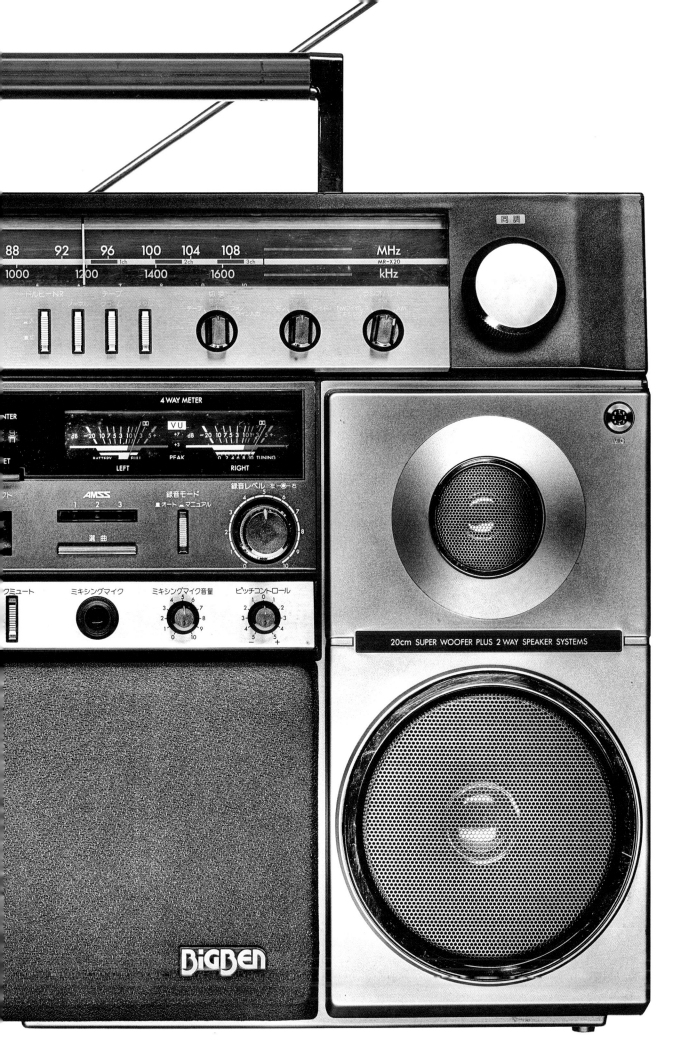

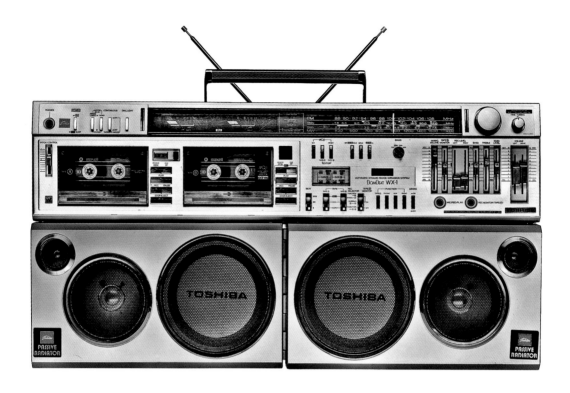

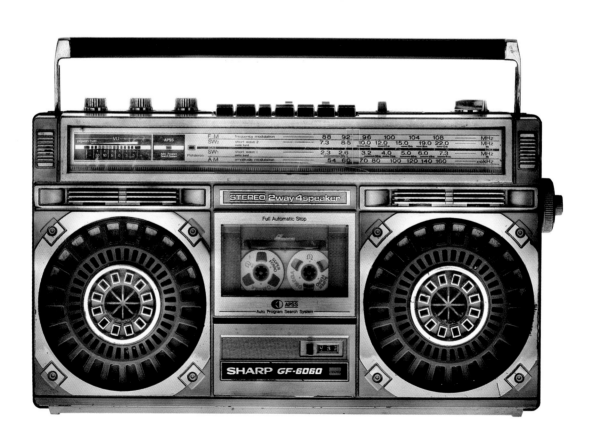

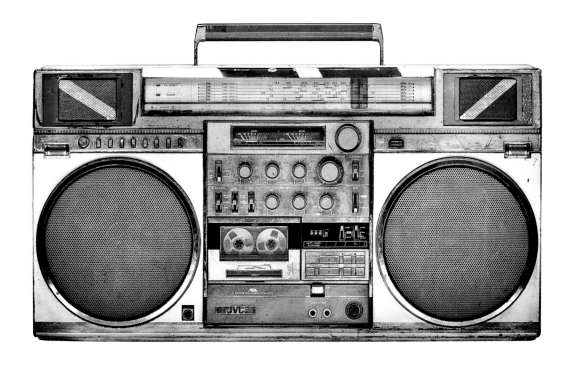

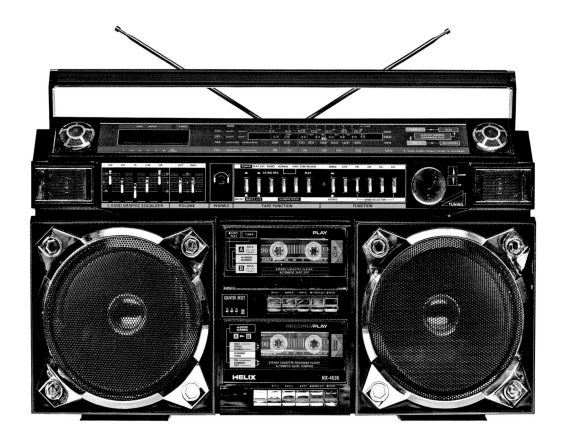

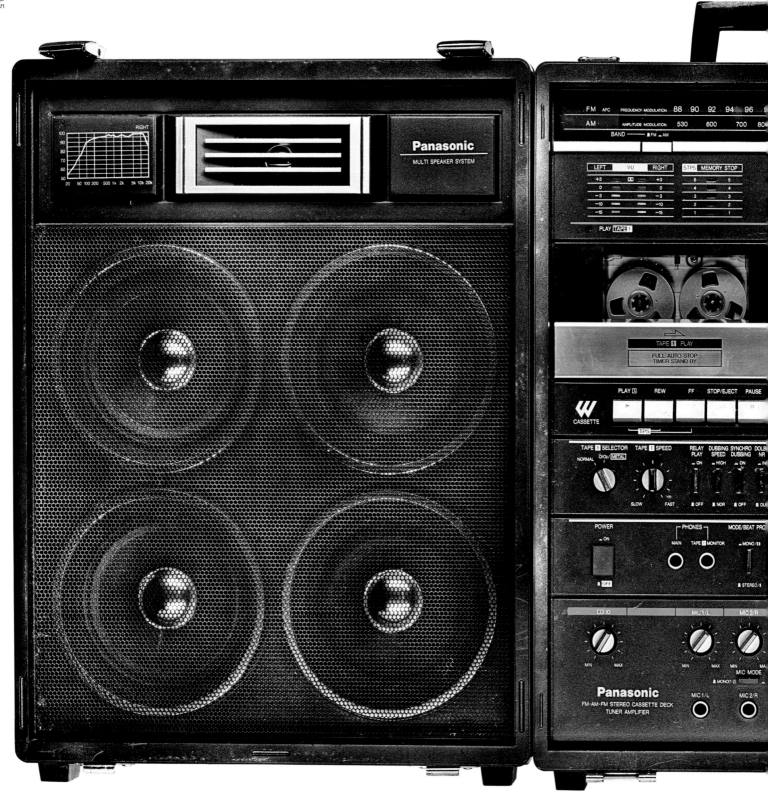

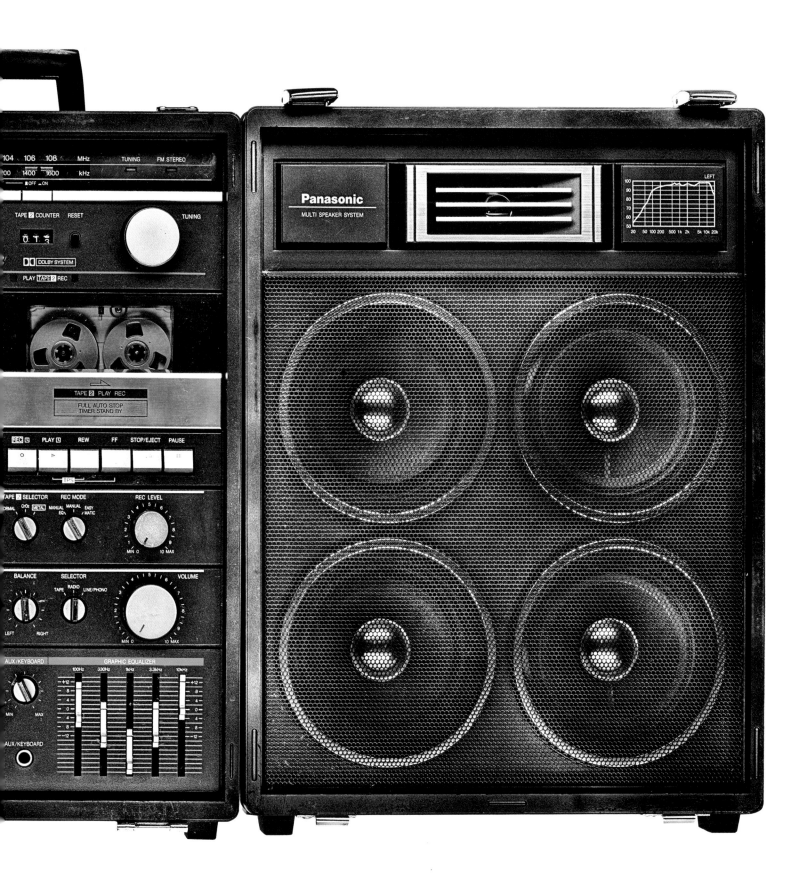

104 106 108 MHz TUNING FM STEREO
00 1400 1600 kHz
■ OFF ▬ ON

TAPE 2 COUNTER RESET TUNING
ᴏ̄ ᴛ̄ ᴣ̄
☐☐ DOLBY SYSTEM
PLAY TAPE 2 REC

TAPE 2 PLAY REC
FULL AUTO STOP
TIMER STAND BY

REC Ⓛ PLAY Ⓛ REW FF STOP/EJECT PAUSE
○ ▷
TPS

TAPE 2 SELECTOR REC MODE REC LEVEL
ORMAL CrO₂ METAL MANUAL MANUAL EASY
EQ /MATIC
MIN 0 10 MAX

BALANCE SELECTOR VOLUME
TAPE RADIO LINE/PHONO
LEFT RIGHT MIN 0 10 MAX

AUX/KEYBOARD GRAPHIC EQUALIZER
100Hz 330Hz 1kHz 3.3kHz 10kHz
+12 +12
8 8
4 4
MIN MAX 0 0
4 4
8 8
12 12

AUX/KEYBOARD
○

Panasonic
MULTI SPEAKER SYSTEM

LEFT
100
90
80
70
60
50
20 50 100 200 500 1k 2k 5k 10k 20k

TAKE THE LUG

Break-dancers, B-Boys, on the
street, New York City, 1981
Ted Polhemus

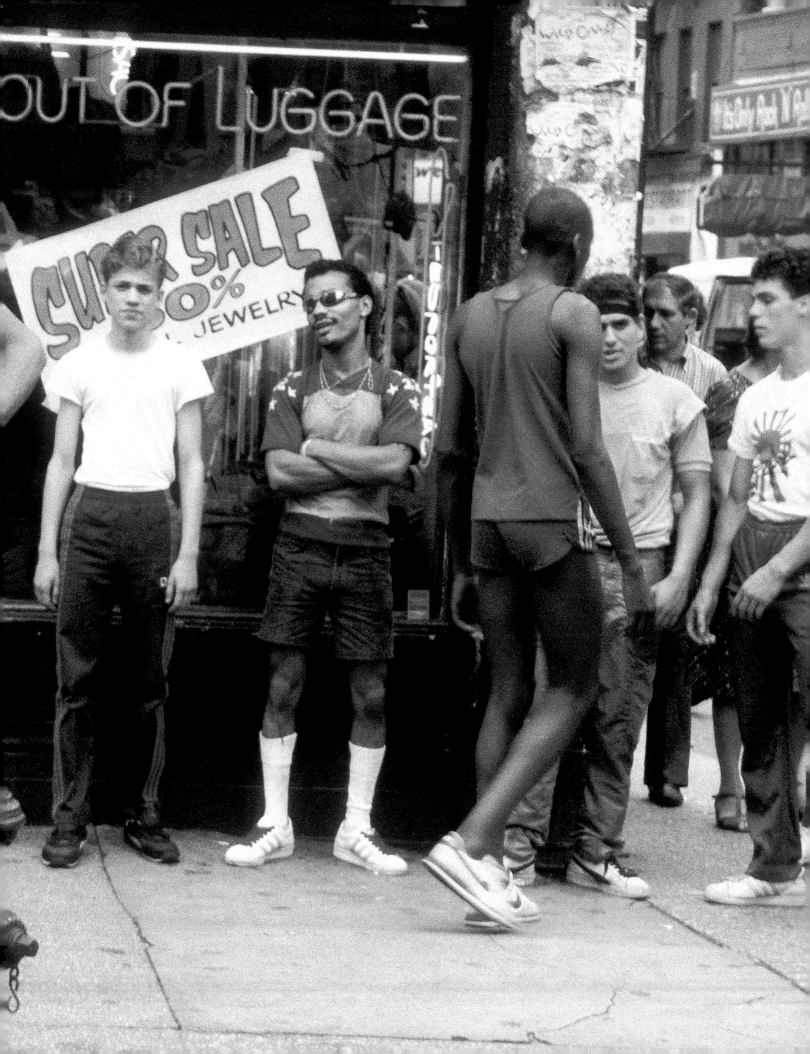

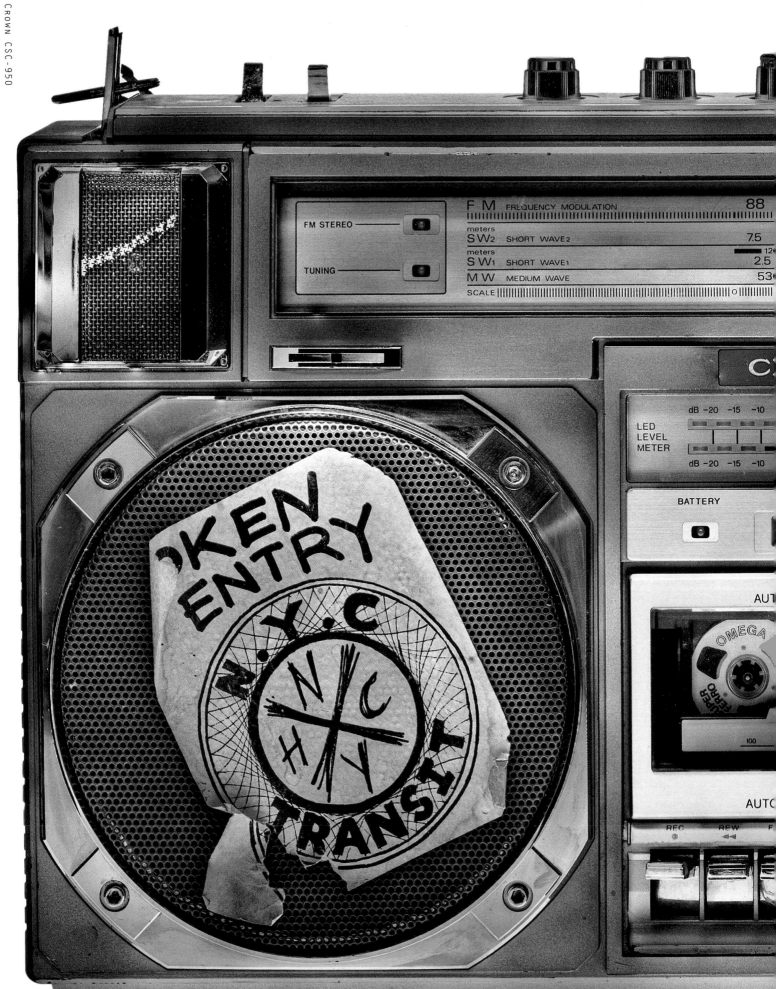

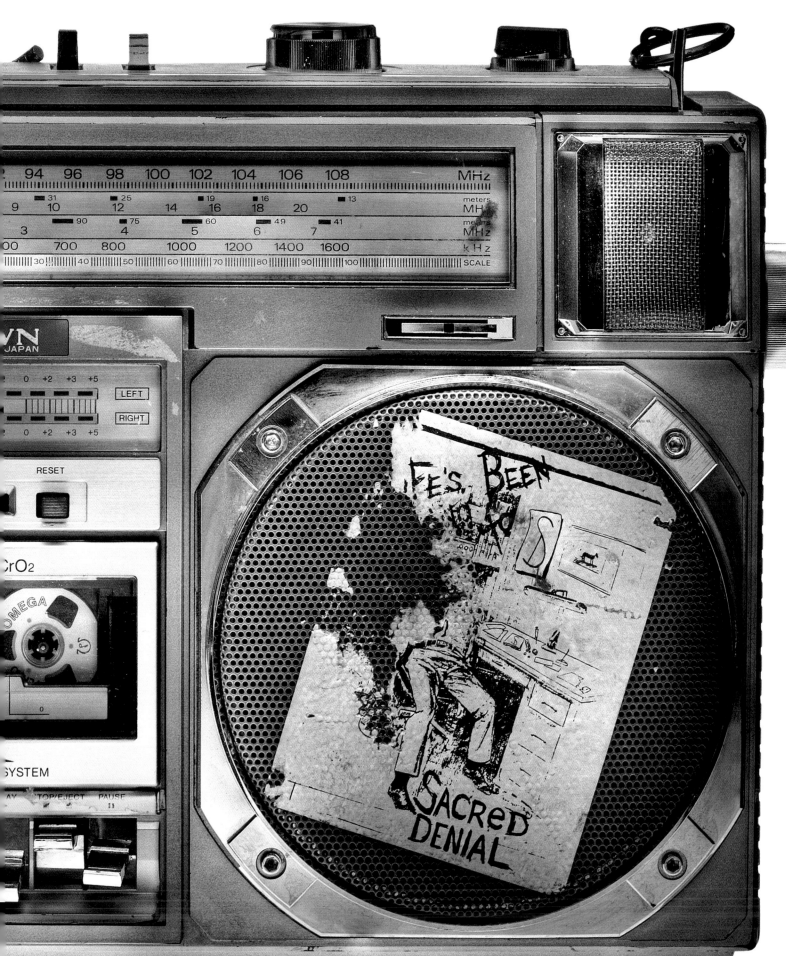

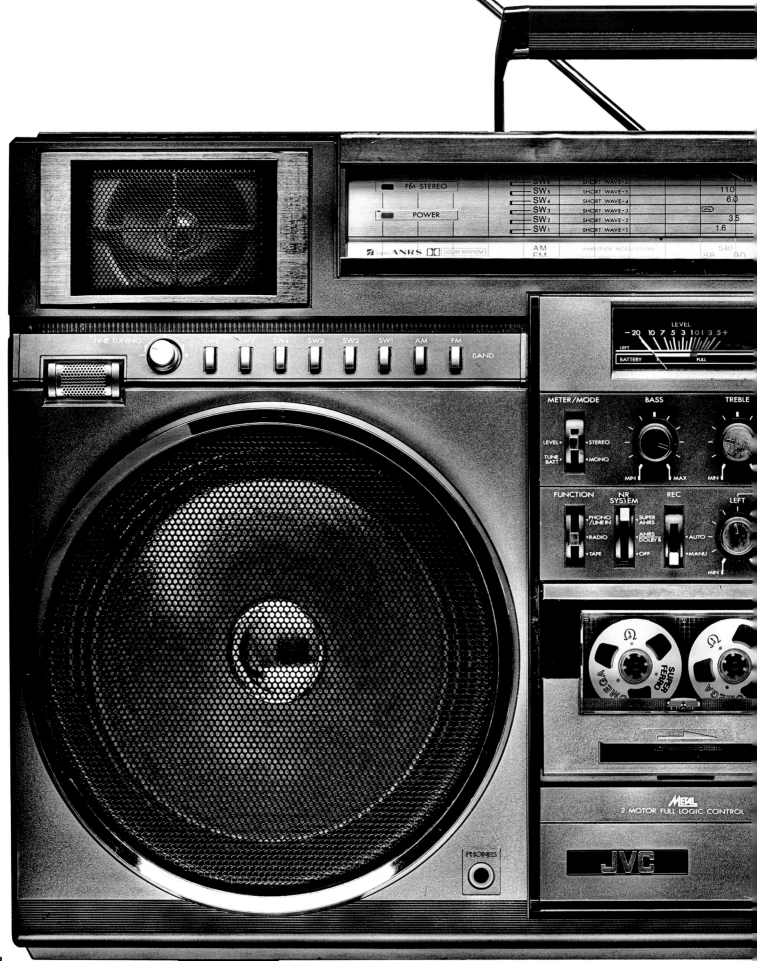

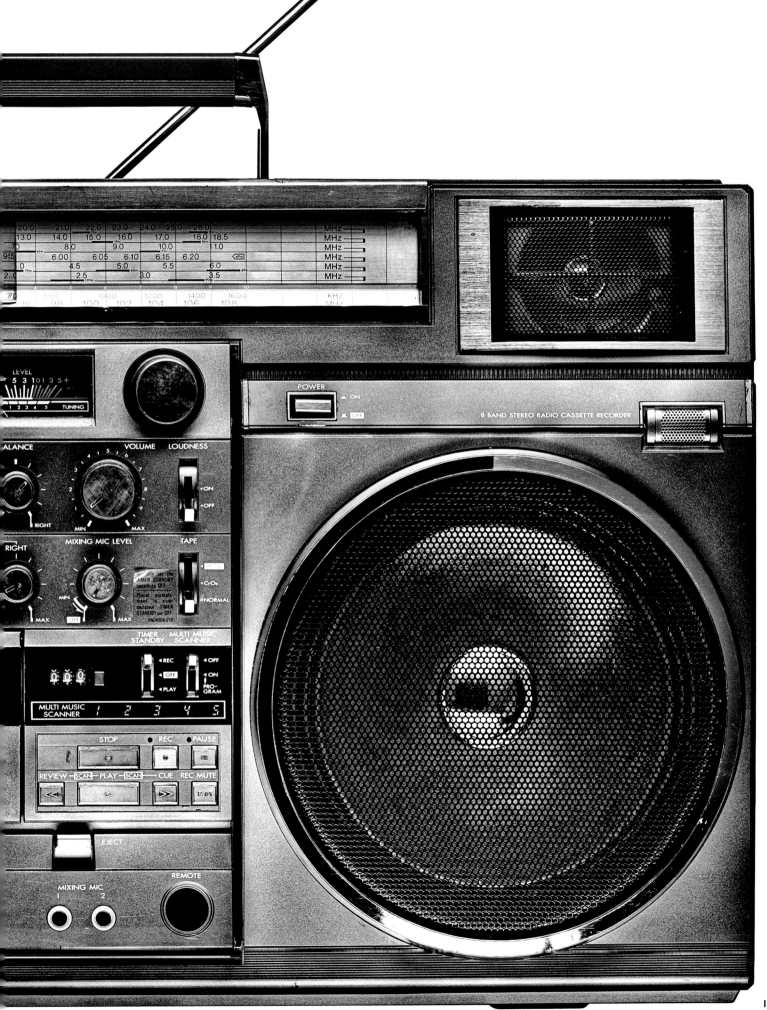

REWIND

5.REWIND ◀◀ Punching down the rewind button on a boombox sent a cassette tape careening through a squeaking and hissing flamethrower of sound not unlike that of a runaway train. ◀◀ After the bone-rattling discourse thudded to a stop, we were back to the beginning, so to speak. ◀◀ This ability to control what you wanted to listen to (and when), created a sense of empowerment previously unavailable to the masses. ◀◀ With this option, radio progamming no longer had a hold on when we could hear our favorite song or not; we could take our favorite tunes with us and listen to them anywhere and at any time. ◀◀ Through the power of song, rewinding allowed us to be torn by wild horses, dropped by a beat, shook all night long, to fight the power or to float on a careless whisper over and over again. ◀◀ For a generation on the move, the ability to rewind was an intrinsic if not noisy part of a boombox's appeal and control. *LO*

REWIND

Within the culture of today, the boombox symbolizes both a call to action and a proclamation for notice and attention. As an icon, it has its place in the history of the power of broadcasting—when the portable radio signaled a call for gathering, or acted with presence, in the battle between races, perspectives, voices, and musical tastes as they collided on street corners, subway platforms, and dance floors alike. It was a physical thing, with stories tied to it, along with the potential to generate new things. Just as hip-hop, punk, new wave, and rock 'n' roll were music movements born along with the rise of portable listening devices, they were just as importantly visual crusades as well. The boombox was a bridge between those movements (and so many more)—it was not just a thing, it was an icon. It was a magnet both literally and metaphorically. The boombox was about expressing something. These large sonic devices were a cultural bullhorn, belting out the sound tracks of choice as loud as possible, exalting the vibe of upbeat dissonance everywhere they were taken. And really, if you opened up one of these boombxes, they had no soul; however, combined with a piece of music, an attitude, and a strut, a beatbox (as they were sometimes known) suddenly became a powerful form of expression. The boombox stood as a daring opportunity to make one's presence known to the world! Long live the boombox—it is forever in our hearts, minds, and ears. *LO*

The boombox is a machine with the ability to tell stories.
— **Nick Egan** *(ALBUM DESIGNER / ART DIRECTOR)*

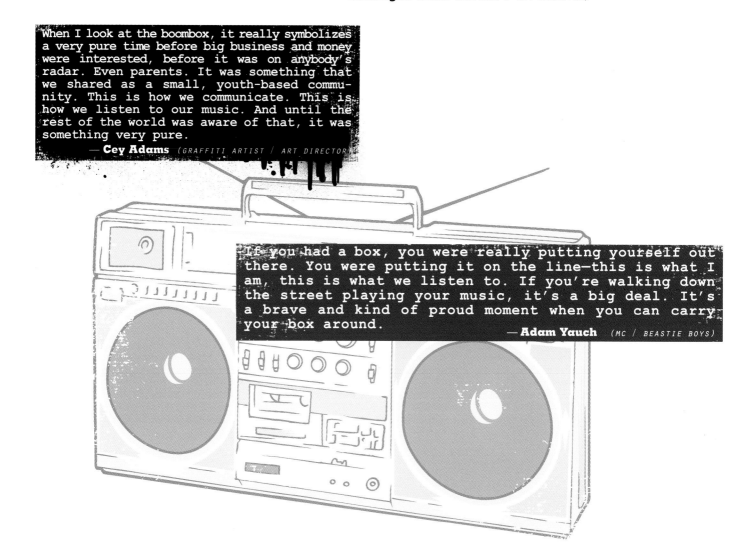

When I look at the boombox, it really symbolizes a very pure time before big business and money were interested, before it was on anybody's radar. Even parents. It was something that we shared as a small, youth-based community. This is how we communicate. This is how we listen to our music. And until the rest of the world was aware of that, it was something very pure.
— **Cey Adams** *(GRAFFITI ARTIST / ART DIRECTOR)*

If you had a box, you were really putting yourself out there. You were putting it on the line—this is what I am, this is what we listen to. If you're walking down the street playing your music, it's a big deal. It's a brave and kind of proud moment when you can carry your box around.
— **Adam Yauch** *(MC / BEASTIE BOYS)*

You'd have your little black leather zipper gloves and your boombox and you feel like you're hip-hop equipped and all that. Then you just throw it up on your shoulder and feel like a maniac. And then on top of that, what I used to do was, even when my man used to drive, I used to take the boombox, put my records on it, and put it facing out the window so people could hear what we was working on at the time. Just blast the neighborhood out like crazy. I was insane with it. And, you know, I just couldn't live without it, man. I really loved music. You know, and when you really love something, you get into it. I really loved it.

— **LL Cool J** (*RAPPER / ACTOR*)

We loved it all—"Square Biz," "The Message," Grandmaster Flash and the Furious Five, "Rock the Bells," Debbie Deb, Stevie B, "Hard Times" . . . If you were a borough kid, you listened to everything, because radio wasn't really segregated for a while. We listened to rock 'n' roll, you listened to punk rock, you know, you listened to hip-hop. We weren't exclusively listening to just hip-hop music; that's a myth.

The boombox was an object that worked as language . . . within different contexts, that object can say something differently, you know? If you're LL Cool J, you're talking about a boombox in a different way than the Clash . . . the boombox was like a perfect icon.

— **Geoff McFetridge** (*GRAPHIC DESIGNER / ARTIST*)

Sometimes the boomboxes were a nuisance, because people would just be blasting crap, or it was too tight of an area where there would be conflicting music. Sometimes people were really fuckin' angry and it'd be reflected in their music choice. But the boombox could make you smile: like the hot, sweaty train ride to Coney in the sweltering heat, you know, and then a good song comes on, it changed everybody's mood. Everybody was sharing their joy, sharing their mood.

— **Rosie Perez** (*CHOREOGRAPHER / ACTRESS*)

The boombox was like a statement. You're walking down the street. You were playing your music and it was like an African shield or some kind of, like, force field this thing was creating around you with your music.

— **Josh Cheuse** (*PHOTOGRAPHER / ART DIRECTOR*)

Boombox was supposed to be a portable radio that you'd probably bring on picnics or whatever. It wasn't meant for you to walk down the street with and blasting your music. But hip-hop was like, "Yo, I'm feeling good about this box. I'm going to blast it." When you played it, you wanted the world to know.

— **Pras** (*HIP-HOP ARTIST / MUSICIAN / THE FUGEES*)

The boombox is like the sonic campfire. It became the way for people to congregate and enjoy music as a group but not have to worry about having a live band. All you needed was a boombox and a good mix and the party could stay live for hours on end, depending on how many tapes you had.

— **Andre Torres** (*EDITOR, WAX POETICS*)

Records were a sort of format—a lot of the music that we were into was only accessible through that format—old soul, jazz, funk records, for instance—without it there wouldn't be hip-hop. These old records that were laying around at Kool Herc's mother's house or Grandmaster Flash's girlfriend's house—by finding these records they essentially were able to create this new medium called hip-hop; utilizing two old records and a couple of turntables they probably found at thrift stores and whatnot. The LP sort of got sort of pushed to the side when the cassette tape came out.

Now vinyl sales are on such a high upswing, and why you have people—now I even get cassettes sent to me. New people making albums will do limited edition cassettes, you know; it's sort of now time for that format to have its moment in the sun. The medium created a sense of community and was able to sort of spread this music . . . If technology has any role in our lives, it's to make those experiences more possible for more people. So I have faith that we will. Somewhere on the horizon we'll utilize technology to create more kinds of experiences.

— **Andre Torres** (EDITOR, WAX POETICS)

> The boombox was . . . just a very bold, big way of expressing yourself, you know, like a chest-beating.
>
> — **Ben Watts** (PHOTOGRAPHER)

I think the boombox stands for a few things. There's a musical integrity that comes with it. You couldn't just listen to Lite FM or oldies radio if you wanted to on it. There was sort of a pride in the music that came with the boombox. It accompanied the dawn of hip-hop, which is this super-authentic music from the street. And then the imaging of the boombox—it's just a great-looking piece. So when you combine it, it's like this sort of weird anachronism of futuristic and the past.

— **Jonathan Daniel** (MUSIC HISTORIAN / BAND MANAGER)

I have one [boombox], in my attic. I saved mine. It's little, but it's mine. It's mine and every time I look at it, it's a piece of time for me, of struggles and, you know, being able to express and being able to listen to those beats, and to make music myself, and to write lyrics. Everything that I went through with growing up. I would never, ever, ever change anything that I've gone through because to me that's what made me who I am today, and that boombox has a lot to do with it.

— **Lisa Lisa** (SINGER, LISA LISA AND CULT JAM)

Back in the days, the music was about social conscience and it was also about love . . . I have a tradition that I have to do in my neighborhood. I call it "flyin' my flag," and I bring my boombox with my old tapes from the eighties and seventies and I have to play music in my backyard to let people know that I exist and that I'm alive. My wife said, "What makes you think everybody wants to hear your music?" And I said, "I really don't care, but I have to do this to let people know that I am alive."

— Jamel Shabazz (PHOTO DOCUMENTARIAN)

Back in the sixties the hippies would have gathered around a fire, but in the eighties we were gathering around our boomboxes—and that might be in Central Park, that might be in a car park or the basketball courts or whatever. But that was the beauty of that thing, is that you could set up and have a spontaneous party almost anywhere, whether it be dancing or rapping or whatever. Once you had your sound track, you could do your thing if you had the balls and an idea.

— **Don Letts** (DJ / MUSICIAN / DIRECTOR)

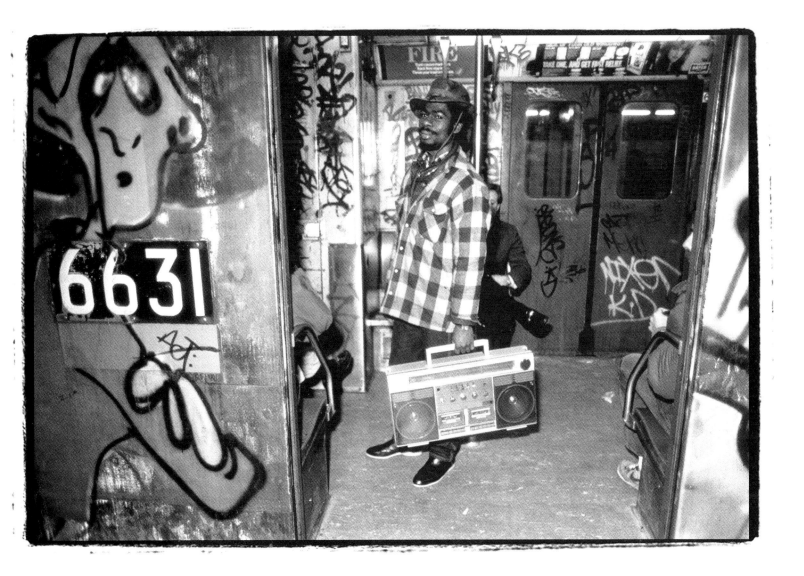

The boombox and the culture of mix tapes allowed you to have your own version of things. This translated to lifestyle— the boombox was social glue: Just set up the boombox on the street; your friends would come over and hang out.
— **Paul Miller / DJ Spooky** (MUSICIAN / ARTIST)

When you had a beatbox, you were living with the music.
— **Bob Gruen** (ROCK 'N' ROLL PHOTOGRAPHER)

SUBWAY GRAFFITI, NEW YORK CITY, 1985
RICKI ROSEN

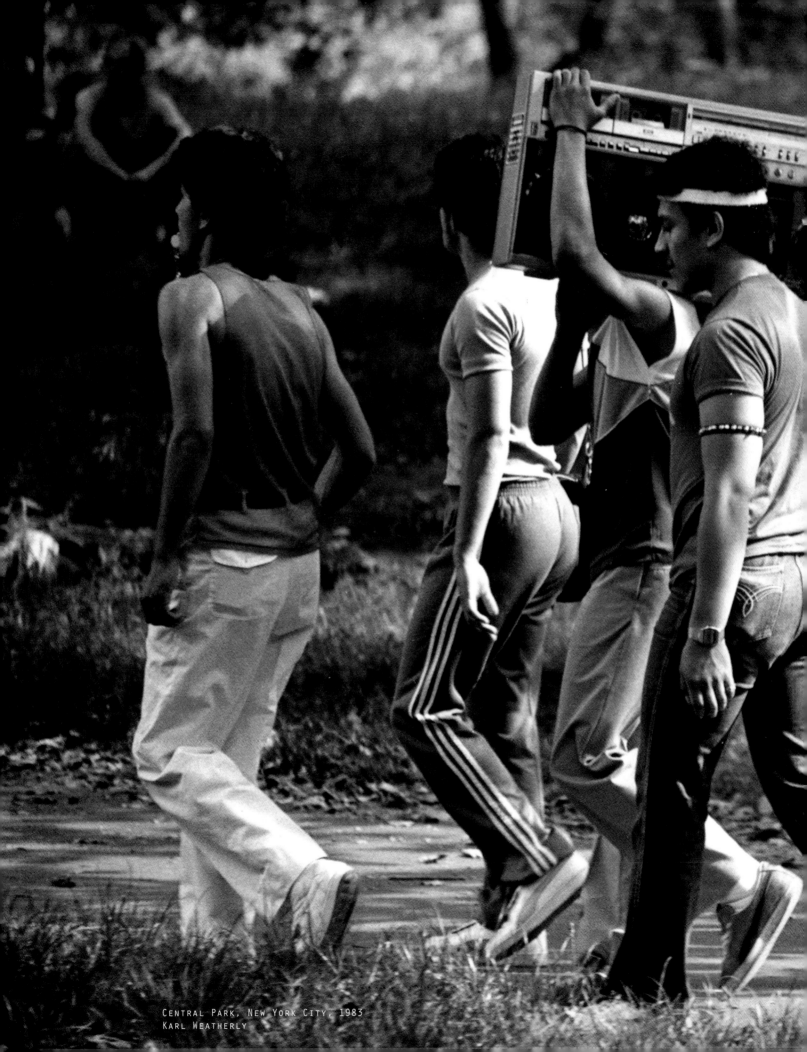

CENTRAL PARK, NEW YORK CITY, 1983
KARL WEATHERLY

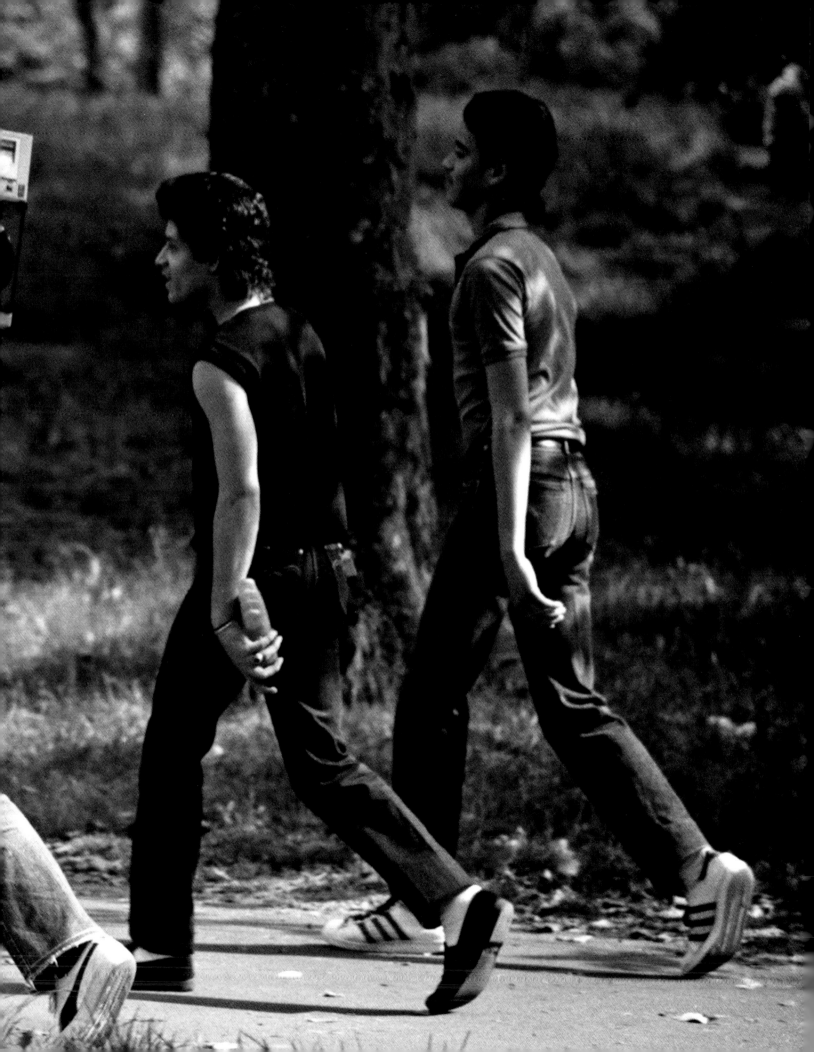

CONTRIBUTORS

The master in the art of living makes little distinction between his work and his play, his labor and his leisure, his mind and his body, his information and his recreation, his love and his religion. He hardly knows which is which. He simply pursues his vision of excellence at whatever he does, leaving others to decide whether he is working or playing. To him he's always doing both.

— Anonymous

Joeseph Abajian
(president, Fat Beats Inc.)

Jonas Åckerlund
(music video director / filmmaker)

Cey Adams
(grafitti artist / creative director)

Adisa Banjoko
(hip-hop journalist / activist)

Josh Cheuse
(photographer / art director)

Trevor Clark
(hip-hop clothing and accessories designer)

Claw Money —
Claudia Gold
(fashion designer / graffiti artist)

Custom —
Duane Lavold
(musician / filmmaker / writer)

André Czarnobai
(author / drum and bass DJ)

Jonathan Daniel
(musician / founder, Crush Management)

DJ Eclipse —
Brian A. Johnston
(indie hip-hop tastemaker / DJ)

George Drakoulias
(music producer / soundtrack supervisor)

Dzine —
Carlos Dzine Rolon
(artist)

Nick Egan
(acclaimed album designer / art director)

Fab 5 Freddy —
Fred Brathwaite
(hip-hop historian / pioneer graffiti artist)

Ricky Flores
(urban documentatrian / photojournalist)

Glen E. Friedman
(artist / photographer)

Noel Gallagher
(founding member of the band Oasis) Quotation from "Stereos of the Stars: What the People You Listen to Listen to" by Matt Hendrickson, *Rolling Stone*: June 12, 1997

Robert "Bobbito" Garcia
(DJ / writer / entrepreneur / streetball player / sneakerfreak / member of the Rock Steady Crew)

Tyler Gibney
(artist / visual entrepreneur)

Billy Graziadei
(musician—Biohazard and Suicide City)

Bob Gruen
(renowned photographer known for his photographs of musicians)

Nicholas Jarecki
(director / producer / writer)

Jim Jones —
Joseph Guillermo Jones II
(rapper / hip-hop entrepreneur) Quotation from an interview conducted by Aaron Farash for *The Boombox Project*, courtesy of Aaron Farash

J-Zone —
J. Mumford
(rapper / producer / CEO of Old Maid Entertainment)

Kool DJ Herc
(DJ / godfather of hip-hop) Quotation from an interview conducted by Davey D at the 1989 New Music Seminar

Kool Moe Dee —
Mohandas Dewese
(prominent hip-hop MC)

KRS-One —
Lawrence Parker
(pioneering hip-hop artist / activist) Quotation from the song "9 Elements" from the album *Kristyles* (Koch Records)

LL Cool J —
James Todd Smith
(iconic rapper and actor) Quotation from an interview conducted by Fab 5 Freddy for *The Boombox Project*, courtesy of MTV Networks

Spike Lee
(ground-breaking film director)

Don Letts
(accomplished documentary director / musician / radio host / DJ)

Adam Levite
(designer / video director)

Lisa Lisa —
Lisa Velez
(member of Lisa Lisa and the Cult Jam)

Geoff McFetridge
(enigmatic graphic designer / visual artist)

Chad Muska
(professional skateboarder / DJ)

Jose Parla
(b-boy / artist)

Rosie Perez
(accomplished actor / dancer / activist)

James Phillips
(college professor / boombox historian)

Pras —
Prakazrel Samuel Michel
(Grammy Award–winning rapper / actor / film producer)

Rahzel —
Rahzel M. Brown
(self-defined "vocal percussionist" / virtuoso beatboxer)

Michael Ruffino
(musician / author / renowned "rock 'n' roll" writer and raconteur)

Mike Schiffer
(college professor / author – The Portable Radio In American Life)

Torsten Schmidt
(co-creator and director of the Red Bull DJ academy / underground music advocate)

Earle Sebastian
(music video / commercial director)

Jamel Shabazz
(photojournalist / urban documentarian)

DJ Spooky —
Paul D. Miller
(artist / experimental hip-hop musician)

DJ Stretch Armstrong
(DJ / radio host / producer)

Rick Thorpe
(boombox collector)

Andre Torres
(editor Wax Poetics magazine)

Turbosonic —
Shogo Turuoka
(world renowned as Japan's best boombox retailer and mini-museum)

Butch Vig
(musician / acclaimed band producer) Quotation from "The 90s Era: The Making of Nirvana's Nevermind" by Rob O'Connor, *Rolling Stone*: May 15, 1997

Ben Watts
(photographer)

Adam Yauch
(founding member of hip-hop trio the Beastie Boys / humanitarian)

Editor: David Cashion
Photo Editor: Lyle Owerko and Jeff Streeper
Designer: Jeff Streeper
Design/Production Assistance: Aaron Monson
Spot Illustrations: One Horse Town
Portrait Illustrations: Erica Simmons
Production Manager: Ankur Ghosh
Cataloging-in-Production data has been
applied for and is available from the
Library of Congress.

ISBN: 978-0-8109-8275-8

Text copyright © 2010 Lyle Owerko

Printed and bound in China
10 9 8 7 6 5 4 3 2

Abrams Image books are available at a
special discount when purchased in
quantity for premiums and promotoon as
well as fundraising or educational use.
Special editions can also be created to
specifications. For details, contact
specialmarkets@abramsbooks.com or the
address below.

ABRAMS
THE ART OF BOOKS SINCE 1949
115 West 18th Street
New York, NY 10011
www.abramsbooks.com

PHOTOGRAPHY CREDITS
All photographs, unless otherwise noted,
are © Lyle Owerko.

Page / Copyright
10-11 / © Olivier Martel/akg-images
18-23 / © Ricky Flores
27 / © Ari Marcopoulos
32-33 / © David Swindells/PYMCA
36 / © GLEN E FRIEDMAN, courtesy Burning
Flags Press
40-41 / © Vanessa Nina
43 / © Eve Arnold/Magnum Photos
46 / © Peter Anderson/PYMCA
50 / © Lisa Beck
50-51 / © Lynn Goldsmith
53a / © Josh Cheuse
53b / © Don Letts
54-55 / © Lynn Goldsmith
59a / © Paul Harnett/PYMCA
59b / © Steve McCurry/Magnum Photos
59c / © Kurt Hoerbst/Anzenberger/CON
60 / © Ricky Flores
61 / © Sophie Elbaz/CORBIS
62 / © Owen Franken/CORBIS
63 / © Thomas Hoepker/Magnum Photos
66 / © Erica Simmons
67 / © Bob Gruen
68abc / © Bob Gruen
69a / © FUTURA 2000
69b / © Josh Cheuse
72-73 / © Bruce Davidson/Magnum Photos
76 / © Joe Conzo
79 / © Joe Conzo
81 / © Laura Levine
82-83 / © Amy Arbus
85 / © Ted Polhemus/PYMCA
86 / © GLEN E FRIEDMAN, from the book FUCK
YOU HEROES, courtesy Burning Flags Press
91 / © Ebet Roberts/Redferns
93 / © Bob Gruen
96 / © Ben Watts
99 / © Normski/PYMCA
106-107 / © Alain Keler/Sygma/CORBIS
112-113 / © Alain Keler/Sygma/CORBIS
122-123 / © Lisa Kahane
130-131 / © Jamal Shabazz
136-137 / © Ricky Flores
144-145 / © Ted Polhemus/PYMCA
155 / © Ricki Rosen/SIPA
156-157 / © Karl Weatherly/CORBIS

THANK YOU

No project could be complete without the people who step into the process to give a lending hand and advice that is over and above the call of
duty - a truly special thanks goes out to: Alex Asher Daniel, Maria Pulice, Leah Hamilton, Aaron Farash, Karyn Marcus, Adam Burke and Phil Green,
Andrea Smith, Fab 5 Freddy, Ricky Flores, Jamel Shabazz, Spike Lee, Ed Burns, Anders Hallberg, Thomas Hayo, Matt Black, Miki Araki, Adam
Weiss, Jesse Raker, Brian Dunn, Michael Costuros and Kim Iglinsky, Jack Lundgardh, Amanda Havey, J. Ralph, Kaori Sohma, Yosuke Kurita, Takahiro
Yamaguchi, Scott Ewalt, Jonathan Podwil, Luis Gonzalez, Pam Lubell, Nick Terzo, Eileen Martin, Julie Kauss, Michael Moschel, Mia Grettve, Tuen van
den Dries, Frank van Haalen, Duane Lavold and Izzy Zivkovic, Christiane Celle, the CLIC Gallery family (Polly, Gardy, Angharad, Mo, and Gilou),
Jacques Naude and Angie Schmidt, Misha Taylor, One Horse Town, Michael Ruffino and Steve Garbarino, NPR (Caitlin Kenney, Roy Hurst, and Frannie
Kelley), ABC Nightline News (Natasha Singh and Jeremy Hubbard), Prasad Boradkar and the team at SMoCA, Jerimiah Smith, Diego de Godoy, Jonathan
Rojewski, David van Wees, Pete White, Michelle Monaghan, Eric Yupze, Amber Noelle, Gudberg Magazine, Christopher Griffith, Mark Owerko, Jennifer
Hall, Raegan Glazner, Shinobu Mochizuki, Ira Friedman, Boomboxery.com, Sunshine Mix 2010 (thanks to Ed Allard, Mike Boombox, Fred Flowers, Robert
Gross, Phil Hines, Bobby Jenkins, Frank Marullo, Juan, Ed and Betty Nollmann, Tony and Linda Palermo, Ramon Ramos, Ralf and Heidi Starke, and John
Tucker), James Phillips, Don Letts, Josh Cheuse, Bob Gruen, DJ Spooky, Jane Newman, Peter Frankfurt and George Drakoulias, Dante Ross, DJ Ross One,
Kool Moe Dee, Pras, David Fahey, Jose Arizmendi, the team of Michael Frankfurt and Rick Gordon, Kristy Hinze-Clark, Jim Clark, John Kim, Shaundra
Hyre and Luna!, Martha North, Stan and Marge Owerko, Deborah Aaronson (for seeing a concept worth pursuing here), David Cashion (for taking bullets
as my incredibly patient editor), Jeff Streeper (my design co-conspirator for so many years...) and a special thank-you to the Abrams publishing
group. As one giant interconnected family we all collaborated together in one way or another to turn this collection of pages into a solid work of
progress. Your belief in this concept opened doors and provided crucial foundations and guidance to this project as it gained momentum over
the last four years. Many things happened along the way to the finish, but we're still all friends, supporters, and believers in the idea, that
"The Boombox Project" is a bigger concept than a book about the appreciation of vintage electronics - it's about gathering and community. For that
I am truly grateful to you all! This project is dedicated to conviction and the overcoming of resistance!

"The Future is Unwritten" - Joe Strummer

EVOLUTION OF THE BOOMBOX

1821 - Charles Wheatstone invents the first microphone

1899 - Music recording industry loudspeakers are invented

1887 - Emile Berliner invents the gramophone

1916 - Radios with tuners are invented, allowing different stations

1979 - Boomboxes become mainstream and are featured in pop culture and advertisements

1976 - First boomboxes begin to appear

1975 - New Wave hits the music scene, pioneered by bands such as Blondie

1980 - First Sony Walkman appears on the market

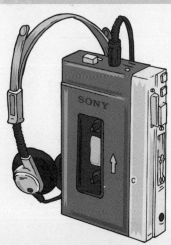

1983 - The golden age of the boombox. Massive boomboxes such as the Sharp GF 777 "Searcher" appeared on the scene